1919 - 2019

GRAND CANYON NATIONAL PARK

10 DECADES OF STORIES & PHOTOGRAPHS
FROM ARIZONA HIGHWAYS

EDITED BY
ROBERT STIEVE

ARIZONA
HIGHWAYS

Editor: ROBERT STIEVE
Designer: BARBARA GLYNN DENNEY
Photo Editor: JEFF KIDA
Books Editor: KELLY VAUGHN
Editorial Assistant: NIKKI KIMBEL
Copy Editor: NOAH AUSTIN

Library of Congress Control Number: 2018939363
ISBN: 978-0-9987893-8-5
First printing: 2018. Printed in South Korea.

Published by the Book Division of *Arizona Highways* magazine, a monthly publication of the Arizona Department of Transportation, 2039 W. Lewis Avenue, Phoenix, Arizona, 85009, www.arizonahighways.com.

Publisher: Win Holden
Associate Publisher: Kelly Mero
Editor: Robert Stieve
Senior Editor/Books: Kelly Vaughn
Associate Editor: Noah Austin
Creative Director: Barbara Glynn Denney
Art Director: Keith Whitney
Photography Editor: Jeff Kida
Editorial Administrator: Nikki Kimbel
Production Director: Michael Bianchi
Production Coordinator: Annette Phares

Dedicated to the memory of Taylor Bates,

a beautiful young girl with a heart as big as the Grand Canyon.

2011-2017

CONTENTS

FROM THE EDITOR

*"You cannot say, 'I have seen the Grand Canyon!' unless your home
is on the canyon rim and the canyon is with you and about you all the time.
The canyon isn't just rock and sandstone and granite, an inert mass of graceful
spires and temples clawed in the earth by a red mad river. The Grand Canyon
is a living thing, always changing. It is never the same, and when
it casts its spell upon you, it is with you forever."*
— Raymond Carlson, Editor (1938-1971)

It took us a while to figure this out — this book about the Grand Canyon. We had gotten several "Centennial" pitches from our extended family of writers and photographers, and we bounced around some pretty good ideas of our own. But none of them seemed quite right, especially when measured against the extensive archive of books that already exists, and the inevitable arrival of so many more.

To do another book of landscape photography would be redundant, we figured. And futile. Our book *Grand Canyon: A Photographer's Favorite Viewpoints*, by Jack Dykinga, is already one of the best in that division. History, geology, archaeology ... there's not much we could do with those subjects that hasn't already been done to perfection by our friends at the Grand Canyon Association. *So, what do we do?* we wondered. We were having the editorial equivalent of writer's block when the idea finally jumped up and hit us in the head: "Why not celebrate the 100th anniversary of Grand Canyon National Park through the pages of *Arizona Highways*?"

Although our magazine is a few years younger than the park, we've been covering the park for parts of 10 decades. There's a built-in parallel: the history of the park and the history of the magazine. And we've always had a symbiotic relationship. For our part, we've given more worldwide coverage to the Grand Canyon than any other magazine. *Ever.* And the park, in turn, has provided us with a steady stream of raw material.

In all, we've published hundreds of stories and thousands of photographs about the Grand Canyon and the century-old park that protects it. For this book, we revisited every single one, and ultimately settled on the 28 stories you'll see inside. Stories written by some of the most accomplished writers in our archive: Raymond Carlson, Charles Franklin Parker, Joyce Rockwood Muench, Frank Waters, Craig Childs, Charles Bowden.

As you might imagine, curating nearly 100 years of content wasn't easy — it was months and months of Sophie's choice. To help narrow the field, we primarily focused on the stories that occurred after the park's official birthday on February 26, 1919. Because of that, you won't see any stories about John Wesley Powell's trip down the Colorado River in 1869 or the arrival of Coronado's expedition in 1540. This book is focused on the park, not the Canyon — the Canyon's centennial, by the way, was about 70 million years ago.

Selecting the stories was a challenge. What to do with them was another dilemma. There were a few things in particular that needed resolution. The first was style. All books and magazines have an official style. Ours is derived from the Associated Press; *Webster's New World College Dictionary, Fourth Edition*; and, to some extent, the *Oxford English Dictionary*. Sticking to a style helps ensure consistency and, in theory, provides a better experience for readers. However, when you're resurrecting stories that were written over the course of almost a hundred years,

Atchison, Topeka and Santa Fe Railway magazine advertisements from the early 1900s tout the wonders of a visit to the Grand Canyon's South Rim. | COURTESY OF NATIONAL PARK SERVICE

there are bound to be some differences. Our choice was to either update all of the old stories, and apply our current style, or let them be. We decided to keep our hands off. Looking back, we like the flavor of the old style, which features some odd hyphenations ("up-draft" and "snow-storm") and all kinds of inconsistent spelling — in the same story, we referred to a certain pine tree as a "piñon" and a "pinion." The style rules for proper nouns were all over the place, too. Or maybe there weren't any rules at all.

Another thing we had to think about was fact-checking. To be clear, there are some errors in some of these stories. In some cases, they were the result of a lack of information at the time — the age of the Canyon, the length of river — and in other cases, there may have been a hint of hyperbole. Or folklore. A good example of that is a quote attributed to President William Howard Taft. As the story goes, the president took a train to the South Rim. When he arrived, he made his way to the edge of the Canyon, looked out and declared, "Golly, what a gully!" It makes for a great story — we even used it as the headline on one of ours — but there's evidence to suggest it might have been one of the president's staffers who made the remark. No one knows for sure, so we left it alone, along with all of the other questionable details.

We didn't want our book to read like a dissertation — the rhythm of the writing would have been thrown off by the interruption of so many footnotes. Also, we think it's interesting to look back and consider the level of understanding in the 1920s or '30s or '40s. Leaving the copy alone allows for a more interesting trip back in time. And that's really what this book is all about. It's a journey back to that day in 1919 when President Woodrow Wilson signed into law a bill establishing the Grand Canyon as the nation's 15th national park. And it's a story-line of some of the people, places and things that have made the park one of the crown jewels of the National Park Service.

John Muir once said this about the Grand Canyon: "It seems a gigantic statement for even nature to make." In the same way that words and photographs can never fully capture the gran-deur of the Canyon — a place that can be seen from outer space, a place counted as one of the seven natural wonders of the world — no single book can fully tell its story. Ours is no excep-tion, but it spotlights a few chapters of the bigger story.

Of course, the best way to learn about the Canyon is to be there. To stand on the rim. To hike down in. To run the river. And even then, it's hard to grasp. As our late friend Charles Bowden wrote: "Off and on in my life, I have walked it, been there in summer heat, camped in deep winter snow. Seen the water low and high. And I know nothing I did not know before I first came. Except this: How little I know or will ever know."

— Robert Stieve, Editor

MARCH 1926

AUGUST 1933

FEBRUARY 1938

DECEMBER 1935

JULY 1942

AUGUST 1947

MARCH 1954

MAY 1957

APRIL 1965

JUNE 1968

SEPTEMBER 1977

NOVEMBER 1978

AUGUST 1983

DECEMBER 1986

JUNE 1996

APRIL 1997

JUNE 2007

JANUARY 2009

MAY 2010

AUGUST 2016

JANUARY 1928

BREAKING A TRAIL THROUGH BRIGHT ANGEL CANYON

BY F.E. MATTHES, UNITED STATES GEOLOGICAL SURVEY

Last autumn — in the month of November, to be precise — it was just twenty-five years since the first pack train made its way through Bright Angel Canyon. It was a rough-and-tumble journey, the hazards of which may be difficult to imagine by those who now travel safely and comfortably across the Grand Canyon via the excellent Kaibab Trail. The perils that were faced by those hardy explorers who passed through the Grand Canyon in boats, and battled with the rapids of the Colorado River, are now known to many, but the adventures of the first party to cross from one side of the Grand Canyon to the other with a pack train have never been told. Here follows a brief statement of the circumstances:

In the spring of 1902 it was my privilege to be assigned to the task of beginning the topographic mapping of the Grand Canyon for the United States Geological Survey. Naturally our party started work on the south side, the Grand Canyon railroad affording the most convenient route of approach.

For several months the surveying operations — triangulation, leveling and plane table mapping — were carried on over the Coconino Plateau and from its rim down into the chasm. Then we began to seek a route across to the north side, but at that time there was no trail across from rim to rim, nor was a bridge over the Colorado. We found ourselves face to face with a

barrier more formidable than the Rocky Mountains — an abyss 280 miles long, containing an unbridged, unfordable, dangerous river.

Not unnaturally we cast longing glances up Bright Angel Canyon — it seemed to us such a convenient, straight avenue. But Bright Angel Canyon, we were told, afforded no practical route for pack animals, and might be impassable even to the foot of man.

Lee's Ferry, at the head of Marble Gorge, of course, was suggested, but to cross the river there would require a tour of some 180 miles, mostly through parched deserts, where feed and water would have to be carried for the animals.

BASS TRAIL SELECTED

There was but one other choice, to go west 35 miles and descend by the Bass Trail, cross the river in some way, and climb out on the north side through Shinumo and Muav Canyons. The crossing was known to be dangerous. The Bass Trail was merely a burro trail, still unfinished at the lower end, and the Shinumo Trail was little more than a faint track seldom used. Yet this was the route we finally selected.

About the middle of August, when the river had subsided to a moderate level, we set out with a pack train of ten animals. W.W. Bass consented to our using his home-made boat, and this, of course, facilitated matters considerably. Unfortunately, however, we found that the boat was on the north side of the river, and two of us, consequently, were obliged to match our strength against the current and swim across to get it.

The camp equipment was quickly ferried over, but the transferring of the horses and mules proved a difficult task. The animals, worn out by the heat, and unnerved by their descent over the great rock slide at the foot of the trail, could not be induced to enter the water. A stratagem had to be resorted to. They were led down to a rock platform, ostensibly so they might quench their thirst, then suddenly they were pushed over into the swirling flood. Quickly behind the boat they were then towed across, one by one. In their frenzy, many of them tried to swim back or downstream, or even to climb into the boat, so that the rowers were more than once in danger of being dragged down over the turbulent rapids below the crossing. Eventually, however, all the animals were landed safely on the other side.

The next day we began the ascent to the rim of the Kaibab Plateau. It took us a day and a half of arduous, exhausting work to gain the top, and the entire trip to Point Sublime, where the mapping operations were resumed, consumed six days.

There was no thought, during the ten weeks while we were on the Kaibab Plateau, of sending back to the south side of the canyon for supplies. The Bass crossing could not be negoti-

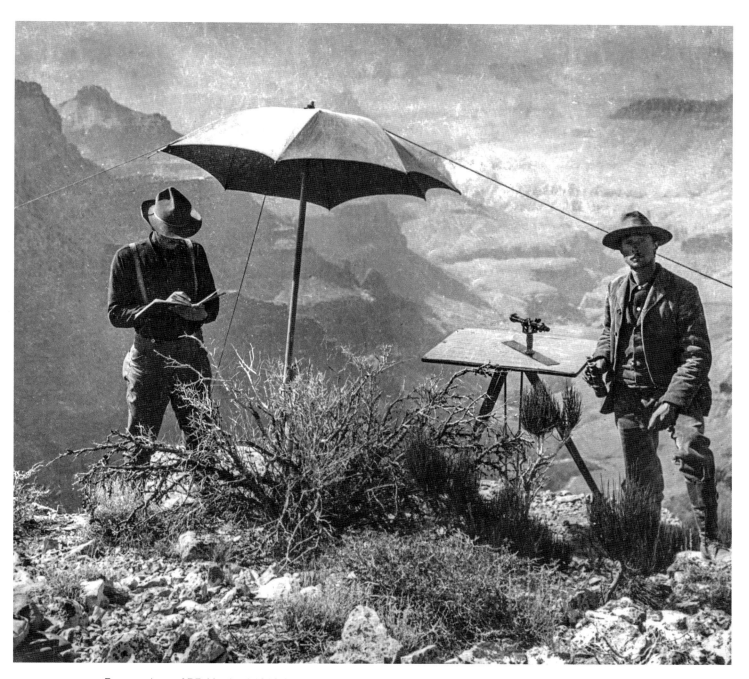

Two members of F.E. Matthes' 1902 Grand Canyon expedition record observations at Cape Royal, which today is a popular destination for North Rim visitors. | COURTESY OF GRAND CANYON NATIONAL PARK MUSEUM COLLECTION

ated by one man, nor even by two, and the whole party numbered only four. Instead we sent to Kanab, Utah, although that place was 75 miles distant by trail and the packer had to make a full week's journey to do his shopping there and return to the camp on the rim.

BRIGHT ANGEL BECKONS

As autumn set in, and the prospect of a snow storm grew more and more imminent (heavy snows begin to fall on the Kaibab Plateau usually early in November), we were forced to consider a retreat to the south side. The survey by that time had progressed as far east as the head of Bright Angel Canyon and we found ourselves directly opposite Grand Canyon station, and only 13 miles distant from it in air line. Again Bright Angel Canyon beckoned to us as a possible avenue, and eagerly we scanned its sides for a practicable way down.

Now Bright Angel Canyon is carved along a great fracture in the earth's crust — a "fault," as it is termed by geologists — on which the strata are offset vertically by more than a hundred feet, and the lines of cliffs are consequently broken. The same fault extends southwestward into the embayment on the south side of the chasm and has made possible the building of the old Bright Angel Trail, now familiar to thousands of tourists. It did not take us long, therefore, to discover a route along this fault where the Red Wall, the Cliff of the Coconino sandstone, and lesser cliffs are interrupted by slopes of debris.

On the very day when we started to examine this route, by a remarkable coincidence, there emerged from the head of Bright Angel Canyon two haggard men and a weary burro. These men, Sidney Ferrell and Jim Murray, had explored up through the Canyon and finally fought their way along the fault zone.

At once the prospects of the return of the survey party by this new route became brighter. However, it does not follow that where a small burro was boosted up, a pack train of heavily loaded horses and mules can come down in safety. Two of the party, therefore, set themselves the task of cutting out brush and rolling out logs and boulders so as to make a reasonably clear way for the pack train. And this work they carried all the way down to the mouth of the canyon.

On the seventh of November, when heavy clouds presaged a change in the weather, we hastily broke camp and proceeded down our new trail. So steep was it in certain places that the animals fairly slid down on their haunches. So narrow between the rooks was it at one point that the larger packs could not pass through and had to be unloaded. Of accidents there were more than can here be chronicled, but none of them, fortunately, was of a serious nature. The mule carrying the most precious burden — the instruments and the newly made maps — was led with particular care, but she lived up to her reputation and made the trip without a stumble.

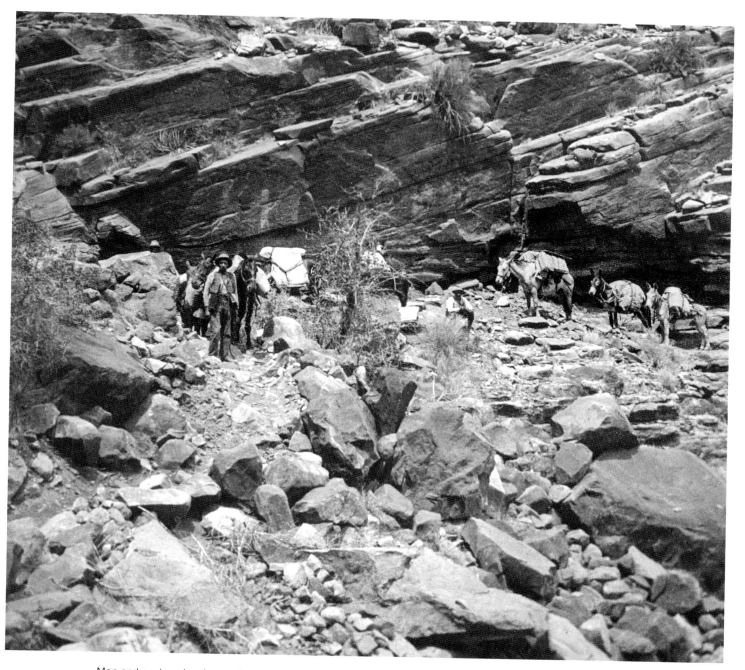

Men and pack mules descend a rugged trail during the 1902 Matthes expedition. | COURTESY OF GRAND CANYON
NATIONAL PARK MUSEUM COLLECTION

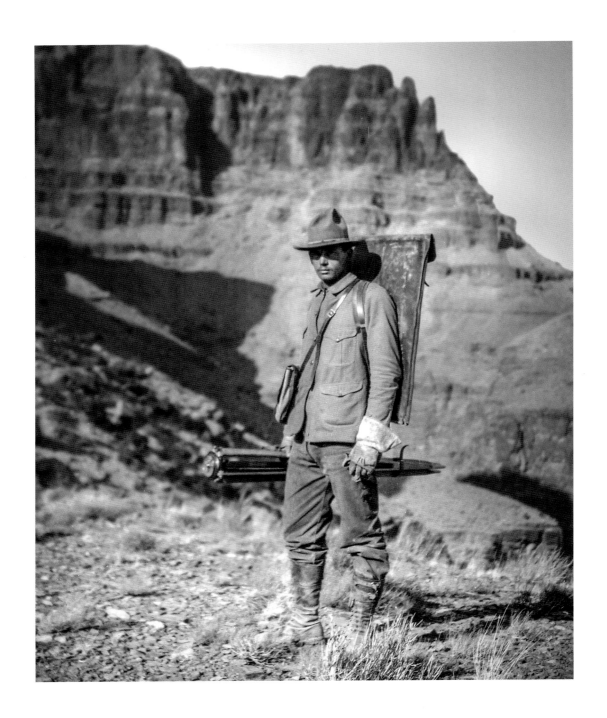

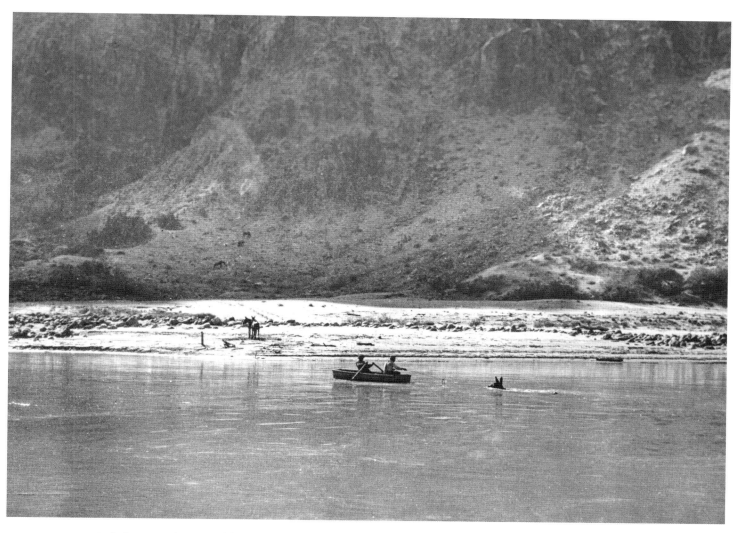

Left: A man carries surveying equipment in the Grand Canyon during the Matthes expedition. | COURTESY OF GRAND CANYON NATIONAL PARK MUSEUM COLLECTION

Above: Bobby, a mule, swims across the Colorado River near Bright Angel Creek. | COURTESY OF GRAND CANYON NATIONAL PARK MUSEUM COLLECTION

CANYON BOTTOM REACHED

By noon the bottom of Bright Angel Canyon was reached, and then the party threaded its way down along the bouldery creek, crossing and recrossing it to knee depth no less than 94 times. Camp was made a short distance above the boxed-in lower part of the canyon, and a large bonfire was lit so that the people on the south rim might see that we had successfully reached that point. Ferrell and Murray had preceded us and had made known our intention of returning via Bright Angel Canyon. That night it rained and the following morning we beheld the rim of the Kaibab Plateau white with snow. Evidently we had left none too soon.

After a sojourn of several days in Bright Angel Canyon, during which the course of the stream was duly mapped, we proceeded to the river and once more faced the problem of crossing it. With the aid of a boat loaned by a friendly prospector, however, this was accomplished with little difficulty, for the animals, now homeward bound, had separately lost their fear of the river. Soon, however, we were scrambling up the prospectors' steep burro trail and without serious mishap reached our goal on the south rim.

The next year, when the survey was extended eastward, Bright Angel Canyon became our regular route of travel across the Grand Canyon, both northward and southward, although the trail remained as rough as ever. A steel row boat, in two sections, was packed on mules to the river crossing, to replace the wooden boat which had been swept away by the flood. Some years later, enterprising citizens of Kanab, in order to promote tourist travel to the north rim, improved the trail up Bright Angel Canyon, and spanned the river with a steel cable along which a traveling carriage large enough to hold a pack animal could be hauled across.

When the National Park Service took over the Grand Canyon in 1919, finally, it set to work in earnest to make Bright Angel Canyon the main avenue for travel across the chasm. It built a good modern trail — the Kaibab Trail, as it is called — from Bright Angel Point to Yaki Point and replaced the steel cable by a fine suspension bridge. Needless to say, it has afforded the writer no little satisfaction in 1925 and again in 1927 to travel over this new, and to him, almost luxurious route. AH

GRAND CANYON LODGE ON NORTH RIM — MILLION-DOLLAR IMPROVEMENT

BY VINCENT J. KEATING, EDITOR

Beautiful new Grand Canyon Lodge, constructed by the Union Pacific System on the North Rim of Grand Canyon National Park, is now open to the public. Standing directly on the edge of the canyon at Bright Angel Point, it affords magnificent views of the great abyss and harmonizes perfectly with its sublime surroundings. Native stone, matching the canyon rim, and great pine logs, from the adjacent Kaibab National Forest, were the materials used. The outer timbers are stained a deep brown; the interior pillars, beams and rafters display the natural light russet hue of the peeled log. The roof is stained in soft shades of green and brown.

The lodge, approximately 250 by 225 feet in dimension, is approached through the forest. The main building contains a central lobby, a dining hall and a recreation room; in the wings enclosing the driveway are a curio store and soda fountain, a barber shop, lavatories and tub and shower baths for men and women, and the kitchen and storage rooms.

On the canyon side, entered through the lobby, is a luxurious glass-enclosed lounge, overlooking the splendors of the canyon and flanked by two open-air terraces. The larger terrace will accommodate 500 people. It has a great outdoor fireplace for evening gatherings and a stone stairway leading past several upper terraces to an observation tower, which is provided with a long range telescope for viewing the canyon and the Painted Desert beyond. Large pine trees rise through the floors of the terraces, the stones having been so laid around them as to

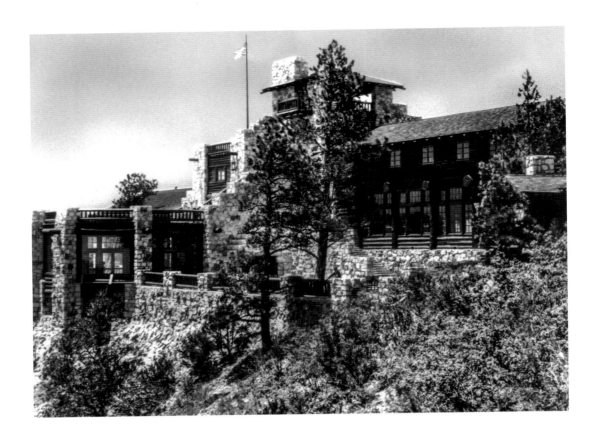

leave them undisturbed.

Bright color and Indian decorative motifs prevail in the interior furnishings. The furniture is of the rustic hickory type, except in the lounge, where it is of ivory-hued wicker, decorated and upholstered in vivid polychrome tints which blend with those of the canyon.

Sleeping accommodations are provided by attractive two-room guest lodges, approximately seventy in number, built of logs and surrounding the central building. Each room contains one double bed or two singles, a washstand, stove and chairs. There are also several deluxe lodges, each room of which has one single and one double bed, a porch, fireplace and private bath. All guest lodges are electrically lighted.

A hydro-electric plant on Bright Angel Creek furnishes electric light for all buildings and

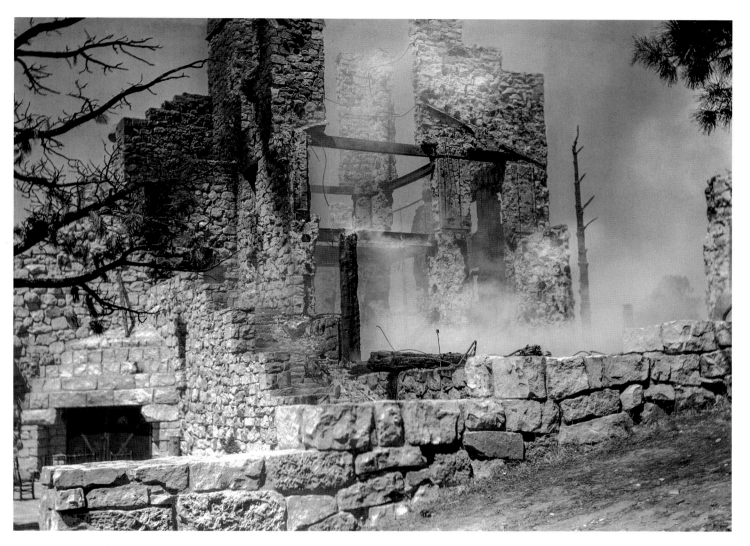

Opposite page: The original Grand Canyon Lodge on the North Rim is shown in 1929, shortly after its opening. Native stone and Kaibab National Forest pine logs were used to construct the lodge. | COURTESY OF GRAND CANYON NATIONAL PARK MUSEUM COLLECTION

Above: The remains of the lodge smolder after a 1932 fire. The lodge would be rebuilt a few years later. | COURTESY OF GRAND CANYON NATIONAL PARK MUSEUM COLLECTION

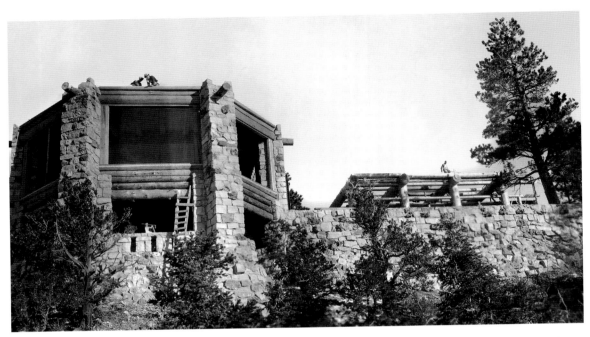

The original Grand Canyon Lodge is shown during construction in January 1928. Crews worked through a harsh winter on the North Rim to complete the structure. | COURTESY OF GRAND CANYON NATIONAL PARK MUSEUM COLLECTION

power to pump abundant pure water from Roaring Spring, 3,800 feet below the canyon rim — probably the highest water supply line in the world. The construction of the pumping station and the laying of the pipes over the precipitous cliffs presented many formidable engineering problems for solution.

Grand Canyon Lodge is one of the stopping points on the Union Pacific's five-day motor-bus tour of Southern Utah and Northern Arizona, which starts from Cedar City, Utah, and visits Zion and Grand Canyon National Parks, the Kaibab National Forest, Bryce Canyon National Park and Cedar Breaks. This tour has shown a remarkable increase in popularity this season, rail travel to Cedar City up to date being more than 52 percent heavier than for the corresponding period last year. AH

NOTES FROM THE NORTH RIM

BY RAYMOND CARLSON, EDITOR

The Grand Canyon, foremost of the world's natural wonders, has a different personality when viewed from the North Rim. As the Canyon itself reflects every mood of time and light, so does it present a new and strange entity when viewed from the different vantage points around its spacious girth.

Perhaps that is the chief charm of the Canyon — why it never grows old or tedious like a tale twice-told — it is never the same. It can be gay, sprightly and dancing like the sunbeams in spring; it can be sad and somber, reflecting the heavy and dark storm clouds that hang above it. It can be silent and unfathomable, mysterious as the dark night that hems it in. It can be alive and active, dazzling as the mid-summer suns that beat upon it.

And for you who have seen the Canyon from the South Rim, a surprise awaits you on your first visit to the North Rim.

You see the Canyon from a different point, at a different perspective and almost as if you had never seen the Canyon before.

Too few visitors to our state, too few Arizonans have gone to the North Rim. It is not of as easy access, yet the few extra hours it takes to get there compensate themselves with the loveliness of Nature through which they take you to the incredibly beautiful Rim wall.

Highway 89, a broad paved highway, leads up swiftly from Highway 66, northward in the

direction of Utah. You cross the Little Colorado at Cameron, and your ascent is hardly noticeable as you speed along through a vast desert. You pass through a portion of Painted Desert and then come alongside Vermilion Cliffs. You cross the Colorado over Navajo bridge and plunge up Houserock Valley, barren and lonely, free from vegetation, through a land where it seems that only the gods of the Navajos dwell.

Your ascent from the valley floor is swift and shortly you attain the plateau floor and come into Jacob Lake. Even in the wintertime the sun will be warm in the valley, but you might expect snow on the plateau anytime after August. Such is the mood of Arizona.

At Jacob Lake, you leave Highway 89, and take the forest service road, which this summer will be completely paved from Jacob Lake to the North Rim, a distance of 42 miles.

You travel 42 miles through rich, heavy Kaibab forest to the Rim. Each mile is a delight in motoring. The road is lined with aspen, fir and cedar trees broken only by green rolling meadows. Frequently Kaibab deer will raise their heads and stare at you with insolence as you drive along.

It is rich, beautiful country through which you pass. Less than an hour ago you were traveling through a desert; now you are in rich timber land, swiftly approaching the North Rim.

The forest is so thick you do not realize you have reached the Rim until you reach Grand Canyon Lodge. This lodge, a mighty creation of Union Pacific operated by the Utah Parks company, is built on the very edge of the Canyon. As you dine you look over the Canyon, and from the verandah the Canyon is below and in front of you.

You are a thousand feet higher on the North Rim than on the South Rim of the Canyon and the spectacle you behold is one to wonder and marvel at. The Kaibab Forest, through which you drove from Jacob Lake, did not stop at the Rim as you did but continues down the Canyon walls, and the view of mighty trees set in the very walls of the Canyon about you presents a view thrilling to behold.

As you gaze from the North Rim, you are tempted to compare your view there with your view from the South Rim. There is an indefinable sameness; and yet it seems strangely different.

The colors are not vivid in late afternoon, because shadows are longer and more pronounced. The sunrise may be more vivid for the rising sun, like a bucket of molten gold, seems to have been poured on the other side of you and the metal seems to be creeping gently to your very feet.

When you leave you remember the proud forest that did not stop with you at the Rim but seemed to overflow the very walls of the Canyon and in the distance the trees seem like eerie ghosts fleeing from the gods that dwell in the bottom of the Canyon, trying with no avail to reach the top. AH

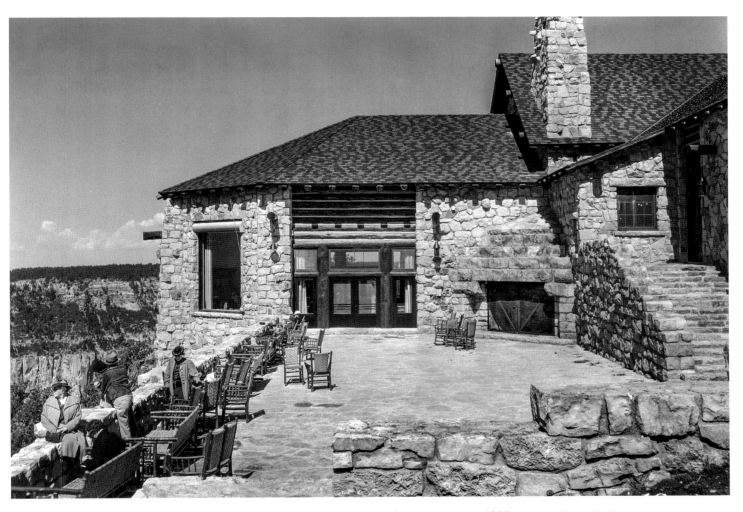

Visitors to Grand Canyon Lodge enjoy the view from the hotel's deck in the late 1930s. | COURTESY OF GRAND
CANYON NATIONAL PARK MUSEUM COLLECTION

DECEMBER 1939

CHRISTMAS WEATHER AT GRAND CANYON

BY H.G. FRANSE

Most writers, good, bad and indifferent, sooner or later find their way to Grand Canyon. Generally they arrive with the throng of summer visitors and stay a day. Walking up to the brink of the canyon, they take a look into the abyss, then crack down with a barrage of verbiage, bristling with superlatives. Tremendous, majestic, inspiring, colossal, they say, all striving for an elusive word to blanket the great gorge with a soul-satisfying description.

In all this outpouring of words, scarcely a line is written about Grand Canyon in the winter. The canyon in its winter duds remains a mystery except to the favored few who brave the unknown and visit the park during the most spectacular season of the year. In the language of a popular entertainer, "you ain't seen nothing yet," until you've seen the canyon in the throes of a winter's storm.

Does it snow at the canyon? Sure it does — lots of it at times. You might find a few inches or a few feet — depending on how the gods dish up the weather. But what's wrong with a beautiful, fluffy snowflake?

It gets cold, too. And there's a good argument by the wife for a new fur coat. At nearly seven thousand feet elevation, the clear, crisp air puts an extra spring to your step that you didn't know you had. Button up your overcoat and take a brisk walk down the snow-banked paths along the rims. It's an exhilarating experience. And in what a setting — a veritable Christmas

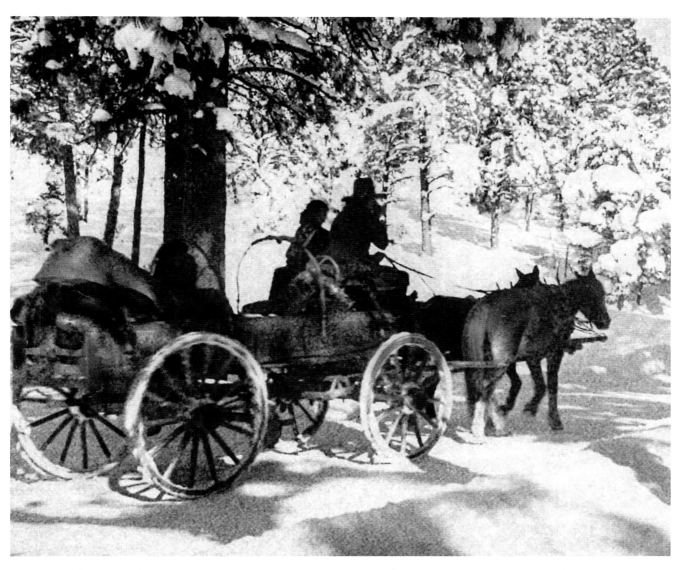

"Snow at the Grand Canyon, South Rim, as infrequent as it may be, forms patterns of beauty," *Arizona Highways* wrote in December 1939. "This is a portrait of winter enchantment, a Navajo and his family in a wagon traveling through a forested area." | ARIZONA HIGHWAYS ARCHIVES

card come to life. Below you lies the mile-deep canyon with its green, gray and red walls, now alternated with bands of pure white. The rims are capped by the great Kaibab forest of pine, piñon and juniper trees, bowed under a blanket of white.

All this is not to say that winter at Grand Canyon is a continual battle of the elements. Unfortunately a storm in the canyon can't be had to order, and visitors must take their chances on getting together with one of these masterpieces of Nature. Or come up and wait for one to happen along.

Actually, the canyon's almanac reads like a weather man's utopia: November, clear sunny days, average temperature 39 degrees; December, days pleasant, nights brisk, winter is in the air, average temperature 32 degrees; January, normally the coldest month of the year, average 29 degrees; and February, wintery conditions pass, temperatures moderate, average 32 degrees. Which all sounds more like a press-agent's ballyhoo. Better not leave your top coat and rubbers at home before the first of May. You're likely to need them.

Back to the snow again, which really is the spice of winter anywhere. The records shows snowfalls as much as eighty-three inches throughout a season, but, of course, it doesn't all fall at once. During the heaviest storms the roads are kept open at all times. On windy days when the snow is dry and drifting, short sections of the drives may be blocked until the park service goes into action with its snow-bucking crews.

So if you're planning to motor in, give your car a swig of alcohol or anti-freeze of some sort and come on up. Even on the wildest days you'll have little difficulty in reaching the park. Last winter Flagstaff and Williams had a deal on whereby motorists were given free meals and lodging during any time that U.S. Highway 66 was declared closed by the State Highway Department in the vicinity of those towns.

———

THE NORTH AND SOUTH RIMS of Grand Canyon are operated independently, which sometimes causes confusion to visitors. Although there's only a distance of ten miles airline between the villages of the two rims, the village on the north rim is a thousand feet higher than its neighbor on the south, which means the difference of remaining open or closing during the winter months. The snowfall on the north side is double that of the south side. So the service on the north rim usually closes in October and re-opens the later part of May, while the south rim is open throughout the year.

With all the snow that falls on the rims of the canyon, rarely does it fall on the floor of the gorge. The higher temperature at the lower levels reduces the snow to rain. Then the warm air,

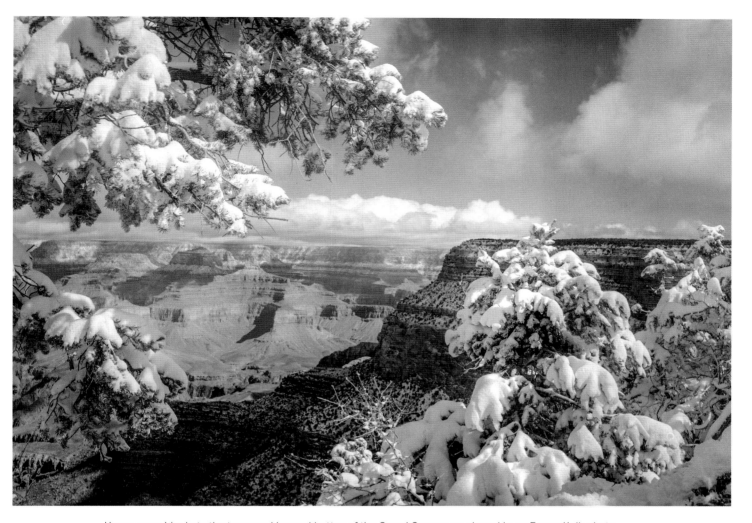

Heavy snow blankets the trees and layered buttes of the Grand Canyon, as viewed in an Emery Kolb photo from the South Rim. | NORTHERN ARIZONA UNIVERSITY CLINE LIBRARY

saturated with moisture, rises into the cold atmosphere above, converting it into fog or clouds that spill over the rims, powdering the forest with a coating of rime. Even unsightly service wires are transformed into things of beauty. Like huge strings of tinsel, the rime covered wires glitter in the dazzling sunshine. Fairies in fur coats are surely about!

At times clouds completely choke the abyss, obliterating visibility below the rims. Captain Hance, a colorful character and pioneer at the canyon, related that at one time the fog was so thick in the gorge that he drove half way across the canyon before he *[Continued on page 32]*

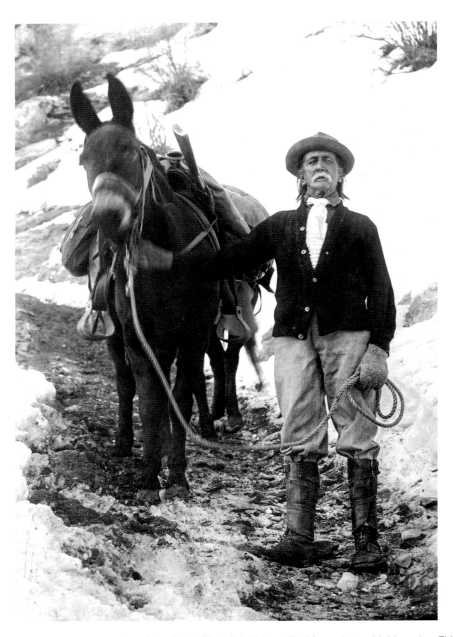

John Hance poses on a snowy section of the South Rim's Bright Angel Trail for a photo with his mules. This photo, by the Kolb brothers, likely was made around 1910. | COURTESY OF GRAND CANYON NATIONAL PARK MUSEUM COLLECTION

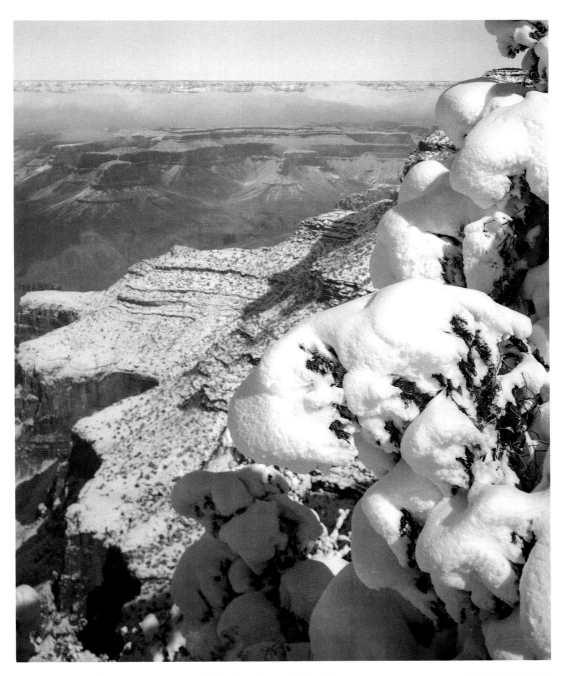

A heavy blanket of snow cloaks the South Rim in an Emery Kolb photo. | NORTHERN ARIZONA UNIVERSITY CLINE LIBRARY

[Continued from page 29] discovered he was on a cloud. But it doesn't get that thick now.

Don't be discouraged if you arrive at the canyon only to find it blanketed with a sea of white. Seldom a day passes that the fog doesn't break and fleecy clouds like tufts of cotton float aimlessly about below the rims, silhouetting magnificent temples that rise thousands of feet from the canyon's floor like edifices of a race of mammoth people. Shafts of sunlight pour through the cloud rifts like spotlights in a theater of wonders. Try, if you will, to visualize the magnificence of brilliant-hued spires hemmed in with billowy clouds and flooded with a burst of dazzling sunlight. It baffles comprehension. There is only one way to grasp the splendor of the exciting spectacle — see it!

Fantastic is a good word in speaking of Grand Canyon in its winter mood. If by chance, however, you remarked that you had seen it snow upward in Grand Canyon, even your closest friends would probably inquire if you felt well, and might even mention something about a fellow called Ananias, the historically famous liar. Strange as it may seem, it does snow up in this astonishing region.

The pilot who landed his airplane on the Tonto Plateau, thirty-six hundred feet below the rims and then flew it out again, explained with a lot of enthusiasm why it can snow upward at the canyon. When he headed his plane toward the rim for the return flight, his worry, he said, was not if he would get out, but where he'd stop when he did get out. He shot aloft at a terrific speed.

The warm air of the inner gorge flows up the walls of the canyon, causing a strong up-draft. That's what throws snowstorms into reverse at the brink of the gorge. Trail parties coming out of the canyon frequently arrive with the bottom sides of their hats plastered with snow. The secret lies in the qualifying "in Grand Canyon."

———

DID YOU EVER GAZE into the sky and wonder what it would be like to sail through space astride of a puffy white cloud? You can't ride a cloud at Grand Canyon, but you can ride a mule through one. If you have the spirit of adventure coursing through your veins, that's what you're apt to find yourself doing — in intimate contact with a mule, headed down a trail to the Colorado river. What a revelation is in store for you.

Like snow-storms, however, clouds can't be had to order. You're in luck if you happen to arrive together. As you travel down the trail, level by level, the clouds thin and soon you emerge below them. From then on, they look like clouds ought to look. Frequently they're only a fringe hanging against the rim, and you ride out into sunshine. At the lower elevations the snow disappears, and you begin to shed some of your heavier clothing. What a transformation! Within

three hours and a distance of seven miles, you pass from deep snows to a climate comparable to upper-Sonora, Mexico.

Of course you can't say you've seen Grand Canyon until you've ridden the trails to the river. To do the job deluxe and get the most out of your trip you should spend a day, a week or a month at Phantom Ranch. This intriguing little guest ranch is in Bright Angel Canyon, a tributary of Grand Canyon. It is on the north side of the Colorado river, and to reach it you cross the river by the Kaibab trail suspension bridge. When you arrive at the ranch you'll probably find the cottonwood trees putting on their new dress of leaves, as they scarcely shed the old crop until new ones come popping out.

The only objection to visiting Phantom Ranch is your reluctance to leave it. Here, charming little cabins nestle among the trees. In this atmosphere of contentment, you're lulled to sleep by the gurgling of crystal-clear water in Bright Angel creek as it flows by your cabin on its way to the murky Colorado. While you loll in the warmth of a brilliant Arizona sun, jetblack butter-flies flutter about. Gazing aloft, two miles distant by airline, you see the snow-capped precipice down which you rode only a few hours before. Alluring, isn't it? All too soon comes the time to mount your mule and head up the trail again.

Even the park animals take on new beauty in their winter garb. The scrubby brown coats of the park deer have changed to beautiful, sleek gray coats, and the bucks are crowned with an impressive set of fighting antlers. Cunning, alert squirrels, with tufted ears and bushy white tails that seem to have been freshly laundered, go scampering about the village, intent on business important to squirrels. Waddling porcupines leave their tell-tale tracks leading to pinion trees where they had a meal of succulent inner-bark.

When the long shadows of winter creep over the canyon, and the sun sinks back of the Trum-bull mountains in the distance, be sure to visit Hopi Point. Colors of unbelievable brilliance blaze in the sky and, reflected into the canyon, light the gorge with an eerie glow.

Truly it is a land of contrasts. In the summer the canyon is charming; but in the winter it is magnificent. No better description can be had than the words of a matronly old lady with a foreign accent, who barged up to the rim for her first view of the canyon on a winter day. Gazing into the gorge, she exclaimed, "Oh, oh, ain't dot bootiful!" ◪

JULY 1942

GRAND CANYON: STUDY IN MOODS

BY RAYMOND CARLSON, EDITOR

The Grand Canyon of Arizona, carved by time and the river, is a masterpiece of changing personalities, a study in moods. It is all colors, and no color. It is all shadow and no shadow. It is all sweetness and light; it is all grimness and darkness.

It reflects all the temperamental whims of fitful weather. It mirrors the slow movement of the passing sun and the slightest cloud can change its demeanor. Each season leaves its mark on canyon walls, each hour of the day etches new patterns in canyon depths.

You cannot say, "I have seen the Grand Canyon!" unless your home is on the canyon rim and the canyon is with you and about you all the time. The canyon isn't just rock and sandstone and granite, an inert mass of graceful spires and temples clawed in the earth by a red mad river. The Grand Canyon is a living thing, always changing. It is never the same, and when it casts its spell upon you it is with you forever.

Yet no matter how many times you have seen the canyon, it becomes the same adventure each succeeding visit. It lives in your memory not as something real and actual but as a misty thing, like a pleasant dream. It is too big for memory, too big for a mind's eye. So when you come upon it again and again it still is a new thing, a new experience. That's the Grand Canyon.

Puny are the efforts of the artist to catch on timeless canvas the timeless beauty of the canyon. The greatest work of art cannot catch the moody majesty of the canyon, its brooding, unfath-

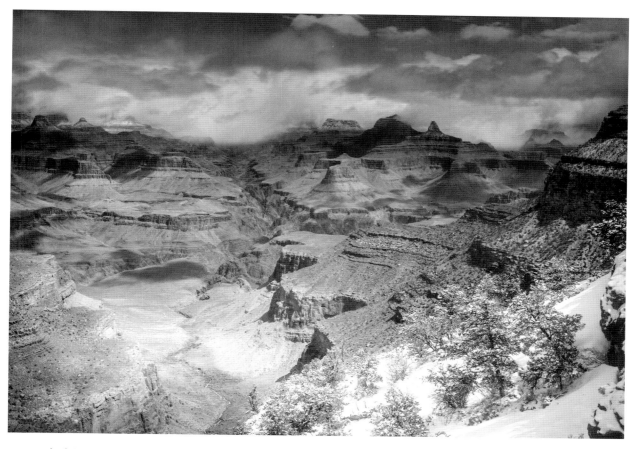

A winter storm brings snow to the Grand Canyon. Emery Kolb probably shot this photo around the time the Canyon became a national park. | NORTHERN ARIZONA UNIVERSITY CLINE LIBRARY

omable silences, the many sides of its personality. You look at the canyon not with the eye but with the heart. You understand it not with the mind but with the soul.

No paint pot has the richness or the color to match the color of the canyon, nor any painter the sublime brush to smear on canvas the delicacy and exquisite detail which makes the canyon the masterpiece that it is. When you duel the gods you don't use a pen knife or a whisk broom.

No! The canyon is too big a job for the artist. Man always tries to account for everything, to explain it away in glib terms. But the canyon escapes the painter. The scientist, mouthing his knowing words, his head packed with the wisdom of a few years of learning, sounds like a

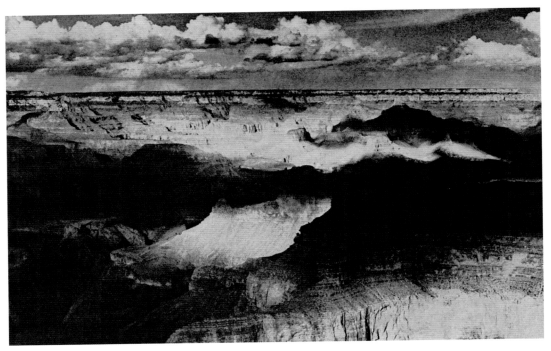

Puffy clouds drape the Canyon's iconic buttes in shadows in a photo published in the July 1942 issue of *Arizona Highways*. | ESTHER HENDERSON

parrot. You cannot explain away millions of years and ages beyond our ken or count with a few scientific phrases. You might try but you won't sound convincing.

The musician might someday describe the canyon, or the poet might, also. The golden notes or the golden words some day might make you understand the canyon.

But must we describe it? Why not leave it alone to its gloomy or merry secrets, whatever its mood may be? Then we can steal in upon it occasionally and while we may never share its secret, we can be happy knowing of its secrets, and knowing that when we return again and again, the canyon will be there as before, holding within itself its same old secrets. **AH**

AUGUST 1947

GOLLY, WHAT A GULLY!

BY RAYMOND CARLSON, EDITOR

History does not record the words spoken by Don Garcia Lopez de Cardenas, proud captain of Castile, that memorable day in 1540 when he and his companions looked into the Grand Canyon, the first Europeans to do so. In all probability those words were strong, soldierly expletives, although a footsore scribe, of a poetical bent, recorded for posterity and prying eyes in Spain that the buttes and towers of the Canyon which "appeared from above to be the height of a man were higher than the tower of the Cathedral of Seville." An apt description, my capitan!

The gentle Father Garces came along in 1776 and was quite impressed by the canyon, giving it the name of "Puerto de Bucareli" in honor of a great Viceroy of Spain. James O. Pattie, trapper and mountain man, arrived at the canyon in 1826, the first American tourist to visit there. Unfortunately there were no comfortable Fred Harvey accommodations awaiting him and he was pretty disgusted with the whole thing.

"Horrid mountains," he wrote. Lt. Joseph Ives, an explorer, came to the "Big Canyon" in 1857 and "paused in wondering delight" but found the region "altogether valueless. Ours has been the first and will doubtless be the last party of whites to visit this profitless locality," was his studied opinion. But the lieutenant's feet probably were hurting him and he should be forgiven his hasty words.

John Wesley Powell, twelve years later, arrived at the canyon the exciting way — by boat down the Colorado. To him it was the "Grand" Canyon and so to all the world it has been ever since. It didn't take the tourists long to follow the explorers. In the early 1890s a stagecoach was in operation from the railroad junction sixty miles to the south. "Them dudes is a'taking over the country," the old timers said.

In 1901, the Santa Fe, with an eye for business and at the request of an ever-increasing traveling public, put in the railroad to the South Rim of Grand Canyon, and went so far as to call itself the Grand Canyon Line. What the first Santa Fe locomotive said the day it chugged up to the Rim has not been recorded, but we can assume it was "toot-toot" and let it go at that. Lt. Ives' "profitless locality" became a national monument in 1908 and a thousand square miles of it became a national park in 1919, the most valuable scenic treasure on earth. Nice going, Lieutenant!

What goes for mouse-traps also applies to canyons, it seems. Build a better one and the world will beat a path to your door. The visitors to Grand Canyon since this century began have numbered so many thousands no one can say for certain. Men of all creeds and nationalities have found their way to the Rim. They have written millions of words about it, put it to music, painted it, stood mute before it.

John Burroughs called it the "Divine Abyss." John C. Van Dyke found it "more mysterious in its depths than the Himalayas in their height." William Winter described it as "a pageant of ghastly desolation and yet of frightful vitality, such as neither Dante nor Milton in their most sublime conceptions ever even approached." Joaquin Miller, the great poet who sang of the mountains of California, could only ask of it, "Is any fifty miles of Mother Earth that I have known as fearful, or any part as fearful, as full of glory, as full of God?"

John Muir, he of the great mind and the great heart, used strong words when he wrote of Grand Canyon and said: "It seems a gigantic statement for even nature to make all in one mighty stone word. Wildness so Godful, cosmic, primeval, bestows a new sense of earth's beauty and size ... But the colors — the living, rejoicing colors, chanting morning and evening, in chorus to heaven! Whose brush or pencil, however lovingly inspired, can give you these? In the supreme flaming glory of sunset, the whole canyon is transfigured, as if all the life and light of centuries of sunshine stored up in the rocks was now being poured forth as from one glorious fountain, flooding both earth and sky." Words of an inspired man, truly inspired.

But the greatest tributes to Grand Canyon have been paid by many whose words were never written. A Sheik of Arabia, beturbaned and solemn, stood on the Rim and for several minutes murmured to himself. To his guide it sounded like a Moslem prayer. Thousands of ordinary

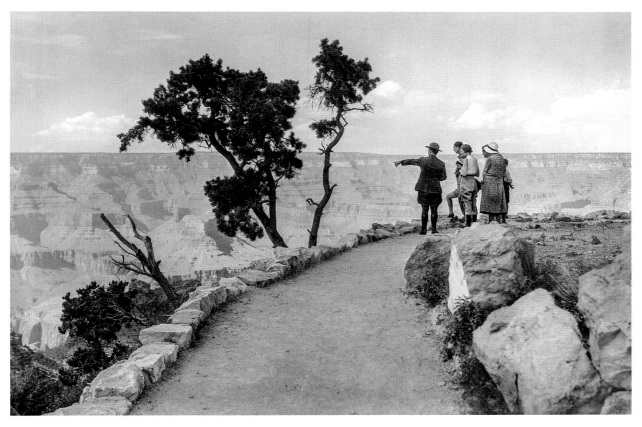

A Grand Canyon National Park ranger guides a small group of park visitors along the Rim Trail, near the South Rim's Kolb Studio, in the 1930s. | COURTESY OF GRAND CANYON NATIONAL PARK MUSEUM COLLECTION

people say nothing and their silence is tribute enough. There is more than humor in the statement of a Midwestern farmer whose only comment was: "Heck of a place to lose a cow!" And there is deep meaning, too, in the way so many people exclaim "Gosh!" the first word that comes when the canyon appears before them.

A president of the United States, William Howard Taft, a man who had seen much of the world, was more eloquent than he thought when his first exclamation, on seeing the canyon, was heard by a guide and carefully remembered. President Taft said: "Golly, what a gully!" AH

AUGUST 1947

ON THE TRAIL

BY LON GARRISON

"All Aboard for the Bright Angel Trail!" The crowd around the corral at the head of the Bright Angel Trail, on the South Rim of Grand Canyon National Park, presses forward — those with tickets for the trip line up at the gate; parents and friends excitedly push to the fence to watch the mounting of the mules. The curious ones just mill around and exclaim about the mules, the funny pants and boots the cowboys wear, the weather, the dust, the time they fell off a mule in a blackberry patch back in Indiana; the camera fiends circle the fence, squinting and squatting or even climbing trees to get an "angle," their light meters, assorted cameras, tripods, and miscellaneous high-priced paraphernalia clanking from their necks or their belts.

And the mules? They stand patiently and quietly, forty of them, soft noses aligned against the corral fence, ears twitching at flies or sleepily at half-mast, eyes half-closed. The Corral Boss collects tickets from the first six or eight dudes in line, they are admitted to the corral and the wranglers begin fitting the dudes to the mules and the saddles to the dudes. Overalls and long-sleeved shirts are standard clothing, with straw hats to protect faces and necks from the sun. Skirts and shorts are taboo, and the weight limit is two hundred pounds.

Plump passengers are boosted into the saddle, cameras and jackets are tied on with the slickers back of each saddle, the lunches are stuffed into saddlebags and slung back of the saddle on

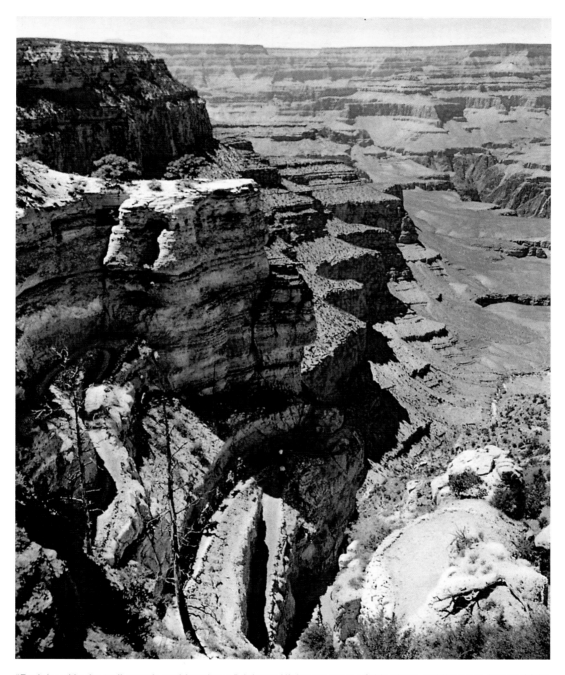

"Each bend in the trail reveals exciting vistas," *Arizona Highways* wrote of this photo, published in August 1947. "As you go down to the Canyon floor, geologic ages are recorded in Canyon walls." | GENE MORRIS

the lightest-loaded mule, and wrangler swings onto his mule, and the crowd at the gate opens to let the first party through. Cameras click, travelers wave to friends in the crowd, and the mules — one by one — walk slowly through the gate and over the tip-off.

For this is the start of the Bright Angel Trail which leads from the South Rim of the Grand Canyon National Park in Northern Arizona.

National Park Service officials fondly boast that it is the most famous trail in the world, and state with some justification that it is the most used trail in any national park in the United States. With a little prompting, they will expand this claim to indicate that it is the most used trail anywhere in the nation — or in the world, for that matter. In 1941, there were 8,030 mule trips into the Grand Canyon; and 9,952 in 1946. In addition, there were 8,934 hikers in 1946.

A short distance below the tip-off is the first stop for a picture of the group. Kolb Brothers' Studio commands a view of a section of the trail, and the party pauses briefly for the picture, which those interested can pick up on the return trip. The guide turns his mule around a short switchback, the others patiently follow, and the trip is under way!

About one-half mile down the trail, the entire party stops while the guide goes over each mule carefully to be certain that cinches are tight, stirrups properly adjusted and everything in good condition for the trip ahead. This stop is due to the habit the mules have formed through years of experience of taking and holding a deep breath when the saddle cinches are first tightened, so that after a short time the saddle becomes loose — bad business on any mountain trail and particularly on this one!

There is a rush of questions — "What's my mule's name?" "Will he bite?" "Do you ever get kicked?" "Will he fall off?" But the wrangler is reassuring. "Lady, that mule is absolutely opposed to falling off. Just stay with him and you'll get there and back."

What the wrangler does not have time to mention is that each mule takes the trip into the Canyon daily all summer, and some of them the year around. Also, each new mule purchased for trail use goes to school intensively for a long time before he is trusted with park visitors. This includes months of use in a pack string, and then a horrible period when he has to learn to stop — just stop — whenever anything goes wrong. And the wranglers see that plenty goes wrong during school hours! Papers blow past him, automobile tires run under him, saddles turn and drag, slickers flap wildly in his face. If he survives these tests, he is ridden by a guide for a few more weeks and is then put into the dude string.

While cinches are being checked, the party also gets accustomed to another trait the mules have. They are trained at each stop to line up across the trail with their heads out over the edge, their tails to the wall. This prevents them from accidentally backing off the edge, and also has

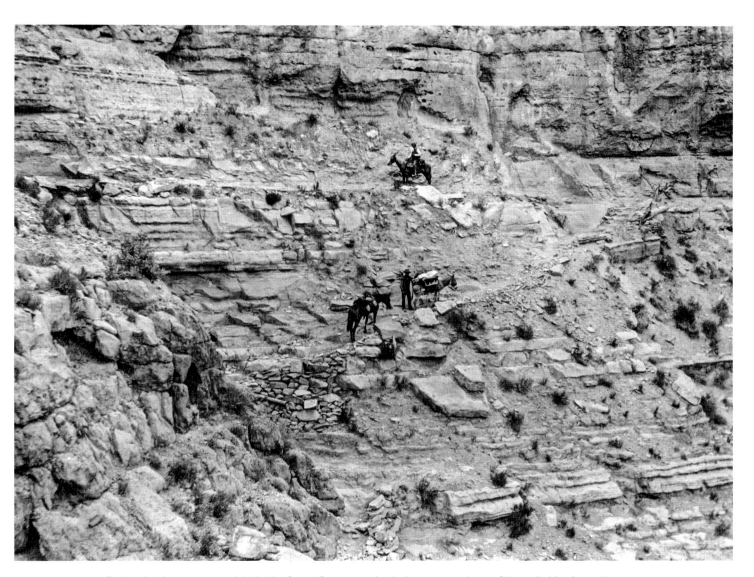

Pack animals, a common sight in the Grand Canyon, make their way around one of the switchbacks on the South Rim's Bright Angel Trail, circa 1930. | COURTESY OF NATIONAL PARK SERVICE HISTORY COLLECTION

the added advantage of giving the riders magnificent views of the Grand Canyon from below the rim — that is, after they get used to the sensation of having nothing but space out in front of them!

Ahead and to the north, the canyon deepens, ledge on ledge, colorful strata on top of others even more vivid, with ranks of projecting points shouldering from the South Rim and fading into the distance thirty miles to the east. The walls below the points emphasize the colored layers of the Canyon formations; and even at this first stop, these walls loom mightily overhead. Below, 4,000 feet down, lies the Colorado River, invisible from here but leaving everywhere erosion evidence of the tremendous force expended through past ages.

A colorful spot of green almost straight below, where the steeply sloping Canyon walls give way to a little open valley at the upper edge of the narrow Tonto Plateau, is identified by the guide as Indian Gardens. "Yup, we'll be there in a couple hours," he comments. "Rest stop."

The mules move on — plod, plod, plod. Never faster than a brisk walk — never bothered by the switchbacks or by the precipices which are always on one side of the trail. After the first involuntary flinching away from those edges, the riders also acquire some of the serenity and confidence of the mules they are astride, and of the guide who so nonchalantly lounges on his mule ahead of the party, now and then looking back to be certain that everything is in good order — that the Molly mule has stopped nipping Chipmunk ahead of her — and answering questions as they are thrown at him by passing members of his party on the switchbacks. An occasional hiker is overtaken and passed. The guide calls attention to the back trail where other parties can be seen — apparently ants crawling slowly along a ledge on a cliff wall, but actually parties of dudes on mules following them down into the depths of the Canyon.

INDIAN GARDENS AND THE REST STOP

The party dismounts for a short period of stretching protesting muscles, and now the impression of the Canyon as a confined, narrow abyss, gained from view along the rim above, fades away and the visitors realize they are in a wide mountain valley. Above, single peaks stand out sharply within the Canyon, and it is difficult to realize that these are the insignificant-looking rock shoulders seen from above. Behind and on the North Rim, the Canyon walls tower, up and up. "Right there's where we started," the visitors tell each other; but here in the shade of the cottonwood trees, it is almost impossible to believe that a scant two hours ago the party started from "right up there by those trees — just by the little high spot there."

Most of them do not realize that the "little high spot" is known on the South Rim as Hopi Hill, and is 180 feet high. This abrupt change in elevation is caused by a geological slip known

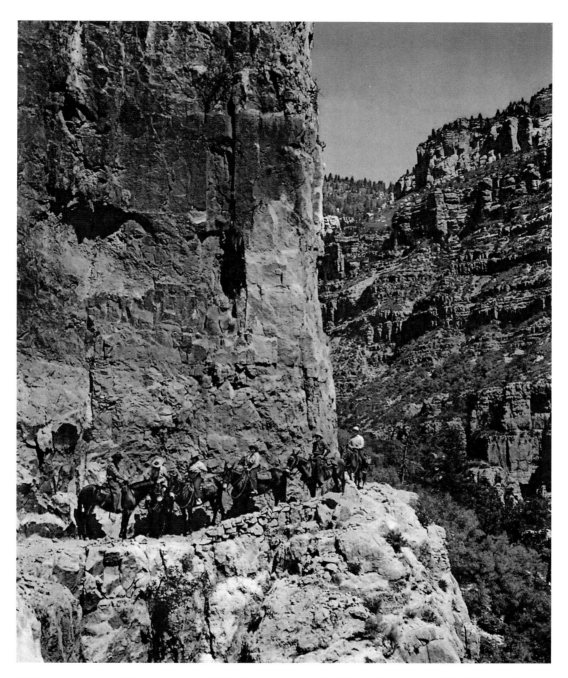

Of this shot, *Arizona Highways* wrote in 1947: "The towering walls of Grand Canyon dwarf the riders on the trail. Here is revealed in all its glory one of Nature's masterpieces." | GENE MORRIS

as faulting, and is really the reason why the Bright Angel Trail is possible. The trail follows this break in the earth's crust which runs across the Canyon, south to north; and sometimes the trail is on one side of the fault and sometimes on the other, but always the strata on the west are 180 feet higher than the corresponding strata on the east, and this makes possible the drops over the cliffs which seem absolutely sheer from above. The alternating bands of shale and sandstone sandwiched between the limestone cliffs carry the trail the entire distance.

One visitor is reading from a map and booklet acquired the day before, and identifying the various strata above. Against the sky, the Kaibab limestone, grayish white cliffs on top of the Coconino sandstone, a thick white, wind-laid material, giving the strong white band visible near the top of the Canyon walls on both rims. Below this lies the Supai formation, shale and sandstone, bright red, and so strong in iron oxides that the stain has washed down onto the Redwall limestone below to color these magnificent cliffs a uniform red the length of the Canyon. Red they are — dull or brilliant, depending on the caprices of the light and the sun, yet chip the surface through the thin layer of iron stain and the rock is revealed as characteristically blue-gray limestone. Below this, and immediately above Indian Gardens, the Muav limestone and the Bright Angel shale — pale, yellowish-green strata, the latter strongly benched to form the Tonto Plateau. Tonto, the Indians say, is a word meaning "foolish," and anyone who imagines that the Plateau is the flat bench above the Inner Gorge that it appears from the Rim is, indeed, "Tonto."

Indian Gardens was originally settled by the Havasupai Indians who had a makeshift trail to their farms there. Prehistoric Indians also were nearby, as remains of stone storage granaries and occasional pottery shards indicate. In more recent years, one ambitious real estate promoter even surveyed and sold lots in the vicinity to gullible easterners, with water to come from the springs at the Gardens! Now it is the source of water for Grand Canyon Village; and after the party once more is under way, following down Garden Creek, below the trees the pump house stands with whining turbines to indicate that even to this remote spot civilization reaches its destroying hand.

A short distance down Garden Creek, the trail swings sharply to the east, over a narrow ridge, and down through the Pipe Creek valley. This romantic name comes from an oldtimer who found a man's discarded pipe near the mouth of the stream. On the old trail to the river, until rebuilt by the National Park Service in 1931, this portion of the trail was known as "The Corkscrew" for good reason; but now the hardy travelers, with full confidence in their mules, ride safely along a wide trail with easy grades, looking eagerly ahead to the mouth of Pipe Creek opening into the Inner Gorge of the Colorado. "Lunch on the banks of the Colorado River,"

promises the guide. And it must be just right there — you can almost see it.

And then Pipe Creek canyon opens further and there is the River — a silent, sinister, muddy torrent, racing madly and quietly past with occasional swirls and boils to indicate subsurface obstructions. It is a mighty stream — much unlike the thin red thread seen from the rim above, and relentlessly and eternally it continues grinding its way down through the hard granite gorge that now confines it. Where rapids are met, the River is a raging, noisy torrent — on quiet days the roar of rapids can be heard on the rim a mile and a half airline above the stream — but here it slips powerfully and silently past.

The National Park Service at this point has installed a small rock rest house with a trailside exhibit. One case is empty and without glass. "Exhibit in preparation," reads the label. But the guide may tell his party that, after the exhibits were prepared and in place with a plate glass front carried eight miles down to this place by hand by CCC crews in 1939, some wanton vandal in 1946 broke the glass and carried off most of the exhibits and labels, only to discard them before reaching the Canyon rim. This senseless vandalism is increasing and is a constant source of concern to the park rangers and naturalists.

At this point, following lunch, the day party to the River starts the long, slow climb back to the South Rim — 4,500 feet of elevation, taking four hours of riding, compared with three hours down. At Indian Gardens they will meet the Phantom Ranch party, stopped for lunch and waiting for the River party to clear the trail below. This group, after reaching the River, follows the River Trail, built by the CCC in 1939 for two miles upstream to the Kaibab Trail, which crosses from Yaki Point on the South Rim to Bright Angel Point on the North Rim, 20.6 miles cross-canyon.

The river is crossed by a suspension bridge constructed by the National Park Service in 1929, replacing an earlier suspension bridge completed in 1922. Prior to that time, the river was crossed by cable car or by boat — always a gamble at best.

A short tunnel, and the mule string is on the bridge, 440 feet long and about 60 feet above the muddy, turbulent Colorado River. Scant wonder that the early Spaniards named it the Rio Colorado — Red River! Across the bridge, the trail follows a little, clear, sweet stream up a side canyon to the north — and this is Bright Angel Creek. It was named by Major Powell and his survey party in 1869 on the first boat trip through the Colorado River canyons. Side streams encountered above this point were disappointing muddy, soupy streams, which provided no relief from the Colorado River itself. In fact, the stream now known as Fremont River was bitterly named "The Dirty Devil" by Powell's party. But when they floated down through the dark gray granite walls above here and pulled ashore to find a clear, pure, running stream, their

gratitude was profound — "Just like a Bright and Shining Angel!" they commented.

Half a mile up Bright Angel Creek lies Phantom Ranch, a guest ranch with cabins beneath huge cottonwood trees, an inviting swimming pool, delicious meals, and a feeling of complete isolation. Here the trail party spends the night, joined by some who have come from the North Rim on their way across canyon.

Phantom Ranch was originally Dave Rust's Camp, and prior to the creation of Grand Canyon National Park, served as a hunting lodge for mountain lion and deer hunters headed for the Kaibab Plateau on the North Rim. After a visit in 1913 by President Theodore Roosevelt, it was re-named Roosevelt Camp; and this continued until the name was changed to Phantom Ranch. This comes from a small tributary of Bright Angel Creek — Phantom Creek — and Phantom Creek, appropriately enough, heads in Haunted Canyon just up under the North Rim.

A NEW DAY

Following refreshing sleep beside the noisy stream, and a harvest hand breakfast, the mules are saddled and the party divides. Some return to the South Rim, some continue across to the North Rim, and others plan a short trip for the day up Bright Angel Creek to Ribbon Falls and return to Phantom Ranch for the night.

The Ribbon Falls trip calls for just five and one-half miles of riding up Bright Angel Creek — a miniature Grand Canyon. The trail follows the bottom of the Canyon, crossing the creek seven times and winding through the sharp, deep gorge known as The Box, to Ribbon Creek and Ribbon Falls. This little stream, leaping around seventy-five feet from the west wall in gorgeous white spray, is more vivid for the dark granite background, and startling in its beauty and its very existence. For this is desert country, except for the narrow strip at the water's edge along the Creek, and water and a waterfall in this arid location is a contrast difficult to comprehend. After securing photographic evidence of this contradiction, the party returns to Phantom Ranch for the night.

"All Aboard!" Only this time it is the Kaibab Trail. At 9:00 A.M. the wrangler leads the way back down Bright Angel Creek, across the suspension bridge, but instead of following the River Trail and the Bright Angel Trail on the return trip, the party heads up the shorter and more abrupt south section of the Kaibab Trail. This was constructed in 1929, making a loop trip to Phantom Ranch. The south section of the Kaibab Trail is 6.5 miles long and comes to the South Rim at Yaki Point, just four miles east of Grand Canyon Village. It is a dry trail — there is no water along it at any place, so full canteens are carried with the lunch.

Up and up — plod and plod — here the traveler has ample time to view and to appreciate

the scenery spread so majestically before him. In reverse order he passes through the geological strata he traversed on the trip down. Page by page, and era by era, he crosses the geological story of the world from the earliest known forms of rock in the Inner Gorge of the Colorado, through the Proterozoic Era, ending again with the Kaibab limestone at Yaki Point, the top of the Paleozoic Era.

The trip up is easier physically than the trip down, the traveler forgets his fear of the precipices and notices the changing desert shrubs as he climbs, the lizards, the soaring birds, the brilliant canyon walls against the intense blue of the sky.

Faithful mules, now seeming individual friends, slowly lift the riders up the side of the canyon with frequent stops to rest and to catch their breath. Lunch time at Cedar Ridge comes before the trip is more than started, it seems — and on to the top around 2:00 P.M., where a bus meets the party to return them to the hotels and the luxuries of hot baths, automobiles, and railroad trains. As the bus drives away, it passes the mules along the rim trail to the corrals, there to rest and be ready tomorrow for another trip to the bottom of the Grand Canyon.

"All Aboard for the Bright Angel Trail!" It has new meaning now. Beauty, adventure, history, geology, change, understanding of nature — it is an invitation to all of these, and more. Each summer, visitors from foreign lands take this trip and when asked why, or how they knew of it, they will invariably reply that some other member of their family or some friend has taken the trip and sung so glowingly of it that it has become a "must" on their itinerary. Arizona is blessed with many gorgeous phenomena of nature — with many adventure trails opening before the resident and the visitor. Few offer the challenge and the rewards of the mule trips into the Grand Canyon. Truly an adventure in living! AH

AUGUST 1948

STORM: GRAND CANYON

BY RAYMOND CARLSON, EDITOR

T he clouds show the way of the wind. There are no clouds and no wind as a long summer day begins at Grand Canyon. The sky is dark blue overhead, light blue, almost white, at the horizon as if there was not enough blue to go around. It is a big sky, this sky that covers the canyon. The shadows in the canyon are long and cool, crazy shaped shadows as if the turrets and pinnacles that cast them are stretching and twisting in grotesque postures after a night's repose. Giants with sleep and dreams in their eyes!

The morning colors in the canyon are dark and cool. The overtones of the blue-black night have not yet been dissipated by the rising sun. At this time of day there seems to be greater depths to the canyon, as if the cool morning air was a glass through which all the facets of this great scenic jewel were accentuated in all their beauty and richness. A challenge to the photographers on the rims click-click-clicking their little cameras, frantically trying to capture the fleeting moment and ensnare it forever on film!

Mid-morning! The sun rides his chariot higher into the sky. Shadows grow shorter. The hot breath of the sun weakens the color in sky and earth. The river digging in the bottom of the canyon becomes a streak of glinting silver as it carries the mud and the sunbeams down toward the sea. The color is all washed out. The rose of early morning turns into burnt brown, a dirty, tired color. Not a color to challenge the trigger-quick finger of the camera addict!

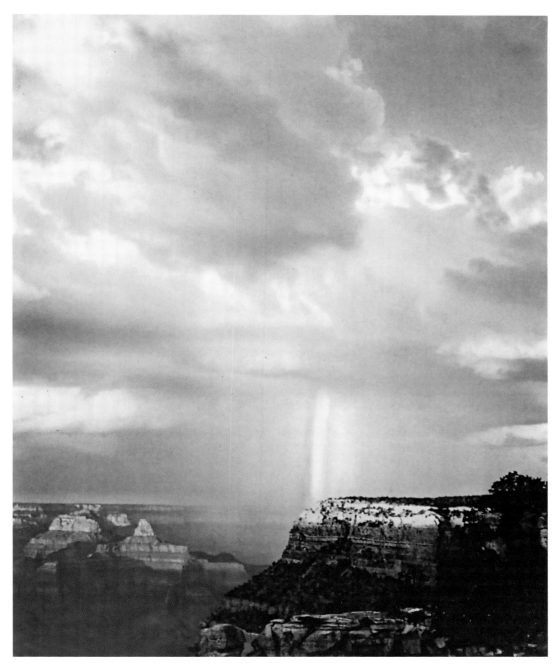

A vibrant rainbow forms over the buttes of the Grand Canyon. In August 1948, *Arizona Highways* described this shot as "a brilliant composition in bright, shifting color." | ROBERT W. FREEBERG

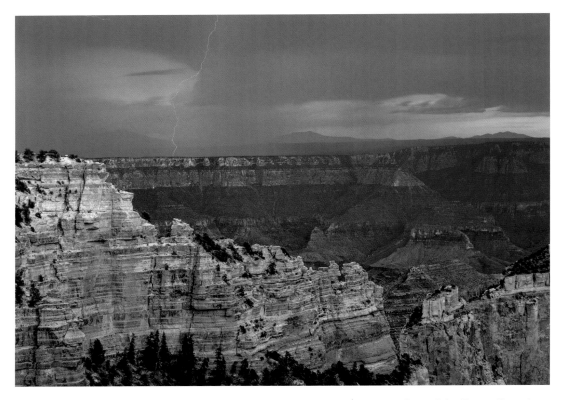

The North Rim's Cape Royal juts into the Canyon, offering a view of a lightning strike and the Flagstaff area's San Francisco Peaks to the distant southeast. | JACK DYKINGA

At high noon the sun is straight up and down, the hot sun of summer, and if there are any shadows in the canyon, the cool shadows that add to the depth of the canyon, they are so little they do not amount to much. The drama has gone out of the canyon and it is just a wide gash in the earth, spectacular to be sure, but nothing to stimulate the imagination. At midday it is in its most prosaic mood.

In early afternoon a small white cloud or two rides in with the wind over the horizon, fleecy adventurers out to see the sights. They do not travel fast because the wind they ride is a summer wind and not overly ambitious. When you are out lazily sightseeing, you shouldn't go tearing around like mad anyway.

The first little clouds that come along are followed by others. Then the fun begins. A summer storm is in the making and when you watch it, from the vantage point of one of the rims of the

Grand Canyon, you are spectator to a superb dramatic production, expertly cast, expertly staged, expertly produced. The white clouds, following each other like a flock of playful sheep, give color and personality to the sky itself. Now you have something to joust with if your weapon is a camera. White clouds do something for a picture every time. The shadows of the clouds drift into the canyon and so the canyon becomes alive again with motion and shifting light and the blue of the sky becomes bluer than ever.

Then over the horizon come the great white clouds with the dark centers, thunderheads they are called, great, clumsy, arrogant fellows, big enough and thick enough to blot the sun out of the sky. They shoulder their way in and take all the blue out of the sky so the sky over the canyon is gray and dark and threatening. Momentarily, flashes of sunlight will break through the clouds and illuminate patches of the canyon, then the color in the canyon is a brilliant, living thing. With most of the canyon in shadow, the brief beacons of sunlight are very gay and very bright, dancing among the spires and pinnacles that people the canyon itself. This light is undisciplined and bad mannered, though, if you try to catch it on your ground glass. It won't hold still for a time exposure.

The four-o'clock sky over the canyon is a dark, brooding sky, heavy with moisture. The fitful gusts of wind will shake the patient cedars on the rim and kick up dust along the trails that crawl down steep rock walls. Flashes of lightning leap out of the dark sky. The cloud gods are flailing the earth with angry whips. Thunder echoes in the depths of the canyon.

Then out in the canyon it begins to rain. Patches here and there, moving about, curtains of water spilling out of the sky, and as you watch you cannot see where earth begins and the dark sky ends. Lightning continues the mad dance, and the thunder is a great wave of noise flooding the canyon. The sun, defiant of the storm, breaks through the clouded sky and, to show what a clever fellow he is, hangs a rainbow out in the canyon for all the world to see. Then the storm ceases to be a dark, fearful thing, but a thing of infinite beauty and the thunder is no longer a roar of anger but high laughter and the lightning is white ribbon with which to wrap the world up in a gay package.

The storm is short-lived. The sun parts the clouds and the rain stops. The dark sky breaks up in little pieces and each little piece becomes a white cloud and the white clouds hitch a ride with the wind and go tumbling along to other places. The newly-washed canyon is clean and bright after the rain. The sun seems to be brighter than ever and then with a triumphant smile and satisfied with a good day's work he decides to call it a day. Before he leaves, he fills the canyon with gold that gradually turns to deep purple. The evening sky is clear and studded with bright, twinkling gems called stars and a summer day and a summer storm end at Grand Canyon. ᴀʜ

HOST TO THE WORLD

BY CHARLES FRANKLIN PARKER

The dim Indian trail followed by the Spaniard Cardenas in 1540 to the South Rim of the Grand Canyon has now become a wide, well-marked thoroughfare.

Over the modern highway, State Highway 64, cars from every state in the union and the Territories come every month. It is not unusual to find cars bearing license plates of four or more foreign countries parked near the hotels any summer day. This dim trail has become the widening way bringing people from all over the world to behold this giant spectacle, the Grand Canyon of Arizona.

The more than half million visitors to the Canyon each year belie the statement recorded of a young U.S. lieutenant, Joseph Ives, who explored the region in 1857, "Ours has been the first and will doubtless be the last party of whites to visit this profitless locality."

Last year 688,673 persons arrived at both Rims to view the awesome chasm. They came by train, plane, bus and automobile. Altogether 204,497 private cars checked through the Park entrances, from all of the forty-eight states, seven territories and thirty-one foreign countries.

Even before State Highway 64 was paved in 1930, automobile traffic was heavy. Since the surfacing of State Highway 67 to the North Rim later in the '30s, additional thousands of cars have traveled in ease to the nation's wonder gorge.

The people who came are the notables and the nobodies, the royalty and the roughnecks,

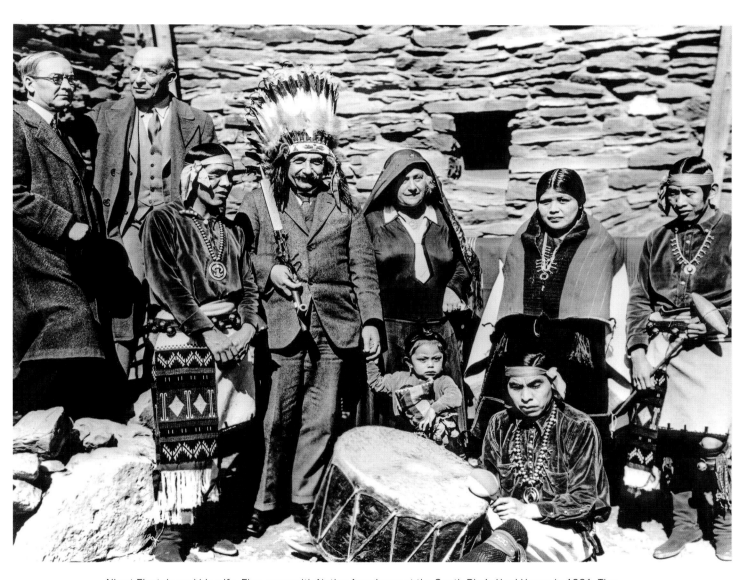

Albert Einstein and his wife, Elsa, pose with Native Americans at the South Rim's Hopi House in 1931. The Einstens' visit to Arizona also included a stop at Petrified Forest National Park. | COURTESY OF GRAND CANYON NATIONAL PARK MUSEUM COLLECTION

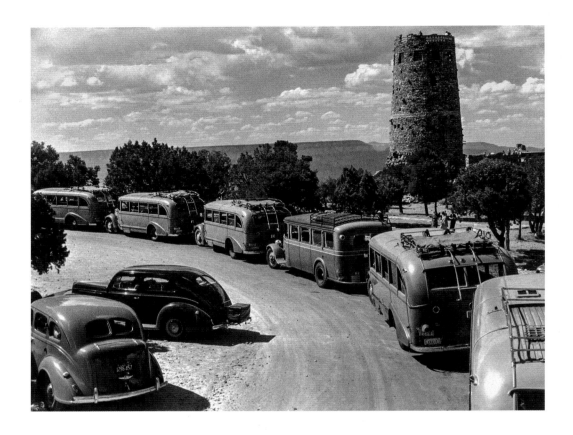

the rich and the poor, the scientists and the sightseers. Whoever they are or why they came they are almost universally deeply impressed. In all probability they will never see anything else that so awes them and inspires them for its magnitude as the rich, changing panorama of hues, of canyons and submerged mountains.

It was George Wharton James in his book *In and Around the Grand Canyon* who recorded the words of a great organist at the turn of the century, Clarence Eddy. After a mule ride up a Canyon trail during a storm, Eddy remarked, "This forms an epoch in my life. I shall play better for this experience so long as I live."

To one who now beholds the Canyon's vast and royal beauty it is hard to imagine that anyone could not understand that man's soul in search of beauty and greatness would not beat a

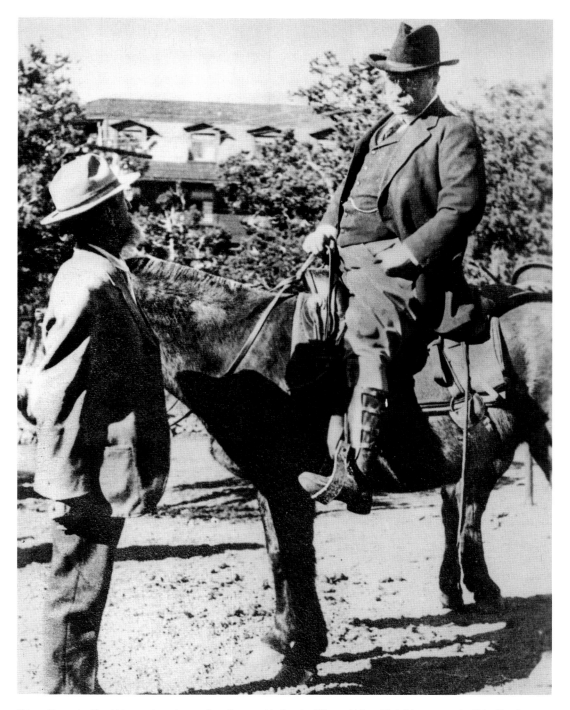

Opposite page: Fred Harvey tour buses line the road in front of Desert View Watchtower, east of the South Rim's Grand Canyon Village, in the 1930s. | COURTESY OF GRAND CANYON NATIONAL PARK MUSEUM COLLECTION
Above: John Hance (standing) speaks with Theodore Roosevelt during one of Roosevelt's trips to the Grand Canyon. | COURTESY OF GRAND CANYON NATIONAL PARK MUSEUM COLLECTION

wide pathway to its Rims. So it is today. The Grand Canyon of Arizona is host to the world, and the "profitless locality" has become a mecca for hundreds of thousands of pilgrims annually seeking beauty, knowledge and inspiration. For it is as John Burroughs, the eminent American naturalist, exclaimed, "The world's most wonderful spectacle, ever-changing, alive with a million moods — that is the Grand Canyon."

WITHIN THIRTY YEARS after the doleful prediction of Lieutenant Ives the future of the Canyon was already looking toward its now recognized importance. In 1884 John Hance had taken a homestead on the South Rim, reworked an old Indian trail into the Canyon, and advertised a guide service for visitors.

Exactly fifty years after the visit of Ives, a bill was introduced in the United States Senate to create "a national park of the lands on the southern border of the Grand Canyon of the Colorado."

The area was already attracting acclaim in 1892 when Charles F. Lummis of *Century* magazine, W.F. Clark of *St. Nicholas* magazine, and Thomas Moran, the artist who was to win fame for his Grand Canyon paintings and etchings, arrived at the Rim. The trail followed by Cardenas and Ives was beginning to widen and by 1899 the Coconino *Sun* reported over 900 visitors for the season.

Much development was now underway. New trails were being built, railroads projected and accommodations for visitors expanding. Santa Fe brought its first train to the South Rim in September of 1901, and the following January, just fifty years ago, the first automobile "steamed" to the Canyon.

When President Theodore Roosevelt made his first visit to the magnificent chasm on May 6, 1903, he declared: "The Grand Canyon fills me with awe. It is beyond comparison — beyond description; absolutely unparalleled throughout the world … Let this great wonder of nature remain as it now is. Do nothing to mar its grandeur, sublimity and loveliness. You cannot improve on it. But what you can do is to keep it for your children, your children's children, and all who come after you, as the one great sight which every American should see."

Five years later, on January 11, 1908, President Roosevelt issued the proclamation creating Grand Canyon National Monument. It was not until 1919 that, by Act of Congress, the area was made a National Park — to become the seventeenth in the plan of setting aside a part of the priceless heritage of the United States to be preserved for the benefit and enjoyment of the people in the National Park System.

General Dwight D. Eisenhower poses on the South Rim for a photo at the Grand Canyon's rail depot in the summer of 1950. | COURTESY OF GRAND CANYON NATIONAL PARK MUSEUM COLLECTION

Though often saying that words could not describe the beauty and grandeur of the Canyon, many who came in the early days, nevertheless, did just that. Charles Lummis, upon his visit in 1892, called it "the greatest thing in the world." Professor John C. Van Dyke, author of books about the Canyon and other natural wonders, said, "It is not the eighth but the first wonder of the world. There is nothing like it." Hamlin Garland described it in terms of "a thousand differing moods."

The Dutchess and Duke of Windsor pose near the South Rim's Bright Angel Lodge in March 1959. Flanking them are Charles E. Shevlin (left), the park's assistant superintendent, and Dan Davis, a park ranger.
| COURTESY OF GRAND CANYOON NATIONAL PARK MUSEUM COLLECTION

Thus the marvels of Grand Canyon had already been described when President William Howard Taft arrived on October 14, 1909. Much preparation was made for him. Not only was there concern as to his assistance in further developing the status of the Canyon by having it made a National Park, but also the question of statehood for both Arizona and New Mexico was of greatest importance in this region.

Captain John Hance's great mule, the best of all the trail mules, was for Taft, and upon him the President made the trip into the Canyon. The press of that day was much given over to the

visit of Taft. One of the best reports is from the *National Hotel Reporter*, which said in part: "William Howard Taft, President of the United States, paid his first visit to the Grand Canyon of Arizona on October 14, 1909. Like all visitors to this remarkable region, the President was greatly impressed with the wonderful canyon, and he was also much impressed with the excellence of Hotel El Tovar of the Harvey System … On the evening of October 14 Governor Sloan of Arizona gave a dinner for President Taft and his party, for which a very striking menu was prepared."

The menu as given was as follows:

Fresh Caviar
Consommé Alice
Crab Flakes, Salamander
Breast of Mountain Grouse, Truffled
Heart of Artichoke
Roast Saddle of Venison
Sweet Potatoes
El Tovar Salad
Nesselrode Pudding, Sauce Sabayon
Assorted Cakes
Roquefort Sierra
Coffee

All of this must have had the desired effect upon President Taft, for some three years later, still during his administration, Arizona gained statehood. The importance of the Grand Canyon of Arizona and the dinner at the El Tovar in the matter of gaining statehood has never been evaluated but it may have been a matter of destiny.

OVER THE PAST HALF CENTURY the annual travel to the Canyon has increased from the 900 in 1899 to approach the three-fourths million mark, and the register at the Rim lists many notables out of the passing parade of the years — renowned scientists, statesmen, churchmen, poets, painters, publishers and potentates who have come to know the spell of its greatness. We can note but a few, mainly those recorded on film and in words, and whose presence and thoughts will register in importance to those familiar with the great of the past years.

After World War I, the great French Marshal Foch visited the Canyon on his tour of the United States sponsored by the American Legion. Astride the famed mule, T.N.T., and puff-

ing his World War pipe of victory, he descended into the Canyon depths. The Marshal called it "the most gorgeous sight." Some wiseacre has credited him also with the doubtful distinction of saying, "What a grand place to throw one's mother-in-law."

Following Marshal Foch came General Gouraud, "Lion of the Argonne," in 1923, and still later the Italian General Bodoglio.

In November of 1922 Lord and Lady Mountbatten (the Lord is the uncle of Prince Philip, consort of Queen Elizabeth) included the Grand Canyon in the itinerary of the royal honeymoon, and joined with other pilgrims on the journey of Bright Angel Trail.

More recent visits of nobility and royalty have been Lord and Lady Halifax of England, during the Lord's service as ambassador to the United States; Prince Jaisinh and Princess Premila of India; the Crown Prince and Princess of Norway, who are remembered by Park personnel for their gracious, warm-hearted gentility; the Crown Prince and Princess of Denmark in 1939; the King and Crown Prince of Belgium; His Highness Tengku Yaacob Ibni, Sultan Abdul Hamid of the Malay States; two Princes from Saudi Arabia; and His Imperial Majesty Mohammed Reza Shah Pahlavi, Shahinshah of Iran in 1949.

Throughout the young Shah of Iran's stay at the Canyon he constantly sought moments alone to meditate on the splendor of nature's creation before him. However, a prior attempt on his life in Iran kept him under the close surveillance of not only his own accompanying generals, but United States secret service men and Park rangers.

The Shah did maneuver one early morning walk when his protectors thought him safely asleep. Accompanied by a single ranger who was on duty in the hotel lobby, he viewed the Canyon in the peaceful solitude of the dawn hours.

Ferde Grofe's deep inspiration is one that can be forever heard in his magnificent symphonic composition, *Grand Canyon Suite*. Incidentally, one portion of "On the Trail" provided an innocent complication when Park officials were entertaining the two Princes from Saudi Arabia.

At a tea Dr. H.C. Bryant, Park superintendent, arranged in their honor, he started a recording of that music for background atmosphere. A government agricultural official, one familiar with the Princes' own country, quickly informed him that the Saudi Arabians thought genies existed in all phonograph records. To break the spell they always smashed them. In his haste to turn off the phonograph, Dr. Bryant himself dropped the record. To be sure it broke the spell, but Dr. Bryant had some difficulty in again completing his Grofe album.

Eminent scientists to come under the natural spell of the Canyon included Marconi and Einstein, who were photographed at the Rim accompanied by their wives. More recently Dwight Eisenhower was a visitor.

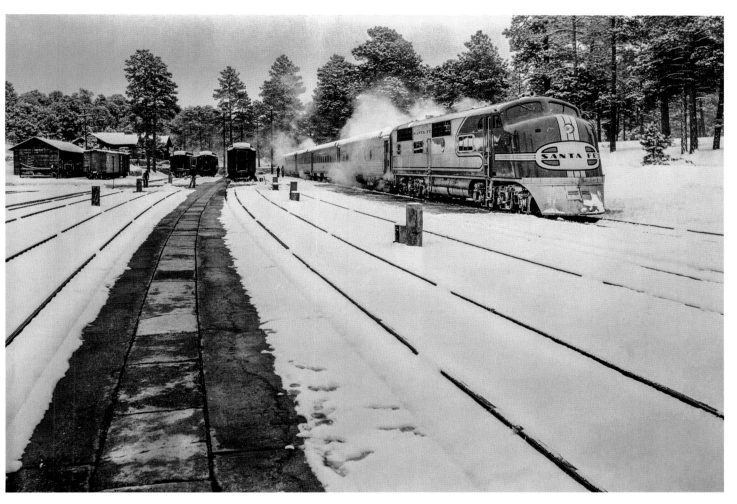

The Atchison, Topeka and Santa Fe Railway's *El Capitan* arrives at the South Rim in February 1938, during its first run from Los Angeles to Chicago. The train made a special detour to the Canyon as part of the inaugural run. | COURTESY OF GRAND CANYON NATIONAL PARK MUSEUM COLLECTION

The deep humanitarian nature of the General was indelibly imprinted on the minds of all who saw him during his July sojourn in 1950. While his luncheon party anxiously awaited his presence, General Eisenhower graciously posed on the terrace for several hundred amateur photographers, then after one small boy asked for his autograph, continued for another half an hour to sign the envelopes and scraps of paper thrust to him. Parents of servicemen who had been under his European command proudly mentioned their boys, and the General expressed genuine interest in each of his former soldiers.

We know from their books either about the Canyon or in using it for descriptive background how deeply impressed have been many writers. John C. Van Dyke, Edwin Corle, and J.B. Priestley are a few who have penned words about it. Zane Grey was only one of many who made the colorful gorge the locale for several of his stories.

George Bernard Shaw, Henrik Van Loon, Irving Cobb, Henry Van Dyke are others who shared the Canyon's inspiration with a writer's perception.

The history of wit, no doubt, is the loser in not having Shaw's voiced expressions of the Canyon when he arrived at the South Rim. In Priestley's work, *Midnight on the Desert*, the reader is aware of the writer's profound impression of the chasm wherewith he begins to delve deeply into philosophical matters including his discussion of the fourth dimension.

Arturo Toscanini is another of the musical notables to have absorbed with his artist's soul the grandeur of the Canyon. Painters throughout the world have brought away with them their canvasses brilliant with color to portray for them their love of its natural grandeur.

GROUPS ARE ALSO IMPORTANT in the Canyon's cavalcades. Every year welcomes one or more gatherings from the American Youth Hostels, including students from Europe, who come on the trains with their bicycles to "do" the Canyon. Three such groups visited during the one month of August in 1947.

One unique group was the Kitty Kat Klub of Canton, Ohio. Comprised of six couples, the members had saved systematically for eleven years to have money for a vacation trip to the West. By V-J day they had saved nearly $2,000, and were offered another $1,000 for a New York appearance on the radio program, *We, the People*. The couples arrived at the Canyon in June 1946, on their memorable Western trek.

Arizona and its natural wonder have been host to conventions and delegations throughout the years. One of the most renowned gatherings was that of the Rough Riders, on the occasion of their 50th and last reunion in 1948. How fitting for this group of old soldiers to gather at

the great chasm — first given national distinction by their commander, Teddy Roosevelt, and the former stamping ground of two of their famed members, Bucky O'Neil and Dan Hogan.

The group most closely associated with the Canyon is probably the Shrine of the Ages Choir from Arizona State College at Flagstaff. For these young singers, under the direction of Dr. Eldon Audrey, each year present the musical setting for the Easter sunrise service held at the South Rim.

From its inception the service has been directed and narrated by Arizona's present governor, J. Howard Pyle. Churchmen from throughout the country have journeyed to the Canyon to speak, including Dr. Daniel Poling, Dr. Albert W. Palmer, Dr. Ronald Bridges, Bishop William Scarlett and Bishop Arthur B. Kinsolving. Their messages from the Rim, delivered against a background of such magnificent splendor, have instilled the deep spirit of Easter promise.

When this writer was honored by being the speaker in 1949, residents from thirty-nine states, from territories and foreign countries were in the worship group there. But in addition to the thousands of people who meet each Easter for this service, other millions around the world are joined with them through the miracle of radio. World fellowship in its highest essence is portrayed as these messages from the Canyon bring all peoples together on this day of eternal hope.

The Grand Canyon is having a very real part in creating and maintaining a fellowship of seekers after the things great, grand and beautiful. World-wide fellowships that may in time inspire men to build among themselves and their nations something comparably as great and beautiful as this miracle of nature.

Perhaps this titanic spectacle that enthralls and humbles all men still has even a greater role in the destiny of the Creator's plans for a humanitarian and peaceful world. Today millions come from everywhere to catch the eminency of its message of time and space. There it is always changing yet unchangeable; austere yet beautiful; immense yet speaking in a still small voice — the Grand Canyon of Arizona: *Host to the World.* ▥

MARCH 1954

VACATION CALL FROM THE GRAND CANYON

BY CHARLES FRANKLIN PARKER AND JEANNE S. HUMBERG

Everybody wants to see the Grand Canyon of Arizona. At least that is a fair conclusion because over nine million visitors have been awed by its splendor since the site became a National Park in 1919. Of these millions who have come many have lamentingly exclaimed: "Why didn't we plan to stay longer?" or "We surely must come back again." The fact remains that one cannot comprehend the greatness of the Canyon by a quickie visit. For when you see this wonder of creation you will want to capture its full inspiration revealed in the moods of its constantly changing panorama. That is why a full vacation at the Grand Canyon is a memorable experience.

It was John C. Van Dyke who wrote these intriguing words: "The great chasm cannot be successfully exploited commercially or artistically. It cannot be ploughed or plotted or poetized or painted. It is too big for one to do more than creep along the Rim and wonder over it. Perhaps that is not cause for lamentation. Some things should be beyond us — aspired to but never attained."

Such a land calls to you and will give you back from its depths and immensity of mystery and awesome beauty a vacation that fills the void of the yearning soul, gives rest to a weary mind as it is challenged to greater visions, and new vigor to a body being cramped in small places doing small routine things. Vacation calls from the Grand Canyon to you!

Motorists line up to pay the park's entrance fee at the South Rim entrance station in August 1951. | COURTESY OF GRAND CANYON NATIONAL PARK MUSEUM COLLECTION

A FULL VACATION will bring great rewards but if such cannot possibly be your plans then arrange in advance for an adequate stay to realize the full glory of this natural creation. During the peak travel months of July and August, when between five and six thousand persons per day stand on the rims of the Canyon, many travelers are bitterly disappointed that their reservations cannot be extended so they may absorb more of the mystic spell of the mighty gorge. The pressure of on-coming visitors prevents an extension of reservations in these busy months and gives wisdom to the suggestion of planning your own vacation if possible at a slightly off-season time. Last year some 729,181 persons came to the Canyon, and whichever month they arrived found unsurpassed vistas to inspire them, for you can greatly enjoy a visit at any time with the gigantic panorama changing with the various seasons and each period offering its own reward.

April, May and early June bring particularly lovely days at the South Rim, which is open all the year, or the fall weather of late September, October and into November is delightful. The North Rim, open only for the five warm weather months, is equally appealing in spring with its profusion of flowers and the autumn months bring the beauty of brilliant colors in the aspen and pine forests besides the splendor of the Canyon. The time you plan your visit will in some ways determine what aspects of life there will be most alluring — the gleam of snow upon the Rim and against the redwalls, the full sweep of colors in spring and fall, or the warmth and full sunshine of summer. Go any time that you can, but if you have a choice we suggest the times just before or just following the rushing mid-summer months.

As you ponder and plan, several questions come to your mind. How do I get to the Grand Canyon? What can I do while there? What are the facilities and what are the costs? Undoubtedly others will come to mind, but we hope we can so completely answer your queries and stimulate your desire that you will be Grand Canyon bound for your next vacation.

IN PLANNING YOUR STAY the climatic variations within the area will be important to you as well as the means of approach. The two Rims of the Canyon, the North and the South, are vastly different and separated as they are by the mighty chasm their approaches involve considerable geography. Seasons will play an important part in your plans and your own interest and temperament will define in part your wants and establish your selection of activities. Within the area you can run the range of variation in climate from sub-tropic at the Canyon floor to the Canadian zone on the North Rim. The South Rim, about 7,000 feet elevation, may have a temperature of 90° in August, while the North Rim, some 1,200 feet higher, will be a cool

Two women take in a westward view of Grand Canyon National Park in June 1930. The photographer was George Alexander Grant, who made more than 30,000 photographs for the National Park Service. | COURTESY OF NATIONAL PARK SERVICE HISTORY COLLECTION

80° and there is likely to be 110° weather at Phantom Ranch at the bottom of the gorge, only 2,500 feet above sea level.

The rock-opened chapters of geological history are revealed at the Grand Canyon as in no other one spot, from the oldest to the newest the chapters are written into the walls. The many zones of life and the ecology of nature are displayed in a small locale not found anywhere else and offer a laboratory for gathering information that might otherwise have to be sought over many continents.

Here is a paradise for artists and photographers with the full glory of nature's colors before you. Here, too, the beckoning out-of-doors offers leisure walks for everyone and the more avid are challenged by remote peaks and canyons and the web of trails that descend into the gorge. And to one just seeking rest, relaxation and repletion of mystery and magnificence, the Canyon calls: "Come unto me — bring your worries, your burdens, your skepticism, your frustrations and I will give you peace and faith and power. I will open for you trails of new concerns and greater dimensions."

Let it be said that actually if you stay around the Grand Canyon you will find yourself drawn to its Rim, spending far more time than you now imagine, sitting on a rock ledge leaning back against a piñon or spruce tree just looking out over the vast expanse. While you watch, the changing colors found in the play of lights and shadows, as the rays of the sun run the arched gamut from east to west, constantly alter the outlines of peaks, crags and canyons in the abyss, and you will be entranced by the clouds that drift across the skies often dropping within the Canyon's vastness, or perchance will witness a summer storm bringing a rainbow arch that becomes lost in the depths.

Yes, you may note the changing season and the snowflakes that come to whiten the Rims and upper walls, and the seemingly evergreen verdure in the little oases one mile below those Rims. All of these things, with the bird calls and scamperings of little animals in and out of rock crevices and the gentle deer running or walking unafraid even in the midst of the curious tourist camps, will hold you.

All of the magnitude of the Canyon has an efficient counterpart in the efforts of man to provide for your comfort and necessities while enjoying an ideal vacation. The services extended to you by various agencies and organizations will make your stay complete. Responsible for your recreation and entertainment is the National Park Service under Dr. Harold Bryant, Park Superintendent.

The roads, trails, registration, public campgrounds, the preservation of wildlife, the naturalist programs and administration of all park activities are the tasks of this government agency.

Employees of the North Rim's Grand Canyon Lodge perform a "sing-away," a traditional musical farewell to guests, in 1933. The remains of the main lodge building, which burned the previous year, are visible in the background. | COURTESY OF GRAND CANYON NATIONAL PARK MUSEUM COLLECTION

This includes supervision of the concessioners who provide the superb hotel accommodations, transportation, shops and services and whose hospitality roles are of prime importance in developing the Grand Canyon's prominence as the foremost scenic attraction in the United States.

As your official hosts the Park Service employees depict to the highest essence the philosophy of this agency — that the splendor of unsurpassed nature is for the appreciation, the understanding and the enjoyment of all people. Their services are offered to you free as part of your heritage in this country and likewise extended in the spirit of American friendship to travelers from throughout the world. The only charge made by the Park Service is the entrance fee for those who drive, $1 per automobile or motorcycle and $1 per trailer. Of interest to many is the information that you are permitted to bring your pets into the Park, the only stipulation being that they must be kept on leash at all times.

To return to the prosaic, you still want to know, "What can I do at the Grand Canyon?" Your own interest will determine to a large extent what you will want to do, but some are musts if you are truly to appreciate this splendor of nature. Since the variance in seasons and natural endowments is so great we will present the North and South Rims separately, their activities, accommodations and methods of transportation.

SOUTH RIM

Like all great works of nature an explanation of this phenomenon is necessary if you are to comprehend its magnitude. The naturalist programs of the Park Service are the perfect answers and it cannot be emphasized too strongly the need for the expert interpretation of scholarly men if your visit is to be memorable and meaningful. The South Rim, since it is open all year, can offer more permanent facilities for this presentation. At Yavapai Observation Station, just one and a half miles from Grand Canyon Village, much of the Canyon is seen before you and the complete history of the earth's existence is bared to man. Its story, told by a naturalist and illustrated with a huge topographical map, exhibits and a battery of telescopes, will convey within an hour a deeper understanding of the miracle of the ages that produced the chasm. You can drive to this majestic point, go by sightseeing bus or walk the short distance over the rim path, but whichever way you choose it should be first on your activities list.

Mecca for those with a deep interest in the natural science of the Canyon is the Workshop and Museum, where a continuing program of research is being carried on by Louis Schellbach, Park Naturalist. In the Wayside Museum of Archaeology, 20 miles east of the Village on the Rim road, the story of early man in the Southwest and his place in the earth's history is revealed through exhibits and in an excavated pueblo ruin nearby.

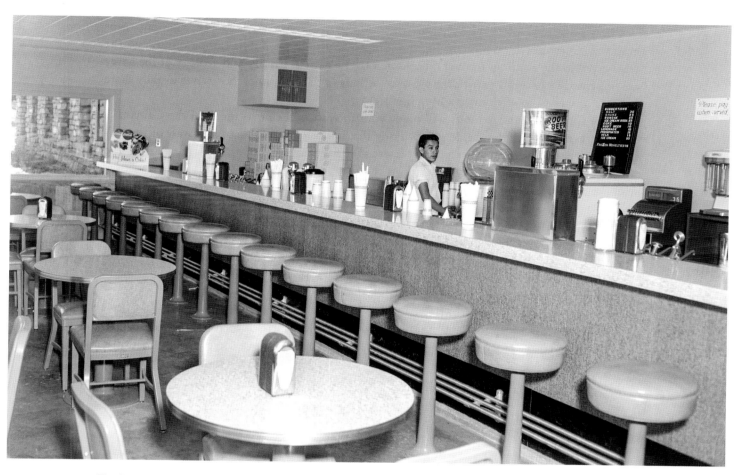

The Bright Angel Lodge soda fountain, shown shortly after its June 1955 completion, was a popular destination for lodge guests and other South Rim visitors. | COURTESY OF GRAND CANYON NATIONAL PARK MUSEUM COLLECTION

Completing the Park Service's explanatory discussions of the Canyon are the Campfire programs conducted each evening during the summer season at the public campgrounds and the talks given in the evenings in the Lodge lounges. The natural history and geology of the gorge are presented by naturalists with the aid of color slides and the visitors themselves usually share in these programs to offer entertaining highlights.

All of these talks and exhibits will pique your interest in seeing as much of the Canyon as possible. From each of the scenic points along the South Rim roads, east and west of the Village, you will discover new and startling views as the full panorama of ever-changing colors and formations opens before you. Westward on the West Rim Drive you will find Powell, Hopi, Mohave and Pima Points and finally Hermit's Rest, a picturesque building of canyon boulders with a massive fireplace.

Eastward the rim road leads to Yavapai Observation Station, to Yaki, Moran and Lipan Points, the Wayside Museum and to the Watchtower at Desert View with its sweeping vista of the Canyon, Kaibab National Forest and far into the Painted Desert and Hopi-Navajo country. Light refreshments are served at Hermit's Rest and Desert View so you need never shorten your meditation of the gorge because of hunger.

The daily sightseeing motor trips, provided by the Fred Harvey Company, are the ideal way to see the South Rim views, and some who have their own cars prefer this method so their full attention can be given to "just looking." Busses leave the El Tovar hotel and Bright Angel Lodge both morning and afternoon for these trips. The morning drive, westward to Hermit's Rest, is $3 per person and the afternoon trip to Desert View is $6 or both drives, including light refreshments at Hermit's Rest and the Watchtower, for only $7. Rates for children, six to eleven years, are half price. The Grand Canyon all-expense tour, which includes the complete rim drives and three meals at El Tovar hotel, is an ideal arrangement for those forced to spend only a very short time and costs $12.75 per person, $6.40 for children. Motor trips subject to federal transportation tax.

Bridle paths extend along the rim also and into the forest, offering long-remembered rides in this scenic wonderland. Saddle horses may be rented in a regular party with guide for $4 for two hours, $6 for half a day or $9 for a full day's ride during summer months only.

Awesome as the view of the Canyon is from standing upon its rims, the most indelible impressions of its greatness can only be realized from within the gorge. No able-bodied person should overlook this opportunity — for a memorable mule trip or a hiking expedition down the safe and wide trails maintained by the Park Service. Truly the Canyon is a hiker's paradise — for the stout-hearted who know with confidence what they can undertake, and for the "good walk-

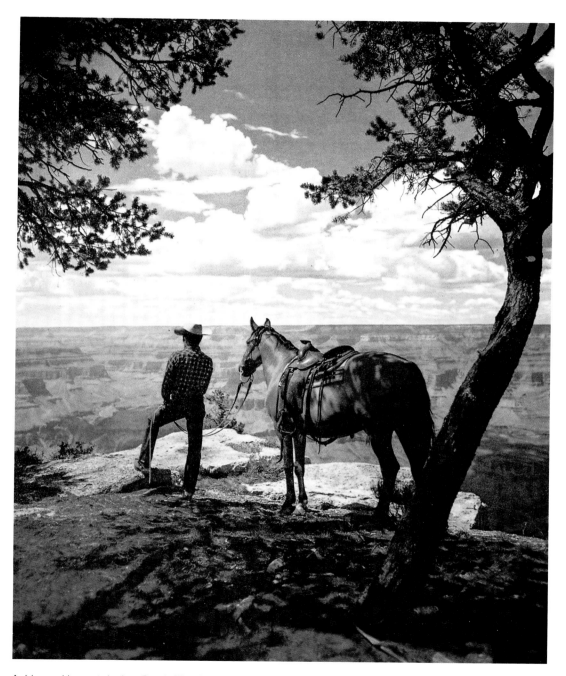

A rider and horse take in a South Rim view on a summer afternoon. This spot is between Verkamp's Curios (now Verkamp's Visitor Center) and Yavapai Point. | ESTHER HENDERSON

ers" who will want to venture partway down one of the trails.

For the advantage of all there is a manual available at the Park Service headquarters that will make your trip pleasant and informative. Trips to the Colorado river down Bright Angel or Kaibab trails provide a fascinating change with each step as the Canyon walls heighten above you and the details of down yonder come into closer view. However, these are strenuous trips for the unwary and that long last mile back up to the Rim should be carefully considered before one descends too far down into the depths.

One can hike from Rim to Rim over the Kaibab trail, staying all night at Phantom Ranch for $10 which includes accommodations, two meals and a box lunch for the second day, or you can camp at a designated spot along Bright Angel creek. Knapsack and camping trips have proved increasingly popular each year and it is a familiar sight to watch a group of energetic hikers, laden with food and gear, start down the trails. For all concerned, it is possible to have mules sent to meet you for the return trip to the Rim, but because it involves special guide service the charge is necessarily higher.

There are many excellent short hikes that even the most timid can safely undertake with confidence. From Hermit's Rest there is a three-mile round trip to a series of natural bridges, rock arches only six feet in height that are perfect miniatures in conformation and color. Another is six miles round trip, also from Hermit's Rest, down the old Hermit trail to an inviting spring. Not to be overlooked are the footpaths to Yavapai Point and Powell Memorial that provide interesting studies.

Here let us inject some advice about clothing, equally applicable whether you ride or walk, that will make your trips into the Canyon more enjoyable. It's simply a caution to protect you from the weather conditions of each season, for the trips are fascinating at all times of the year.

In the summer the sun's rays are intensified within the gorge, so brimmed hats and long sleeved shirts (both can be rented at the hotels) are advisable. Seems unnecessary to add a case of sunburn or heat fatigue to perhaps a few sore muscles and the spirit will have tough sledding responding to the Canyon's splendor if the body is uncomfortable. On the same score, in the late fall, winter and early spring months, when there may be snow upon the Rim and the crisp mountain air fills you with vigor and ambition, just remember that although it will be some degrees warmer down in the gorge, it still won't be balmy. There are many miles both up and down where the trails are in shadow and warm clothes are your guarantee for a pleasant trip.

———

UNDOUBTEDLY ONE OF THE MOST famous and stimulating means of travel in the world is offered

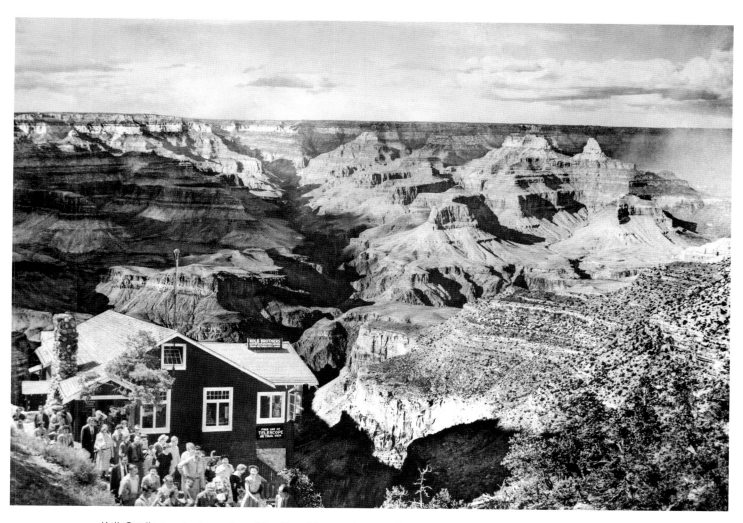

Kolb Studio punctuates a view of the Grand Canyon from the South Rim. Emery Kolb likely made this photograph in the mid-1920s. | NORTHERN ARIZONA UNIVERSITY CLINE LIBRARY

by the Grand Canyon trail mules — your invitation to a thrilling adventure. There's always much ado and excitement when the day trips leave the corral at the head of Bright Angel trail at 9 a.m. The return is about 5 o'clock with a pleasant noon stop for a box lunch. The plateau trip to the brink of the inner gorge high above the raging current of the river is $10, while the river trip, somewhat longer and ending at noon on the banks of the swift Colorado, costs $11.50.

Phantom Ranch, that intriguing place of mystery and anticipation in the bottom of the Canyon on Bright Angel creek, extends a welcome to all who can possibly arrange their schedules and budgets. It is a never to be forgotten two-day trip to this restful haven in a cottonwood grove.

Starting down Bright Angel trail at 10 a.m. your mule party will travel to Indian Gardens, then over to the river trail to follow the inner gorge and cross the Colorado over the 440-foot suspension bridge not far from Bright Angel creek. In the summer the swimming pool is inviting, and throughout the year the ranch meals will more than satisfy your increased appetite and the pleasant camaraderie be long remembered.

The return trip the next morning is up Kaibab trail with its rugged switchbacks. The Phantom Ranch trip is $32.75 per person and for an extra day at the ranch, which includes a side trip to Ribbon Falls, the charge is an additional $33.38. Much of the cost is computed on the hourly use of the mules and when you consider that every single thing at the ranch, all its furnishings, its food for guests and for the animals, is brought in by mule pack train, over the same trails, the price is not exorbitant.

Fishing is fine in Bright Angel creek and from the ranch a trail also leads to Clear creek where the trout are awaiting the fisherman. Within the Park fishing is permitted all year with 10 the limit. The Arizona state license is obtainable on the South Rim at Moqui Camp near the Park entrance, and on the North Rim at Jacob Lake. It is an unequalled experience to be camped deep within the Canyon's walls and enjoy eating a trout you have successfully played out of a swift stream.

The activities at the South Rim also can include a trip to Havasu Canyon, home of one of the smallest tribes of Indians in the United States whose picturesque abode is within the confines of the National Park. The village of Supai is located on ever-flowing Havasu Creek with its three waterfalls of great height, and a three-day pack trip to this green valley of orchards and abundant growth is full of delight. Arrangements for this trip, which also may be undertaken by hikers, are made at the Grand Canyon Village. Supai offers tourist cabin accommodations and campgrounds, but no meals are served, guests either bringing their own supplies or obtaining them from the limited stock in the Indian-owned store.

For you who are photographers and eager to record on film a lasting impression of the majes-

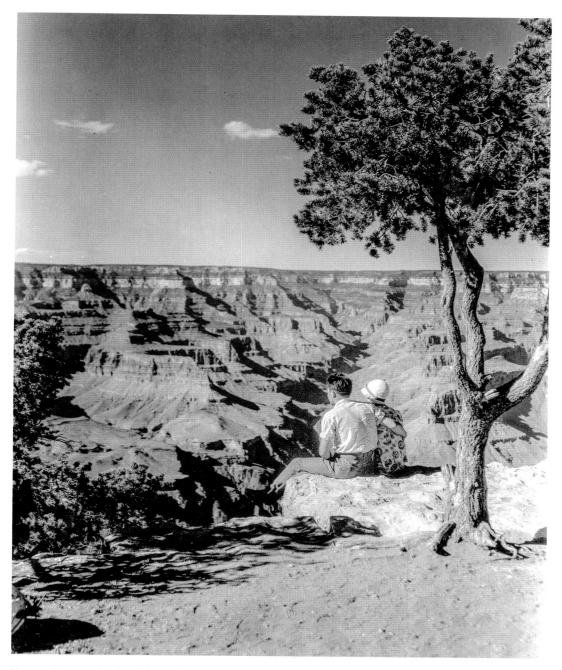

Yavapai Point, on the South Rim, offers a view up Bright Angel Creek in a George Alexander Grant photo from the late 1920s. | COURTESY OF NATIONAL PARK SERVICE HISTORY COLLECTION

tic Canyon there is a myriad of shots, ever changing, ever wonderful. A word of advice from an expert will aid you in obtaining the best results. Norman Rhodes Garrett, FRPS, noted photographer whose inspiring pictures have appeared in many *Arizona Highways*, has this to say: "First and foremost, use a sun-shade whether you're shooting in black and white or color, and secondly, don't fight your light meter but believe it, even though it gives a surprisingly high reading. For black and white use panchromatic film and a yellow filter to obtain a true reproduction. In color use a Skylight filter to reduce the over-abundance of blue. The same advice is given to motion picture enthusiasts. For the best results shoot your pictures in the early morning or late afternoon since the Canyon goes flat during the middle of the day."

Even though you have doubts of your own skill with a camera there is no reason to leave the Canyon without some colorful pictures, for the thousand moods and hues of the gorge have been captured for you by other photographers and artists whose works are on sale. Lookout Studio, perched on the very rim at Bright Angel Lodge, is the mecca for photographers and can supply all camera needs as well as develop and print your film. There is an excellent collection of canyon prints and color slides for sale here as well as in Kolb Brothers Studio, the shops at El Tovar hotel and Bright Angel Lodge and Verkamps.

The Kolb Brothers travelogue and lecture, given each evening in their studio at the head of Bright Angel Trail, will interest all visitors. The adventure of the boat trip made by Emery and Ellsworth Kolb down the Colorado river as recorded in film is a unique experience in which you see and feel the treacherous power of the river. Prints of outstanding Indian artists are found in the curio shop along with beautiful pieces of polished petrified wood.

For a true portrayal of the Southwest Indian's craftsmanship the Hopi House, opposite El Tovar hotel, is the center. In this authentically built reproduction of a Hopi mesa home, the best of Indian art is found, from the silver and turquoise jewelry, colorful rugs and costumes to a wide selection of souvenirs. No visit is complete unless you schedule your time to see the Hopi dances presented each afternoon before the building, except in inclement weather when the dancers perform inside. Collections of Indian handicraft and Canyon souvenirs are also found in beautiful displays at Verkamps, whose founder brought the first curios to the South Rim in 1896, at the shops in the hotel and lodge and in the Village store.

Movies are shown at the Community House two nights a week and the informal programs provided by cowboy musicians for dancing at Bright Angel Lodge are additional entertainment. The entire area along the South Rim roads abounds in scenic picnic spots with the Village store ready to supply all the ingredients for an outdoor meal. Most important is the warm feeling of congeniality found among Canyon visitors. Coupled with your own absorbing interest in the

natural splendor of the gorge with its daytime color and fantasy of shadow and shape by moonlight, all of this means a wonderful vacation.

––––––

IN ANSWER TO YOUR QUESTION "What accommodations will I find?" the reply can state that there are many types, depending upon your tastes and finances, from free campgrounds to one of the finest resort hotels in America. The hotel, lodge, auto camp and transportation services at the Rim are all under the efficient Fred Harvey system.

El Tovar, the most famous resort hotel in the Southwest, has extended its hospitality to Canyon visitors for over forty-eight years. Its range of accommodations is from $3.50 per person for room without bath to a limited number of deluxe suites. The dining room with large picture windows overlooking the gorge serves breakfast table d'hote for $1.50, lunch $1.50 to $2 and dinner $2 to $3.50. At the Bright Angel Lodge prices for both accommodations and meals are approximately twenty-five per cent lower. A room without bath for one is $2.50 to $3.50, with bath $4.50 to $7.50 and the deluxe rim cabins with fireplaces are available for $10 to $12 for two.

The a la carte meals are at moderate prices and include convenient counter service. Barber and beauty shops are further conveniences for guests. At both the hotel and lodge children from three to seven are half rate and youngsters eight and over full rate. Some additional accommodations for guests are offered at Rowe's Well and Kachina Lodge.

The Grand Canyon Auto Lodge cabins with comfortably furnished sleeping and housekeeping facilities have a wide variance in prices depending on the number in a family group. Cabins without bath but with running hot and cold water are $3.50 for two; with bath, $4.50, and for four persons, $6.50. An excellent cafeteria with very reasonably priced meals is located in the main building which also includes a gift shop.

Opposite this grouping of buildings and at Desert View are the public campgrounds, maintained by the Park Service for the free use of visitors bringing their own equipment or house trailers. Although travelers are welcome to bring their trailers, no electrical or sewage connections have been arranged.

In all accommodations we cannot stress too strongly the need for advance reservations, except in the public campgrounds. The summer months are crowded and your stay may have to be limited to a few days because of on-coming travelers. That is why off-season vacations have a definite advantage; you can extend your visit when the appeal of the mighty Canyon calls to you.

To portray better the many other facilities found at the South Rim you must realize that in many ways the Grand Canyon is unique among National Parks since there is a permanent

population of about 1,000 persons in the Village and during the summer months this is almost doubled. Thus many services and conveniences of a modern community are offered.

Besides the expected services of telephone, telegraph, laundry, souvenirs and information, the Village has a well-stocked general store operated by Babbitt Brothers Trading company with a large grocery section, fresh produce and meats, clothing, hardware and other travelers' needs in addition to a soda fountain and drug department. The garage offers storage and repair facilities, a nearby service station provides all car necessities. An excellent, well-staffed hospital under the direction of an able physician serves the community the year round, and is set up for any emergency. The Grand Canyon Community church, a vital part of the Village, holds its Sunday school classes at 9:30 a.m. and worship services at 10:30 a.m. and 8 p.m. During the summer sunrise services are held at the "Shrine of the Ages" on the Rim.

National organizations are well represented including Rotary International, which meets each Friday noon at El Tovar hotel; American Legion post and auxiliary; Masonic Lodge; PTA; Business and Professional Women's club; Boy and Girl Scouts; and the National Federation of Federal Employees. All of these activities create a steadfastness and community spirit so readily felt if one remains in this setting for long.

———

WITH SO MUCH AWAITING you at the Grand Canyon, you now ask, "How do I get to the South Rim?" By automobile over modern highways from any point in the country; by the Santa Fe railway which operates daily trains to the Rim; by motor bus service, or by airplane with Frontier Airlines landing its planes at the Flagstaff airport, carrying passengers from transcontinental lines at Phoenix, and by connecting bus to the Canyon.

From U.S. Highway 66, the main east and west route through Northern Arizona, motorists drive to the South Rim over State Highway 64 from the junction between Williams and Flagstaff, or you can take U.S. 89 north from Flagstaff to Cameron which then connects with the rim road. All of these routes are kept open throughout the year.

The branch line of the Santa Fe to the South Rim junctions at Williams with certain mainline trains carrying through Pullmans which are taken directly to the Canyon. An estimate of the travel costs by railroad can be computed from a few starting points in the United States, either directly by Santa Fe or connections with other railroad lines. From Minneapolis, a first class round-trip ticket would be $105.35; from New York, $178.12; San Francisco, $54.80; and New Orleans, $99.60. The charge for berths is additional and coach travel of course less.

The Pacific Greyhound Lines and Continental Bus System both operate busses to Williams

and Flagstaff where connections are made with the Fred Harvey line to the Canyon from Williams and the Navahopi Tours operating between Flagstaff and the South Rim. Private plane owners may land at the Grand Canyon Airlines airport located 18 miles from the South Rim or at Valle Airport. Over Canyon flights are available in summer, where services are maintained. A new airport near the park entrance is contemplated.

The means of transportation are excellent and varied, offering convenient ways by which you can reach the South Rim of this scenic wonderland where so much awaits your arrival. However there is no direct bus route between the South and North Rims.

NORTH RIM

On the North Rim one experiences a closeness to the Canyon that does not exist elsewhere. Approximately 1,200 feet higher than the South Rim, it permits visitors to look down upon the vast temples which form the background for the panorama from the South. The approach to this inspiring view is through one of America's most beautiful forests, the Kaibab, with its dense virgin stands of pine, fir, spruce and quaking aspen. Secluded Alpine meadows add lure to the trip and the abundance of wildlife enchants young and old.

Because of heavy winter snows, visitors may come to the North Rim only between May 15th and October 15th. Accommodations at Grand Canyon Lodge and the full facilities of the area are available from June 18th to September 10th, but the cafeteria and sleeping cabins are available throughout the whole North Rim season. Spring flowers are in abundance here during that season and early fall is outstandingly beautiful. To see an Alpine fall as well as the Grand Canyon is worth the adventure of late season travel.

Visitors to the North Rim are welcomed of course by the ever-congenial National Park Service and a wide program of activities is made available so their stay will be enjoyable and impressive. Like the Santa Fe-Fred Harvey operations on the South Rim, the combined talents of the Union Pacific Railroad and the Utah Parks Company form the integrated service unit which supplies transportation, lodging, eating and other necessary facilities.

The shorter season permits some highly interesting activities not included in the year-round schedule at the South Rim. Many of the unique features center on the young college students who are employed by the Utah Parks Company to do most of the work around the Lodge and Auto Camp. In selecting these young men and women their individual talents for entertainment are taken into account, resulting in not only a proficient group of workers but an excellent combination of dramatic, vocal and instrumental young artists.

This leads to two features enjoyed wholeheartedly by everyone. One is the program the young

people present in the evenings in the recreation hall of the Lodge following the nature talk. The other is the "singing away of the busses" each day. As the departing guests are ready to leave the young men and women forsake their various duties to gather in front of the Lodge and sing an unforgettable farewell. Both of these events are indicative of the warm friendliness that prevails throughout the season.

Although the Park Service has not established museums on the North Rim, its efficient corp of naturalists and rangers so expertly explain the geological and natural splendor of the area that each visitor gains a well-rounded knowledge of the Canyon. One of the most interesting features of the entire park program is the nature walk, a definite must at the North Rim.

Each morning, leaving at 9 o'clock from the Lodge, a naturalist conducts a tour along one of the trails to Bright Angel Point or Transept Canyon, interspersing his talk on the history of the area with a humanized discussion of the plant and animal life found along the way. The walk is not strenuous but is sufficiently long to permit each person to form an individual appreciation of the greatness. The Campfire talks, presented each evening except Sunday at the public campgrounds, are always informative interpretations. The nature talk in the Lodge recreation hall is an additional feature, followed by the employees' clever program and informal dancing.

The North Rim with its dense forested beauty and spectacular Canyon trails offers a wonderland to hikers and campers, to the thousands who take the mule trips and to horseback riders. The same precautionary measures as to clothing and health to assure pleasant trips are urged for all who enter into these activities. The footpaths along the rim are always inviting to visitors and here one's own energy and interest will determine how far you will wander afield.

———

KAIBAB TRAIL, the excellent rim-to-rim trail, is an exciting route for the mule trips and hikers. In places the trail is cut into the sheer redwall limestone creating a series of half-tunnels, and the entire trip to Roaring Springs, location of Cottonwood station, or on to Ribbon Falls or Phantom Ranch is a constant delight as new vistas of the Canyon are revealed.

The trail mules, under the management of affable Jack Church, offer the most memorable means of transportation. The round trip to Roaring Springs is $12 and the two-day Phantom Ranch journey with an overnight stay at that picturesque setting is $35. Arrangements can be made for special trips to Clear Creek for unexcelled fishing and camping, or the spectacular trek the length of Kaibab Trail to the opposite rim can be made from either rim for a charge of $96.25 round trip.

Saddle horses for rides through Kaibab forest and along the rim are available with a compe-

tent guide conducting the parties to the most scenic points. A full day's trip is $7.50, half day $5.

From the panoramic view at Cape Royal, reached by car or the motor busses, there is another excellent trail to a spring and restful picnic area. The motor bus trip to Cape Royal and Point Imperial, which is the highest point along the Canyon's rim with an elevation of 8,801 feet, is a welcome convenience offering an inspiring three-hour tour at $3 per person.

At Cape Royal, which juts far out into the gorge, one gains a sweeping view in all directions with the distant desert and South Rim panoramas contrasting with the near-at-hand study of formations like Wotan's Throne. Farview and Vista Encantadora are other scenic points on this eastward road.

One of the most beautiful drives in the entire Canyon area is to Point Sublime, and journeys also can be arranged to remote hunting camps such as Big Saddle and Pine Valley in the Kaibab National Forest. Undoubtedly the most astounding trip from either rim is to Thunder river, 30 miles by automobile from the Lodge to Little Saddle, then by trail for 14 miles of spectacular vistas to where a tremendous spring erupts from the redwall limestone. Horses may be rented for the trail trip either before or after the hunting season, but this journey is for the hardy only. No hunting is allowed in a National Park.

Those who want to find restful retreats and unsurpassed nature will welcome the old fire roads through the forest. Motorists travel at their own risk although the Forest Service has kept the roads in fair condition. Information available from the rangers will make these side excursions outstanding for they will bring you in close contact with the abundance of animal and bird life found here as nowhere else. There are the rare Kaibab squirrels, which unfortunately delight in sitting in the middle of roads and too often pay the extreme penalty when motorists do not avoid hitting them; the bandtail pigeons and dusky grouse; the graceful deer; and many others to intrigue you.

THE ANSWER TO "What accommodations will I find?" brings information of the very best in hotel, auto camp and campground facilities. Grand Canyon Lodge, majestically perched on Bright Angel Point, is the perfect work of man in combining the grandeur of rocks and beauty of the forest into a series of structures that harmoniously blend into the Canyon surroundings.

Commanding a superb scenic view, the Lodge is built on the very rim so that one can look through its huge windows directly down into the colorful depths. This is a strangely-moving experience, standing under a man-made roof with the full glory of nature so close at hand. During the dinner hour a concert of organ music lends enchantment to the setting.

At the Lodge are found the dining room, lounge, recreation room, curio shop, postoffice and other services the traveling world needs. Grouped under the pines around it are the sleeping cabins, also built of rustic stone and logs, offering accommodations from $2.50 to $9 per day depending on your selection. The dining room serves outstanding food with table d'hote meals at $1.50 for breakfast, $1.75 for lunch, $3 for dinner and a special steak dinner for $4. The meals, but not lodging, are half price for children under eight years.

The highly popular auto camp and cafeteria, located one mile north of the Lodge, have fine accommodations for travelers. Standard sleeping cabins with two double beds and running cold water are $4 for two or $5 for four. A limited number have been set up for housekeeping but you must provide your own cooking utensils and dishes.

Meals are served at the cafeteria in the main building with the special combination club menus offering tempting food for the vacation appetite that is sure to be stimulated by the clear air and activity. Breakfast is served from 70 cents to $1.25, lunch $1 to $1.50 and dinner $1.50 to $2, with half prices for children under eight years. In the cafeteria building are also found a curio shop and general store with limited supplies for the camper's needs.

Aside from these services maintained by the Utah Parks Company there are two public campgrounds established by the National Park Service at Bright Angel Point and Neil Springs. The settings are perfect for a relaxed and comfortable stay and the facilities well supervised. Many visitors to the North Rim also enjoy the tranquil surroundings at Kaibab Lodge, located on VT Meadow just five miles from the Park entrance. Some of the first accommodations for travelers to the Grand Canyon were established here 29 years ago, and the Lodge continues to offer accommodations from May 15th until after the fall hunting season. There are also splendid accommodations at Jacob Lake, operated by the Bowman family.

All of the essential services that one would expect to find are well established — postal, telephone, telegraph, barbershop, beauty shop, and laundry. The health of visitors is guarded by a registered nurse on duty at the Lodge throughout the season. A modern service station is located near the cafeteria and any necessary car repairs or towing may be obtained from the Utah Parks Company garage. There are washing machines and irons to be rented as a further convenience to vacationers.

Church services are held each Sunday morning at Grand Canyon Lodge. The Catholic service is at 6:45 a.m. and the Protestant worship, conducted by employees, is at 10 o'clock with visiting clergymen of any denomination invited to participate.

Well-stocked photographic supplies are provided at the Lodge and auto camp so no one need "miss a shot," and since the forest country and abundant wildlife are additional attrac-

tions besides the Canyon's grandeur, these are always busy counters. The beauty and exquisite workmanship of Indian jewelry, rugs, baskets and pottery are also found in fine displays at the curio shops along with souvenirs, postcards and other necessities.

Combined with all of the excellent accommodations, activities and services at the North Rim is a wide variance of transportation methods by which you reach the Grand Canyon — each is an ideal answer to your question, "How do I get there?" U.S. Highway 89, that scenic route from Mexico to Canada, brings you to Jacob Lake and the junction with State Highway 67 for the 43 mile trip to the Rim. Because of heavy snowfall, this approach road is closed from October 15th to May 15th. Whether you are driving from the north or the south, U.S. 89 will bring you through spectacular country to the Canyon area.

The Union Pacific railroad offers fine transportation, including many tours. Its terminus for Canyon travel is Cedar City, Utah, where travelers are met by Utah Parks Company busses for the drive to the Rim. One of the outstanding advantages of this method of travel is that you may conveniently include visits to Bryce Canyon and Zion National Parks and Cedar Breaks National Monument along with your vacation plans at the Grand Canyon.

Your round-trip rail fare over the UP and connecting railroads from Boston, for instance, would be $187.61 first class or $137.43 coach; from St. Louis, $98 and $75.60; from Seattle, $78.45 and $60.55; and from Atlanta, Ga., $135.70 and $104.10. These rates do not include federal tax and costs for berths would be additional.

One of the most popular tours offered by the railroad and Utah Parks Company from the terminus at Cedar City to the North Rim is all inclusive for $43.25, which takes you by way of Zion National Park to the Rim and the return trip is via Cedar Breaks National Monument. This includes all meals and overnight lodging, but you may easily extend your stay at the North Rim for only $8.25 American Plan per day with standard cabin accommodations. This arrangement is ideal for those who do not plan a motoring vacation and is a happy combination of both train and bus travel to take advantage of the full spectacle of scenic attractions in the area.

Cross-country bus lines make convenient connections too. At Cedar City the Burlington Transportation company and Interstate Transit Lines operating between Salt Lake City and Los Angeles are scheduled to meet the Utah Parks Company busses, and Jacob Lake is a scheduled stop for the Continental System with transportation then available to the Rim. For the airplane traveler one may take Western Air Lines to Cedar City and thence by motor coach, or come by Frontier Airlines to Flagstaff, where daily bus service is available via Continental Bus northward. No method of bringing visitors to the North Rim has been neglected and all offer expedient accommodations to assure pleasant vacations.

BESIDES THE SPLENDOR of both the North and South Rims of the Grand Canyon, which will hold you spellbound and inspired, there are other outstanding scenic attractions within easy driving reach of both rims that will heighten your appreciation of the great Southwest. Already mentioned are Zion and Bryce National Parks from the North Rim and Havasupai Canyon from the South Rim.

Your own motor trips or conducted tours into the Navajo and Hopi Indian reservations will take you into the spectacular Painted Desert and high mesa country where these important Arizona tribes reside. Sunset Crater is not far away and you can have the experience of seeing dinosaur tracks found in the desert. But it is the strength of the Grand Canyon that will draw you to Northern Arizona with an appeal irresistible and unsatisfied until you have stood upon one or both of its Rims. It offers a soul-inspiring vacation that will instill poignant memories for years to come. Van Dyke described the Canyon's mystic appeal when he wrote that "wrapped in her purple mists and under her blue immensity of sky she should rest forever aloof and inviolate. The mystery that surrounds her should remain a mystery." Yes, this it is, but somehow you, as you sit and look and listen, become a part of the vast mystery and are wafted away into a land of serene beauty and unconquerable quest. Many hours you will so spend with the Grand Canyon if you woo her company and welcome her pleasant spell. ᴀʜ

FEBRUARY 1955

NATURAL BRIDGE DISCOVERY IN GRAND CANYON

BY BARRY GOLDWATER

It was on the morning that Rainbow Lodge burned four years ago that this bridge became such a part of my life as to be almost an obsession. Bill Wilson telephoned me before sunrise that morning and told me of our disastrous loss, and I immediately made plans to fly to Navajo Mountain to see what could be salvaged. Charles Ray, a close friend of mine from Indiana, went along with me; and, inasmuch as Charlie had never seen the Grand Canyon, I flew over the eastern end of it, going over the Canyon from the Indian Watch Tower, up toward Saddle Mountain at the south end of House Rock Valley.

As we cruised along, I happened to look down to my left and there was the shadow of what appeared to be a bridge. I was quite startled, because I had never heard of a bridge of this seeming magnitude being located in this particular part of the Canyon. So I circled at great length and Charlie and I both verified the fact that the sun's rays going through an opening in the cliff indicated the existence of a bridge.

We then turned the airplane to the east and landed at our strip at Navajo Mountain, went over the damage caused by the fire, and then, in late afternoon, headed back toward Phoenix. I wanted to be sure of this bridge, so we flew over the place where we had sighted it, but in the afternoon it was undistinguishable and I began to wonder whether what we had seen was really a bridge or just an optical illusion.

The next time I happened to pass over that portion of the Canyon was about a year later when another friend, Bert Holloway, and I were travelling by air to some mineral properties in Utah. We covered the same route at about the same time in the morning and again the bridge was discernible. On returning in the afternoon, however, it was lost to our view; and my curiosity was nearly at the breaking point, so certain was I that what I had seen on two occasions previously was not entirely a figment of my imagination.

In 1952, when the plaque at Marble Canyon was dedicated to Doris and Norman Nevills, I asked Ben Avery of the *Arizona Republic* to fly up with me, and I told him that on the way I was going to fly over what I thought was a natural bridge in order to get his opinion of what it actually was. So, when we approached the location, sure enough, there was the shadow of the bridge on the red wall of the Canyon and, as we circled it, Ben remarked that it certainly looked like a bridge to him. Naturally, this statement relieved me of the thought that maybe I had been seeing things for these several years. We landed at Marble Canyon and told an embarking Colorado River trip of the existence of this bridge and gave them what we thought were adequate instructions to find it. This party explored both Little Nankoweap and Big Nankoweap canyons for this bridge, but my instructions were apparently not sufficient, for they failed to find it.

I planned, then, to make a river trip myself in 1953, to discover and photograph this bridge, but because of the press of the Congressional Session in Washington, I was not able to make it that year. Another long session occurred in 1954, so it became necessary to give up previous arrangements for a boat trip from Lee's Ferry to Phantom Ranch.

———

DURING THE CHRISTMAS HOLIDAYS in 1953, I had made adequate aerial reconnaissance of the entire area and had actually gotten a photograph of the bridge from the air, so was certain what I was looking for was not an hallucination but an actual bridge. Subsequent discussions with the Department of the Interior, with Louis Shellback, Park Naturalist of the Grand Canyon, and others interested in the geography and history of the Canyon, had led me to believe that this was an undiscovered bridge.

This only added to my determination to visit this spot high up in the gorge of Nankoweap Canyon, so I decided this fall that the only chance I had of reaching it was either by walking down the old Nankoweap Trail or by landing in the bottom of Nankoweap Canyon in a helicopter. I discussed the possibility of the trail trip with the Park Rangers and with two young men who are exploring caves in Little Nankoweap Canyon for the Museum of Northern Arizona. From their description of this trail, which has long been out of use, I decided that this approach

A previously undocumented rock formation stands below the Canyon's North Rim in the 1950s. Today, the formation's official name is Kolb Arch, in honor of the pioneering Canyon photographers. | BARRY GOLDWATER

would not be practical because of the time involved in traversing this almost obsolete trail.

Since the helicopter was the only means left to me, I contacted Bob Gilbreath of Arizona Heli Dusters and made arrangements with him to haul one of his helicopters to Cameron on Saturday night, the 29th of October, from which point we would depart for a trip into Nankoweap the following morning.

Bob and I had previously surveyed the route by airplane and decided that it was entirely feasible to land the helicopter in the bottom of Nankoweap, there being a difference of only 2,700 feet from the East Rim to the point in the Canyon where a desirable helicopter landing area

showed itself. The East Rim of the Canyon is fairly constant in its elevation and Nankoweap Canyon itself is very wide and quite long, making it possible to descend easily and, more important, making it possible for a gradual ascent to clear the east wall of the Canyon on the way out.

I flew to Cameron Saturday night from Yuma, and spent the night with my friends, the Richardsons, eagerly awaiting departure at sunrise the next morning. We were up at 6:00 and hauled the helicopter over to the landing strip on the northeast side of the Little Colorado River. There, we took it from its trailer and started it up, and it wasn't long until we were airborne in the direction of Point Imperial on the North Rim of the Canyon. This was not only an excellent landmark, but it is also the point under which the bridge is located, so we had a navigational point for flying purposes and an exploring point for the object of our trip.

We flew at about 300 feet over the terrain, crossing the tremendously deep gorge of the Little Colorado just east of the Lookout Tower. Because of its narrowness and sheer depth, this Canyon is as spectacular to me as the main Canyon, and viewed from above its depth is greatly accentuated.

We flew directly over the Blue Springs in the Little Colorado, from which pour great quantities of the sky-blue waters which mark the Little Colorado during the periods of the year when the upper sources of the river are not productive. It was a beautiful, clear morning with the sun rising slowly in the east, lighting up the North Rim of the Canyon and the long, gentle slopes of the Kaibab Plateau.

Toward the north we could see the low, red range of Echo Cliffs as they turn eastward to meet the Colorado where it comes out of Glen Canyon. Then, coming down on the other side of Marble Canyon were the great Vermilion Cliffs as they stood majestically in the morning sun, turning themselves up into Utah to help form House Rock Valley which runs to the south down to Saddle Mountain, the southern end of that valley, and also the northern rim of the eastern end of the Canyon.

The great height of Hayden Butte came into sight almost as soon as we gained altitude, and when we crossed the junction of the Little Colorado and the Big Colorado, many of the prominent points such as Duppa Butte, Swilling Butte, Ehrenberg Point, Nankoweap Butte, and Saddle Mountain came into view.

We flew between Nankoweap Butte and Nankoweap Mesa directly over Kwagant Canyon into the rather wide valley of Big Nankoweap. The point of landing that we had selected previously proved to be an excellent one and Bob expertly lowered the helicopter onto this little, flat spot on the south side of Nankoweap Creek.

Barry Goldwater's fascination with natural arches and bridges wasn't limited to the Grand Canyon. This one, on the Navajo Nation, he named Margaret Arch in his wife's honor. | BARRY GOLDWATER

NANKOWEAP IS A PAH-UTE WORD — singing or echo canyon — because of the deep echoes in the Canyon where it joins the River. We arrived there about 8:00 o'clock, or just about a half hour after taking off from Cameron, and we immediately started a seven-mile walk from the river itself to the point where the bridge is located. From the spot where we settled our helicopter, however, I estimated it to be a three-mile walk. In Nankoweap Creek we found water, which was more than welcome since we were equipped only with small Army canteens and had depended on finding water either in the streams or in the springs.

Approximately three-quarters of a mile up the Canyon from our point of landing the Canyon forked, one branch going to the southwest toward Kibby Butte and the other continuing up the main Canyon between Bourke Point and Mount Hayden. This pinnacle is the main guidepost for those people seeking this bridge, and as one approaches this area, either as we did by helicopter or by walking up from the mouth of Nankoweap Canyon itself, one must keep this high rock in sight and keep it on the left.

Bourke Point is the extension of a long, slender mesa that starts at Woosley Point and runs for approximately a mile and a half or two miles to the east from the North Rim. By climbing up the small embankment to the right of the creek (Nankoweap bears to the right), one is able to see the natural bridge in the distance in the morning light.

It is important to remember this because it is the thing that had me fooled when I flew over it. The light has to be coming from the east in early morning in order that this bridge may be seen from any distance at all, and it is impossible to see it from directly overhead unless the light is from that direction. Once the sun has passed the peak of noon, the shadows completely hide the bridge and it is impossible to distinguish it from its neighboring cliffs. My photographs were made, of necessity, after noon, so they do not contain the contrast that pictures taken in the morning would have.

I had made what I thought was a thorough reconnaissance of the Canyon to determine whether or not ropes would be needed in climbing it; and, from as careful observation as is possible from the air, it appeared that there was nothing standing in our way of an easy approach to the bridge. The early part of our trek bore this out and I kept thinking that it was "too good to be true." Going over these river boulders is comparatively easy walking with just a little bit of climbing. Our good luck did not hold out, however.

To the northeast of Mount Hayden — in fact, almost directly under the giant pinnacle of stone — we came to a waterfall in the canyon in which we were walking. It was impossible for us to climb up this sheer face because we did not have rope with us and I was afraid that the

moss that covers the face of that fall would prove too slippery for safe ascent.

I am not certain that this particular place cannot be climbed by the use of proper equipment. Consequently, while I would hesitate to try it myself, inasmuch as I am not acquainted with the procedures used in this method of climbing, I would not recommend against it by experienced people. This unforeseen obstacle necessitated our walking back approximately a half mile to a place where we could climb the rock wall on our right via a landslide that had come down from the talus slopes above. This was most difficult climbing through scrub trees and brush and, at one place, it required a sheer climb over a series of rocks edging the Canyon.

Once on top of this ledge, we proceeded in a direction that would return us to the stream about where we encountered the waterfall. The contour map showed that the stream continued above that point and that there were no other possibilities of precipitous climbs. It took us approximately two hours to work our way through the manzanita brush to a point where we discovered deer trails which could lead to only one thing — water. So we followed the footsteps of our antlered brothers to the stream bed below.

Returning approximately 200 yards upstream from the sheer waterfall that we had encountered we continued our climb up the bottom of the creek. From this point the climb is very steep and the rocks are bigger, making climbing more difficult but certainly not impossible. From this point to the bridge is approximately one-half to three-quarters of a mile and, as tired as we were, we were able to make this distance in one hour's time.

IF I DO THIS AGAIN, I will arrange things differently in order to avoid that most difficult climb up the right side of the canyon and the hard walk over the ledge. I think that the wash that comes in from the left or south side at the waterfall could be scaled; and, upon reaching the first ledge, it would be only a matter of several hundred yards around to where, again, one could enter the bottom of the Canyon and proceed to the bridge. If that failed, I am sure that the proper use of rope and roping equipment could get one up the series of waterfalls, which are, in effect, pot holes after the first climb has been made.

The reader's attention should be called to the danger of these pot holes in these canyons because it is very easy to start into them and then find it impossible to get out, either up or down, so it is best to proceed with caution even though it might entail extra hours of work. However, I am sure that subsequent parties will find an easy way to get around this fall and so make the trip to the bridge a relatively simple one.

Pressing on, we came finally to a full and complete view of this spectacular bridge that I had

first seen from the air some four years ago. By then I was exhausted and every muscle in my body ached, but a great peace and calmness came over me as I realized that here at the end of this arduous trail was that which I had been seeking.

I sat there and wondered if any other white man had ever looked upon this thing from such a close vantage point. I suspected that Indians in the past had travelled up here because we found pottery down below and because we know that Indians at one time lived at the mouth of Nankoweap. None of the usual evidence of man's visits, however — tin cans, empty cartons, and the like — disturbed the cool calmness of this bit of God's handiwork.

The bridge is in the limestone and is, I would say, 200 feet high and about the same dimension in width. Picture, if you can, a gigantic limestone stage with this bridge forming the valance or top front of the stage. Hundreds of feet above it is the start of a waterfall that must be spectacular when the winter snows are melting and water comes over the redness of that sheer rock. This water would fall behind this bridge and I imagine fill it with spray as it gushed out to fill the dry stream bed in which we were standing.

We took pictures to our heart's content and then, realizing that time was short and that we would have to get back to the helicopter in time to get out of the canyon by dark, we immediately began our backward trek. Our first glimpse of the bridge was at 1:30 and at 1:45 we started back down. We did not carry altimeters on this hike, but by a study of the contour map of the east half of the Grand Canyon it can be ascertained that the climb from our helicopter to the bridge involved approximately 2,000 vertical feet. Imperial Point, under which this bridge is located, is the highest point along both rims of the Canyon, with an elevation of 8,800 feet, so the bridge is about 1,800 to 2,000 feet under this point.

On reaching the top of the fall on our return trip, we walked to the left or north side of the canyon and kept lower than on our hike up, maintaining a position just along the top of the first ledge. We were making excellent time and feeling quite good about it when we discovered that we had gone past the point where we had climbed to this ledge.

I had been expecting to run across our trail so wasn't too much concerned about it; but, after having walked what we knew to be some distance past the spot where we came up, we reconnoitered from the edge of the cliff and found a slope that had trees from the edge to the bottom, which meant, of course, that there was a dirt slide by which we could go down. This was not the exact place where we came up, but it made an easy downhill trip, as it was at about a 45-degree angle and of soft dirt. Although we fell down three or four times, we weren't worried because there were plenty of trees and brush to prevent any descent more rapid than would be comfortable.

Once we reached the bottom of the canyon it was not difficult at all to retrace our steps to the point where we had left the helicopter. We reached it about 5:30 in the afternoon, filled it with gas from a reserve tank, and, after a short warmup, took off to climb out over the east rim of the Canyon. The helicopter performed so beautifully that it required only one 360-degree turn to get our altitude and it was only a matter of minutes until we were directly over the Colorado, then out over the great plateau that stretches from there to Highway 89 and Echo Cliff.

The sun went down, however, shortly after we climbed out and the major portion of our return trip to Cameron was made at night. Cameron, with the large neon sign on top of its hotel, was an easy landmark in the dark; and, coming up to it, I told Bob to watch for a white dirt road that turned off from the black asphalt road, and to follow that until he saw the glimmer of the tin hangar. We ended our day's journey at about 7:00, following nearly an hour's flight from the bottom of the canyon to Cameron.

THE NEXT TIME I take this trip, I will go by boat to the mouth of Nankoweap. I plan to do it in three days, by carrying bed rolls and supplies up to the bridge, establishing a base camp there, and then working the bridge early the next morning to get the best photographs, returning to camp that evening, and back to the river and the boats the next day. This is the most spectacular part of the Grand Canyon and I imagine that, in the future, many boat parties will visit Nankoweap Canyon and the bridge. A study of the map will show many interesting side canyons that can be visited from Nankoweap and I am sure that many delightful surprises lie undiscovered in them.

I am going to suggest to the Department of the Interior that this bridge be named Kolb after the famous Kolb brothers, Ellsworth and Emery, who have travelled over this canyon so much by foot and down its waters so successfully by boat, and who have contributed enormously to the knowledge and lore of the Grand Canyon.

Here, then, ends another interesting chapter in the many which I find in the book of my life in my native State of Arizona. It is a land of never-ending wonder and beauty — a land of both age and youth, of antiquity and newness. There must be many places here still unexplored by man, such as that cool, quiet place high up in a side canyon of Nankoweap, where Bob and I sat in peace and saw the bridge for the first time. More of us should seek the hallowed, untainted grandeur which God has tucked away beyond the sunswept highways of our bountiful State. AH

MAY 1957

PHANTOM RANCH

BY CHARLES FRANKLIN PARKER AND JEANNE S. HUMBURG

Deep within the purple shadows of the world's greatest canyon lies a tiny oasis — a mere splash of green glimpsed from a single spot on the South Rim of the Grand Canyon of Arizona. Miles by trail away and fully one mile below into the mighty depths, the cottonwood grove seems infinitesimal and remote. Yet it enfolds its verdant bounds a paradise — an enchanted spot of sunshine and towering trees, a rushing mountain stream, a herd of deer — each inspiring a tranquility awesome as the heights of the jagged canyon walls rising high above. This is Phantom Ranch.

It's a world in its own, far removed from the turmoil of our modern age, surrounded by a wild palette of vivid colors and among the most spectacular rock creations that nature has carved upon this earth. It is nature at her greatest and yet, too, at her weirdest, for the sheer existence of this green oasis within the very depths of the canyon is phantom in human understanding.

Science can explain the formation of this huge phenomenon of canyon within canyon, gorge within gorge, lofty cliffs of brilliant rock and dark shadows. But it is purely with the heart and soul, given time to absorb the vastness and splendor, that the canyon becomes comprehensible, and the reality of the cottonwood grove understood.

What each person feels and sees depends on his temperament and artistic eye, but no where else has nature offered such an incontestable variance as she does to those who travel the trails

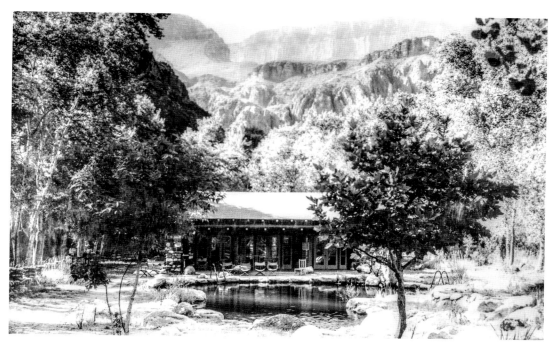

Phantom Ranch's swimming pool and recreation building are pictured in a George Alexander Grant photo from the 1930s or '40s. | COURTESY OF GRAND CANYON NATIONAL PARK MUSEUM COLLECTION

to Phantom Ranch. In reaching this haven, the full splendor of Grand Canyon is revealed, in timeless miles of towering walls, rushing water in river and stream, dazzling sunshine and labyrinthine shadow, vivid color and arid somberness. Most important, there is the element of leisure and peace as the panorama unfolds, the same pace that opened up this wonderland to the pioneers of old. For you either walk or ride a mule down the trails, there's no other way to reach Phantom.

BEFORE YOU CAN WALK IN under the lofty cottonwood trees that shelter the cabins and lodge of the ranch, the mighty canyon demands that you experience the full magnitude of her strength. There are no short cuts to reach this oasis, no quick methods to rush in and out and say you

have been there. For in spite of one motorist who wired the El Tovar Hotel that he was arriving on a certain date to drive to Phantom Ranch, this is not a place touched by the modern wheels of civilization. It can only be reached by legs — either yours or a mule's.

Undoubtedly this is why the ranch seems so mysterious. It is well named Phantom, existing but unseen by most who pass along the canyon rim. From the shadow of its giant trees it gives shade and comfort to the weary summer traveler who descends the trails along the hot canyon walls. For the winter adventurer it offers warmth and shelter from the raw, bitter wind that whips through the gorge. And for the most fortunate of all who can pick either the spring or the fall for a vacation, the cottonwood grove spreads wide its arms in a rush of fresh color or rich autumn hues.

Only two trails will bring you to the ranch. Kaibab Trail traverses the canyon from rim to rim and crosses the Colorado River over a high suspended bridge just a short distance from Bright Angel Creek where the ranch is located. North Rim visitors use this trail to descend into the canyon, to Ribbon Falls and on to the ranch. Traditionally, the South Rim mule parties leave by Bright Angel Trail, the best known in any national park. From Indian Springs, far down this trail, the ranch riders or hikers travel on to the banks of the roaring river, then follow the curves of the inner gorge to meet Kaibab trail by the suspended bridge.

For both riders and hikers the approach to this span over the river is sensational. A black tunnel, cut through one hundred five feet of solid granite, leads directly onto the bridge, four hundred and forty feet of steel suspended sixty-five feet above the current, its network of cables and bars forming a lacy pathway to the opposite side. The feeling of height is acute looking down upon the brown churning water, the narrowed channel sending up a thunder of power.

But for the riders there is suddenly a new awareness of sound. It's the tread of the mules with a rhythmic sharpness, the clear staccato cadence of *On the Trail* from Ferde Grofe's *Grand Canyon Suite*. Always before the hoofbeats had been muffled by sand upon the trails, by the wind and the river, but here, on the asphalt-surfaced bridge high above the current that carved the canyon, the air reverberated with the musical beat.

BY WHICHEVER TRAIL or mode of travel, hiking or riding, you have time to absorb the canyon's greatness before the charm of Phantom Ranch is opened to you. The warmth of friendliness and comfort of every convenience are found here, plus delicious ranch meals. By the small corral where the riders dismount, the sign on an arch means what it says — Phantom Ranch Welcomes You. The swimming pool behind the nearby recreation room is a blessed sight to the

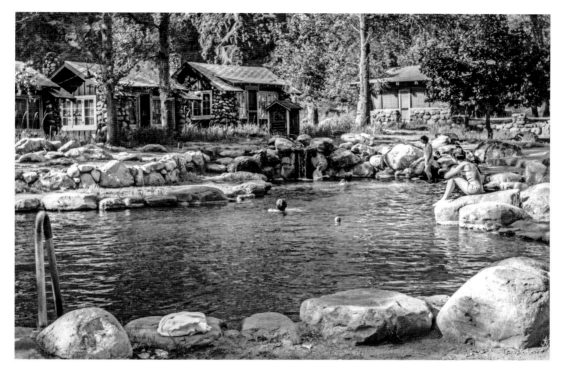

Phantom Ranch visitors swim at the facility's pool in the early 1960s. In the background are several of the ranch's guest cabins. | COURTESY OF GRAND CANYON NATIONAL PARK MUSEUM COLLECTION

hot summer guests who have dreamed about shade and cool water during the noontime hours.

Facing a wide parkway of grass, crossed by many small ditches of water that feed the cottonwood trees, are the cabins, modern in rustic garb. The lodge, with its huge dining room and ranch kitchen, is at the end of the parkway and welcomes a rush of hungry guests each time the call to meals is sounded. Behind one row of cabins flows Bright Angel Creek, a sparkling mountain stream that sings and echoes through the ranch and gives gay promise of the trout that are there for an eager fisherman.

The beauty and tranquility of this cottonwood grove have attracted visitors for many years. As early as 1903 Dave Rust of Kanab, Utah, established a tent camp there, the first to provide a stopping place for guests within the canyon's depths. President Theodore Roosevelt came in

Guests relax at the pool in the mid-1950s. The pool was removed in the early 1970s. | COURTESY OF GRAND CANYON NATIONAL PARK MUSEUM COLLECTION

1913, and for sometime afterwards the location was known as Camp Roosevelt. In the early days a suspended bridge, swaying alarmingly in the wind, spanned the Colorado river where the rigid bridge now stands, and pioneer travelers braved the narrow pathways to cross the canyon from rim to rim before the modern Kaibab trail was built.

Then Rust's camp was forgotten for a time, until 1921 when the Santa Fe-Fred Harvey interests took over the scenic spot and built Phantom Ranch, named for the mystery that surrounded a nearby side canyon the early Indians thought bewitched. The present development was urged by Mary Jane Colter, long associated with the tourist growth at the canyon in her role as interior decorator. Native rock was used in the structures, blending them into the can-

Old wagon wheels punctuate a view of the Phantom Ranch swimming pool in a Josef Muench photograph from the 1950s. | NORTHERN ARIZONA UNIVERSITY CLINE LIBRARY

but still high above, its terraced wall a study in color. The trail tops out at Yaki Point and the canyon's depths have been left behind.

But one spot far back on the trail will be remembered with poignant clarity and a wistful smile. Panoramic View, with its breathless sweep of the canyon country — the deep purples of the inner gorge and North Rim's rugged outline, long will be recalled. Far below the river is a mere thread. Beyond it is the cottonwood grove. This is the final nostalgic glimpse of Phantom Ranch. 🏛

JUNE 1960

WE GO HIKING IN GRAND CANYON

BY JOYCE ROCKWOOD MUENCH

Those who know the Grand Canyon best will admit frankly that the hardest part of sight-seeing there is to really SEE what you're looking at. When an elevator zooms you to the top of the world's tallest building to look down onto New York's traffic, you have several ways of gauging its 1,250-foot height. Those scurrying ants down there are people and the many little beetles — cars, 102 stories below.

The rims of the world's largest canyon are approached from a level plateau. Suddenly your eyes are confronted by a gash that drops a vertical mile. Four Empire State Buildings, one on top of the other, would still be about a full-sized football field length short of your vantage point. The brown angleworm, seen in sections, squirming through the bottom, is a 300-foot wide river. The Statue of Liberty, laid on its side, pedestal and all, would just about span it. With telescope you can make out a spiderweb thin line of the Kaibab Suspension Bridge that does cross it.

Instead of measurable "stories," you are looking down millions of years of earth structure. It's very difficult to grasp. Eyes are just not enough to really appreciate the Grand Canyon.

So I say, the easiest way to really SEE the Grand Canyon is to go down into it, from rim to river and then back up the other side. Any able-bodied person of almost any age can do it. He'll return with new dimensions of beauty, size and grandeur written indelibly into muscle and fibre — acquired not alone by his eyes but with all five of his senses — plus, for this is a soul-satisfying experience that will never be forgotten.

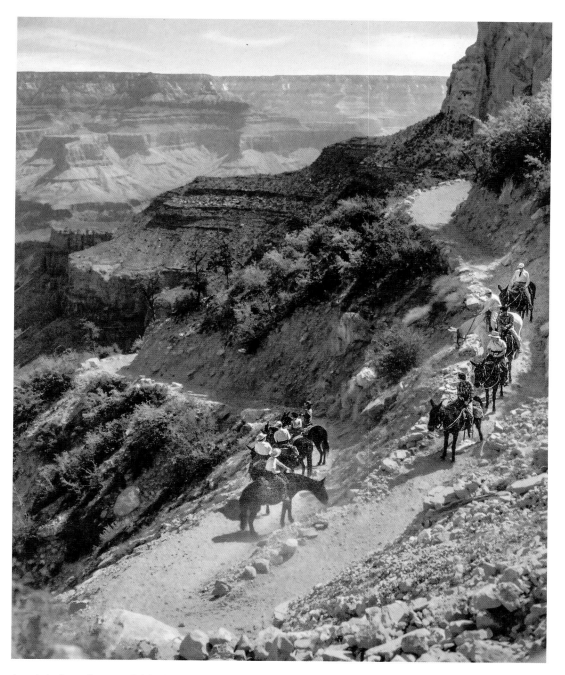

A mule train navigates a Bright Angel Trail switchback below the South Rim. "Fred Harvey's mule-train excursion into the Canyon and as far as Phantom Ranch is one of the popular attractions for visitors to Grand Canyon National Park," *Arizona Highways* wrote in June 1960. | JOSEF MUENCH

BEFORE CONSIDERING HOW it can be done without taxing normal powers, let's scout out the trip.

We might begin on the Bright Angel Trail at the edge of Grand Canyon Village among the gracious western yellow pines. Here on the South Rim the elevation is 6,870 feet above sea-level, higher than any peak in the eastern states, and the "climb" down drops to about 2,500 feet altitude at the river.

Broad, hard-packed and at an easy slope, the trail delves first through a brief tunnel and switchbacks down an alcove. Nature might have broken the steep walls here especially so the trail could drop by easy stages.

Inevitably, within a few minutes, you will have forgotten the outside world. Only a stone's throw from the thousands of visitors in the Village, you are already in a vast vertical wilderness, exploring one of the wonders of the globe.

Within protecting arms of the Grand Canyon, no wind touches you from out of the abyss beyond. The sun is pleasantly warm, the air refreshingly clear and fine to breathe. The very limitations of the first outlooks are reassuring, letting you get your "trail-legs" before the scenic explosions begin.

Soon, on cliffs above, but still under the rim, tall Douglas firs are noted. You'd expect them much farther north, but on this journey in time and space, you are also passing through four distinct climatic and plant zones. You will cover a thousand miles of climate — from southern Canada to Mexico — with trees, shrubs, flowers, birds and animals of the various zones accompanying you.

With the first switchbacks behind and every turn of the trail now opening new windows — across to the North Rim, up canyon to the east and down canyon to the west, the dimensions of the mighty gorge begin to expand. Like a moving picture film, shifting from distant views to close-up, the rocks around balloon from fist-size, seen far away, to Gibraltar-bigness when you reach them. A flat-ledge, on which the trail runs, turns into a soaring cliff as you slant down its edge and will soon be left, hanging above. Only the limitless sky seems to remain the distance away that it always was.

Anything you have read or heard of geology will quicken interest in the rainbow tones, laid down in rock layers. A knowledge of flowers helps place the vegetation, much of which may be unusual. Signs, put there by the National Park Service, will point out some of the flora and hint at the age and names of the rocks.

Your emotions will depend upon your own backlog of experience and whether your name for the master builder be Allah, God, or just Erosion.

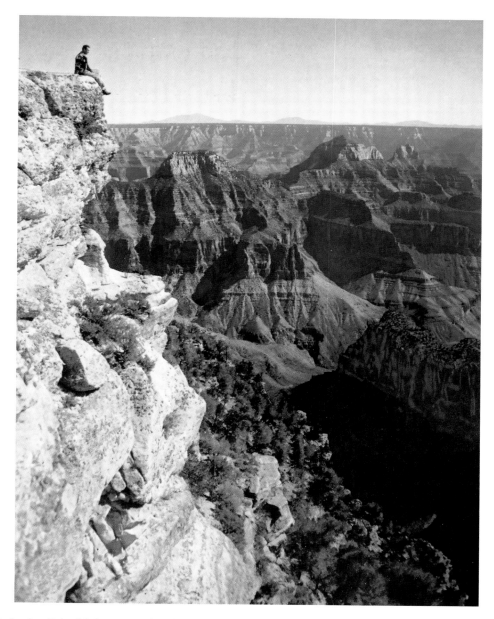

Photographer Hubert A. Lowman enjoys his precarious perch at the North Rim's Bright Angel Point on a June afternoon. "Never being able to find anyone else willing to pose in such an exhilarating spot as this, I always have to do it myself," Lowman told *Arizona Highways* in 1960. "The camera was on a tripod and settings made so that all another member of our party had to do was push the cable release." | HUBERT A. LOWMAN

Picturesquely enough, the Bright Angel descends Jacob's Ladder, a set of switchbacks through the Redwall, and emerges on a sloping spread of shale, the Tonto Platform. This extensive, gray-green plateau is conspicuous from above as a winding shelf, dividing the upper ramparts from the steep inner gorge of granite. A little-used trail can be traced along it for miles, turning and twisting as the contour of the canyon demands.

Into the Tonto shales a valley has been excavated, without man's help, to hold the miraculous green of Indian Gardens. Cottonwood trees offer welcome shade and Garden Creek, which proceeds from it, is bordered for a ways with willow, grape, arrowweed and redbud. Indians once used the bubbling springs to irrigate small fields. When early prospectors came, there were still patches of beans and squash, planted by the Havasupais.

Most trail parties, whether afoot or on mule-back, make this the lunch stop, relaxing at picnic tables in a bright oasis, that not only looks lush but has that distinctive odor of well-watered plants in the midst of an arid country.

FROM THE GARDENS, a trail pushes out to the north edge of the Tonto Rim to Plateau Point for a view straight down into the granite gorge that falls 1,380 feet to the river. Up and down canyon, nothing but crystal-sharp air stands between the spectator and massive buttes and mesas, lifting their colored walls, side gorges breaking away in the marvelous complexities of the Grand Canyon System.

The Bright Angel Trail now turns northwest, down into the Valley of Pipe Creek, twists through the Devil's Corkscrew in more switchbacks and approaches the river.

If you have been too busy along the trail to feel the full immensity of your surroundings, surely when you stand at the edge of the Colorado River, it will be borne in upon you.

Rugged, irregular cliffs are close at hand on either side of the water. They appear enormous, much more than the some thousand feet we know them to be. With the ultimate rims lost to view, these inner ones seem to soar literally miles above. It's an awesome place, even though close at hand, a sand bar may invite relaxation, or a deer break suddenly into view, swim across the river and disappear in a startled rush on the other side.

The brown flood, swirling by, has no resemblance to the angleworm of rim views. Depending upon the season, it hurries by with a speed of anywhere from two and a half to 20 miles an hour. A fleet of 50,000 twenty-ton trucks would be needed to carry off the load of silt that goes by a given point every 24 hours. Eternal as the rocks may seem, that brown color is proof that the plateau country, and the Grand Canyon itself, is being worn down inexorably to a level plain.

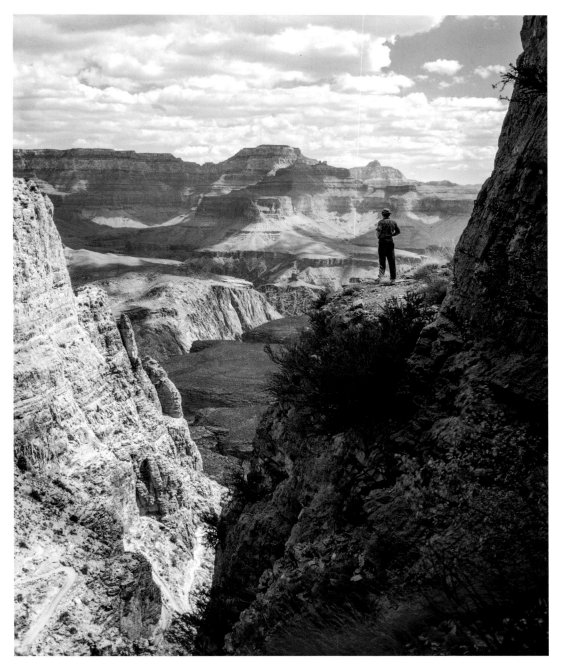

The Canyon's towering cliffs and buttes dwarf a solitary hiker, as photographed by Josef Muench. | NORTHERN ARIZONA UNIVERSITY CLINE LIBRARY

Here, at the river's edge, called by the Havasu Indians, "The Place of the Roaring Sound," where the Bright Angel Trail ends, one-day trips reach the halfway mark and turn back, unfolding the rock layers, pushing the sky up, to emerge in the late afternoon on that mountain eyrie, the South Rim.

The River Trail takes over, pushing upstream for an exciting two miles to the only bridge over the Colorado for some 200 miles in either direction. Views along the stretch, where the trail rises and drops to accommodate the terrain, are very spectacular. Mountainous formations break the skyline in palaces, temples and pinnacles, while the coloring on the rock walls are modified by shadow or angle of sunlight.

Only if you happen to know the distinctive shapes of various buttes can you realize that of, say three, which bulk equally large and of similar height: one may be a "small knob" on the crest of the inner gorge, the second hundreds of feet above it and correspondingly larger, while the third is almost level with the South Rim. From below, they appear of the same order of magnificence and massiveness.

Seen across the river, Bright Angel Canyon, cut clear down from the North Rim, enters the main canyon and the clear spring water which it carries, empties into the master stream, visibly blue until it mingles with the silt of the Colorado. Confusingly enough, Bright Angel Trail comes down from the South Rim, but the canyon of that name and the creek, named by the first Powell Expedition when they saw its sparkling clarity, is on the north side.

One dramatic piece of the trail has been blasted from the solid walls and the traveler mounts easily until he can look down a sheer 600 feet to the water. Just beyond this climax is a junction — with the only cross-canyon trail in the national park — the Kaibab Trail. Leaving Yaki Point, some seven miles east of the Village on the South Rim, it offers 20.6 miles of canyon trail, down and then up to the North Rim where it joins State Highway 67. All pack trains carrying supplies down to Phantom Ranch use its southern portion and many hikers prefer it even to the Bright Angel Trail.

Views along the Kaibab Trail are more open, with vast panoramas of color, form and distance shifting like an enormous kaleidoscopic vision before the hiker, as the ground falls away beneath his feet. From Yaki Point down, the very trail seems in a hurry to get to the river, using switchbacks and long slopes as alternating devices for losing altitude. There is no water, no green oasis anywhere on the route, but they are hardly missed so enthralling are the vistas and the sensation of treading the rim of an archaic world. At the Tip-Off, the edge of the inner gorge, the trail makes its final descent.

The Kaibab Suspension Bridge, 440 feet long and one-mule wide, transports the trail over

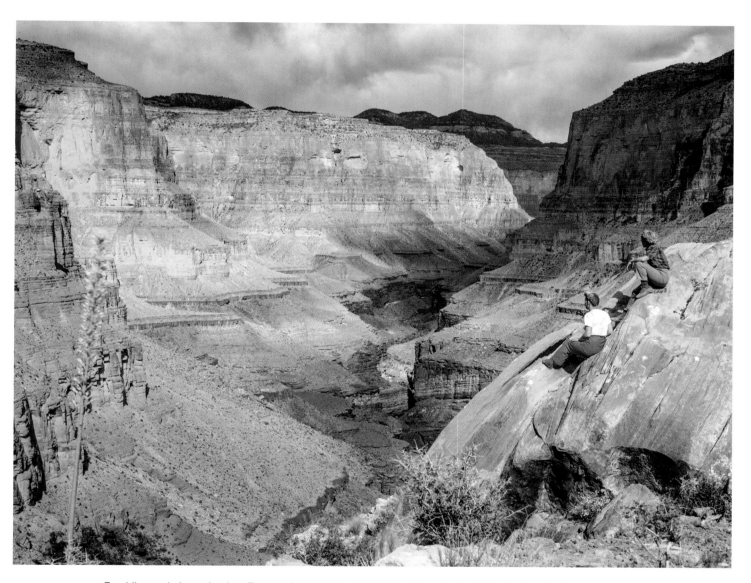

Two hikers admire a view into Tapeats Canyon from their perch above the North Rim's Thunder River. Josef Muench photographed the scene. | NORTHERN ARIZONA UNIVERSITY CLINE LIBRARY

the river. A long tunnel of solid granite was blasted through to make the approach and the bridge is securely anchored and slung with steel cables high over the water. Man's place in the world, so little in evidence within the canyon, is focused sharply here. It was no mean feat to bring those cables by mule-back down the winding trail, and set it in the very teeth of the gorge. Within a few years, the watcher on the span, as he pauses midway cross-canyon, will be treated to a further miracle. When Glen Canyon Dam (some 100 miles upstream) is completed, it will hold back most of the silt, and while the water flowing past may be less in volume, it will, no doubt, be blue.

One more mile partly along the cliffs and then turning north into Bright Angel Canyon, brings the trail to Phantom Ranch, as remote and delightful a little paradise as any traveler could hope for. Under big cottonwoods, rustic cabins of wood and stone, recreation hall and dining room are clustered around a turquoise swimming pool. There is comfort indeed for pleasantly tired muscles, excellent food for the ravenous appetite and friendly companionship. You can listen in on the after-dinner talk of the guides and packers — usually about the all-important mules, those kings of the trail. Each is named for some Indian tribe and stories of Hopi, Navajo, Havasu, everyone a real character, are something to remember.

After a night in this quiet spot, where the stars, as long as you can keep awake to watch them, are penetratingly brilliant, you'll be rested — ready and eager to climb back up the mountain. The northern section is quite different from the southern side. Instead of open views and a feeling of vast space, you will now be almost wholly within a smaller gorge, rugged and with great walls lifting interminably. If occasional glimpses did not remind you of the unique architecture of the Grand Canyon, you might forget at times, just where you are, amid the creeks, waterfalls and more abundant vegetation.

The trail first follows Bright Angel Creek up into Box Canyon, crossing and recrossing the stream some seven times. A side trail leads to Ribbon Falls in a secluded, green spot, where water drapes over a kind of altar among the rocks.

Lunch stop is at the foot of Roaring Springs. The air is noisy with the sound of the water that comes right out of a cliff, tumbles 400 feet over a fern-green slope and then hurries on.

Pushing up-trail we come to a three-quarter tunnel with one side opening onto a creek and canyon walls and sloping up through the Redwall. Now views grow in magnificence and the Devil's Backyard, switchbacks up the walls of Manzanita Canyon, make every step of the way a triumph. Still more of these switchbacks of easy gradient bring us into shrubby growth with trees gradually getting larger until the trail enters the luxurious Kaibab Forest on top of the North Rim.

Now, when you look down upon the canyon from Cape Royal, Point Imperial or Bright Angel Point, it will be with an entirely new respect for its vast features. You can really say: "I have SEEN the Grand Canyon."

———

IN THE 16TH CENTURY, when white men first glimpsed the awful drop of cliffs and declared it was impossible to surmount their difficulties, they were right to hesitate before making the attempt. The 20th Century has robbed even this adventure of its dangers. There are excellent trails, with telephones along the route. A "hotel" is provided midway. There is water to be had at certain points. Anyone who can sit astride a mule or walk some 11 miles (with as many rest stops as he chooses during the day) can make the journey in perfect safety. If he will listen to advice, accumulated through the years, he can do so with a minimum of effort.

Arrangements can be made, on either South or North Rim, for the mule trip, including food, lodging, transportation. The canny animals, trained on the trails for 10 years before they carry their first rider, and escorted by experienced guides in small groups, know enough for rider and mount. You need be no "horseman." Whatever temporary muscular discomfort comes from sitting so long in the saddle (if you are unused to it), might be regarded as the seal on your diploma. It proves that you worked for your new degree.

Going afoot has other problems, all easily solved by a little planning. Reservations can be made for food and lodging at Phantom Ranch, or just for food, if you care to camp by the sparkling waters of the Bright Angel.

No hiker should descend into the canyon, past the registers placed there by the National Park Service, without writing in his name. This is like signing an insurance policy.

There are some inflexible commandments of the trail — not to be lightly ignored.

Don't leave the trail. As a corollary — don't follow unused or unmarked trails. (The Bright Angel, the Kaibab, the River Trail, can be combined in a surprising number of ways. They are well maintained and patrolled. They are safe.)

Mules have the right of way on the trail. When they come — whether pack or riding mules — find a spot where you can be out of the way and stand quietly until they have gone on.

Carry water in a canteen, but drink as seldom as possible. The supply will not only last longer, but you'll hike better.

Plan your trip carefully. Dress appropriately. Conserve your energy by a steady, not too fast pace.

Summer heat, particularly to those unused to it, makes the trail twice as hard and as long.

Spring, fall and winter can reduce this as well as planning to take the hardest, uphill stretches in the cool of the day. (Two of us once left Phantom Ranch at 4:00 A.M. when the moon was still up. We reached the Village by mid-morning, refreshed and having seen that indescribable phenomenon — the canyon as it emerged from night.)

The right choice of clothes is tremendously important. Boots are essential with one, or better still, two pairs of socks inside. Sneakers or low shoes, with no protection for the ankles, are a sad mistake.

Depending on the weather, you need fairly light clothing, with sweater or jacket for pauses (any breeze feels cold on a body heated by hiking). A hat to keep the sun off your head is sensible.

If camping is intended, some extra baggage must be carried but travel as lightly as possible without omitting essentials. These common-sense precautions in preparation and the details of planning which trail to take and on which to return, are vastly important, but variable.

If you want to cross the canyon, you may leave your car on one rim. This makes it necessary to have it driven to meet you on the opposite side — a distance of about 200 miles, while you cover only twenty.

The planning can be fun (a Ranger will be glad to help) and the rewards of the trip are out of all proportion to the effort involved. Mule-back or afoot — you can really see the Grand Canyon. It's the easiest way. █▊

APRIL 1965

GEORGIE WHITE

BY JOYCE ROCKWOOD MUENCH

In this push-button age of assembly line, mass production, many of the sturdy products, with American trademarks, seem to have been pushed off the shelves. Strangely enough, although we still admire their style, most people do not seem to take the time to make them at home, and the efficiency expert has not come up with any factory models, so they cannot be turned out wholesale. It is refreshing, therefore, when one does come across, for example, some genuine, dyed-in-the-wool, Pioneer B and *Courage*.

Georgie DeRoss was born in Chicago the year the Phillies beat the sox off Chicago, to take their first World Series pennant. Had there been no discrimination against women in the National League, perhaps she might have stayed in Chicago to help get it back.

From New York City, where Central Park was her favorite haunt, Georgie drifted west — on a bicycle! — in winter! I would like to hear a firsthand account of that trip, but the request would bring up a tragic memory. Some years later, in Los Angeles (which she had found as warm and friendly as advertised), her fifteen-year-old daughter was killed by a hit-run driver, while the two of them were cycling together.

By then, she was Georgie White, as she is now, and her husband, "Whitey," encouraged a hiking trip through the desert as therapy. I have hiked in the High Sierra and called it fun. My trips, with burros backpacking supplies, pup tent for rainy weather, and water galloping down

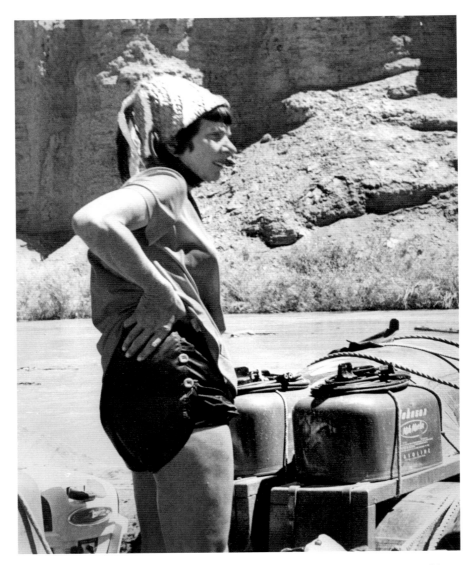

Above: River runner Georgie White stands on one of her rafts during a Colorado River rafting trip through the Grand Canyon. | COURTESY OF GRAND CANYON NATIONAL PARK MUSEUM COLLECTION
Right: Boaters enjoy a stop at a Colorado River beach beneath the towering cliffs of the Canyon's Lower Granite Gorge. | JOSEF MUENCH

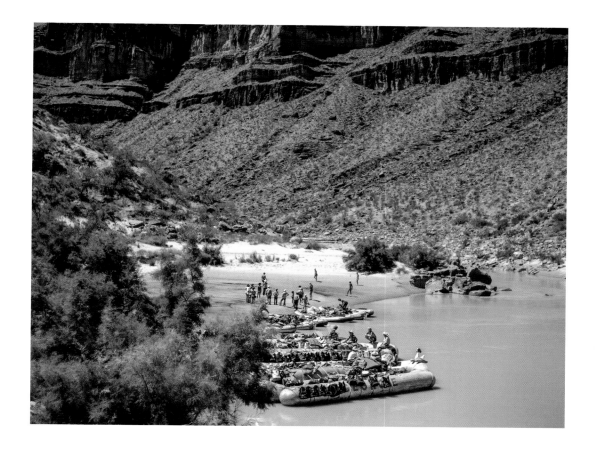

every canyon, were the red-carpet kind, compared to Georgie's. Starting off with a pocketful of dried edibles and a measly quart-size canteen of water, to brave the open Navajo Indian Reservation, would be another matter. A jeep is more my style in the desert than shank's mare. Nor has the Colorado River, particularly in rocky canyons, appealed as the best place to swim. It did to Georgie and Harry Aleson, who counts the rugged Colorado Plateau his own special playground.

After a jaunt, building muscle and know-how, the Chicago woman came across the BIG RIVER, and fell under its spell. That is not just a manner of speaking. The Colorado may drop silt when restrained in lake form behind a dam, but its hold on people who once succumb to that vivid personality is as potent as an electric-powered magnet, with no turn-off switch.

Lacking cash for the outlay which cataract boats or a guided trip in them entails, Georgie and Harry took to the water sans boat, a little food tucked into a life preserver, worn over a bathing suit. To swim 185 miles through wilderness, as she did, is really starting "at the bottom" in the travel business. For not content with enjoying the exhilaration and profound beauty of wild rivers personally, Georgie wanted to share the experience with as many other people as possible. The happy solution she reached came after graduating, first to the ten-man rubber raft, and then the thirty-foot neoprene bridge pontoon, a threesome lashed together. The now popular, "Georgie White Share the Expense Trips," provided an answer to cost-cutting for all takers.

Nor was the Colorado River her only field of operations. While she does consider the GRAND as the supreme thrill, her parties roll off thousands of river miles in a given year. Scheduled trips include such choice spots as *Cataract*, and *Glen* (Colorado River in Arizona and Utah); The Mexican Hat run on the *San Juan River* (in Utah); *Snake River* (in Oregon and Idaho); Hell's Canyon on the *Snake* (Oregon); The Middle Fork and "River of No Return" on the *Salmon* (Idaho); *Green* and *Yampa* (Utah); Big Bend of the *Columbia*, and the *Fraser* (Canada). In Alaska she has included the *Chitna*, *Copper*, and *Kenain* Rivers, and in Mexico, the *Aros*, the *Rio Grande* (from Guadalajara to the Pacific Ocean), and the full lengths of the *Balsa* and *Griapalpa* Rivers.

Some of the finest of adventure films have come out of these trips, multiplying to almost astronomical figures, in proportion to the few who ordinarily experience such unusual scenes, by TV presentation. On *I Search for Adventure*, Georgie made her debut in 1956, and has been called back three times. *Bold Journey*, *To Tell the Truth*, and Art Linkletter's programs, have been other vehicles for her talents. For this woman, who is not afraid of lonely places, loves people, and they reciprocate.

Each year, between river-running seasons, members of her own organization, "The Royal Order of River Rats," gather from all over for a happy reunion, and to pay their respects to the "Queen of the River." They do not mind in the least having to drive or fly across the continent to do it.

For those readers who tremble for the future of Georgie White's trips, and the hundreds who hope to join her next year (or the year after), there are some reassurances. On some streams, construction of a dam may wash out the rapids, or even turn an exciting river into a quiet lake, but there will be still others to conquer or rediscover. Even when the flow is stabilized on the Colorado, as little as 6,000 second feet of surging stream, between Lake Powell and Lake Mead, will carry raft or pontoon on their joyous way. **AH**

JUNE 1968

THE FRED HARVEY STORY

BY CHARLES W. HERBERT

Former Governor Howard Pyle expressed his appreciation on December 3rd, 1951, when he wrote the Fred Harvey Company, "The people of Arizona are deeply grateful for the vital part the Harvey House has played in the building of this great state."

"The Coming of Fred Harvey" is the title of a chapter in James Marshall's book, *Santa Fe, The Railroad That Built An Empire*, in which he gives Harvey credit for civilizing the West — that is, so far as eating facilities and table manners went. Many others spread the fame of Fred Harvey in books, magazines, newspapers, poetry and motion pictures. Among them, Frederick Tisdale wrote "Englishman's U.S. Revolution" for *Holiday*; Dickson Hartwell placed "Let's Eat With The Harvey Boys" in *Colliers*; and Lucius Beebe wrote "Purveyor To The West" for *American Heritage*.

Working for his Master of Arts Degree in History at the University of Arizona, James David Henderson researched eighty-two publications and printed pieces to come up with his thesis, "Meals by Fred Harvey — A Phenomenon of the American West."

There is a Digest of Henderson's Thesis once printed in "Arizona and the West," by the University of Arizona, and the whole thesis is to be printed in book form by Texas Christian University Press.

CREDIT AND PRAISE have not gone to Fred Harvey alone during these ninety-two years of multiple services — lunch counters, dining rooms, hotels, newsstands, curio shops and various transportation services — scattered over "three thousand miles of hospitality" across the West and Southwest with a slight penetration into the South. Right up front in the eating establishments, and often on the front page, have been the Harvey Girls — a vital part of the Harvey tradition almost from the beginning.

The Harvey Houses might have provided the atmosphere and the finest food in the land, but it was served with a smile by the Harvey Girls. They had an opportunity to make friends with many substantial citizens along the line, which eventually led many of them down the matrimonial trail, so many, in fact, that Will Rogers once said Fred Harvey kept the West in food and wives.

The story of Fred Harvey began inconspicuously in 1850 when the fifteen-year-old boy with ten dollars in his pocket boarded a sailing vessel in England to become a speck in the swelling tide of immigrants heading westward to the challenges of the New World. In New York his restaurant experience started with a job washing dishes for $2.00 a week and meals. Like thousands of other immigrants, young Harvey intended to use New York only as a stopping place before heading for opportunities that beckoned from beyond the Appalachians.

By diligence and thrift he was able to save enough money for his boat trip to New Orleans. He was able to get work in the finest restaurants and hotels and to get a good look at fashionable dining rooms with luxurious surroundings. This opportunity doubtless fired his imagination and stirred his ambition to have a restaurant of his own.

A bout with yellow fever slowed him down and caused him to move on up river to St. Louis, the rich, bustling gateway to the West. By now Harvey was twenty. He worked as a jeweler and tailor for four years, saving his money, and then found a partner and started his first restaurant. After accumulating a tidy stake, he married Barbara Sarah Mattos. Restaurant success was short lived. With the outbreak of the Civil War, his partner took off for the South — with the restaurant funds.

Out of business and broke, a job on the Missouri River Packet Line was a stepping stone and an introduction to the railroads of the West when Harvey signed on as a mail clerk at the St. Joseph Post Office, in the first railway mail car, sorting Pony Express mail as the train sped from St. Joseph to Quincy.

With little chance of advancement with the Postal Service and aware of the surging prosperity of railroads serving the West, Harvey went with the Hannibal and St. Joseph Railroad, com-

El Tovar's Harvey Girls, wearing their evening uniforms, pose for a photo with manager Victor Patrosso in the 1920s. | COURTESY OF GRAND CANYON NATIONAL PARK MUSEUM COLLECTION

monly called the "Horrible and Slow Jolting," and eventually joined the Chicago, Burlington and Quincy as Western freight agent with his home and headquarters in Leavenworth, Kansas.

Harvey was a busy man. He had to learn the cattle business as part of his railroad work. Then he bought a ranch, invested in a hotel and sold advertising for the *Leavenworth Times and Conservative* as a sideline as he traveled the rough rails across a rapidly developing section of the country.

On these trips he came face-to-face with the frightful conditions which existed in ill-equipped, poorly operated, crooked restaurants which the traveling public had to depend on. Bitter coffee, greasy food, poor service, high prices made up the bill-of-fare along the line. Added to this was the shameful practice of trainmen who sold tickets in advance for meals, then blew the whistle before the passengers could eat. The trainmen got a cut and the food was saved and served over again.

FRED HARVEY, who had developed into an epicure and enjoyed good food served in good style, missed many meals on the road. Then and there the spark was kindled that fired his determination to do something about it. As a starter, he and a partner, Jeff Rice, operated three widely separated restaurants along the Kansas Pacific Railroad Line. The venture was successful but they parted. Rice did not see eye-to-eye with Harvey, who envisioned a grand network of restaurants bringing good food and superior service in attractive surroundings to the ever increasing number of travelers. They split the cash and Harvey started looking for greener fields.

Although he put up a good sales talk to the Burlington officials, they couldn't see getting mixed up with restaurants and suggested he try the Santa Fe. When Harvey approached Superintendent Charles F. Morse of the Atchison, Topeka & Santa Fe he found a man who shared his ideas about food and service and received a "green light" to go ahead.

In the spring of 1876, the first Harvey House was born when he bought Peter Kline's lunchroom in the Santa Fe's Topeka, Kansas, depot. It was closed for two days for a thorough going over, then opened with fresh tablecloths, napkins, polished silver — and excellent food. It was an immediate success as passengers, trainmen and townfolk flocked in to build it up to capacity business.

The Harvey recipe for a successful operation included these essential ingredients, all blended together harmoniously: a ready market, an above level establishment, good, out-of-the-ordinary food, pleasant, efficient service and reasonable charges. Add to these an agreement with the Santa Fe which would supply the buildings, coal, ice and water, transport Harvey furnishings, food, supplies, and personnel without charge, and allow all profits to go to Fred Harvey. Thus a potentially vast enterprise was launched along the rails to a land of promise.

Next the Santa Fe-Fred Harvey combination decided to buy out a rundown hotel in Florence, Kansas, and make it over. Fred and Sarah Harvey replaced the old furniture with attractive walnut pieces, put in new mattresses and springs, modern kitchen ware, stocked the dining room with Sheffield silver and Irish linens and hired a chef from Chicago's Palmer House.

The chef's thoughts on food fell right in line with Fred Harvey's and he obtained fresh meat, vegetables, eggs, butter and wild game from local farmers. Such delicacies as prairie chickens were bought for a dollar a dozen, quail at seventy-five cents a dozen and butter a dime a pound. Through the touch of a master chef, signed up at a salary of $5,000 a year, the Harvey House meals quickly gained fame along the line as travelers began staying overnight.

With the second link in the chain firmly in place the Harvey System began to spread. From a meager beginning, Fred Harvey soon proved himself and his theories as he put on a full head

THE GRAND CANYON CAPER

BY JOHN MATTHEWS

The glorious age of the motor car arrived rather sluggishly in northern Arizona, one cold winter day in December of 1901. Significantly not under its own power but as cargo aboard a Santa Fe freight train, chugging into Flagstaff.

It was a new horseless carriage, a modified Toledo Model C steam automobile. Not only was it destined to become the first to roll on the streets of Flagstaff but it was also to make automotive history as the first car to "run to the Canyon."

This engineering marvel, created by the American Bicycle Company of Toledo, Ohio, was first introduced in 1900. Within a year, ABC was ready to market five models, a four-ton truck, and an electric car named "The Waverly."

In those days, steam car makers took their product anywhere and everywhere to attract investor and public attention. They established world records for hill climbing, endurance, speed and other feats on wheels.

The motor madness began August 31, 1899, when F.O. Stanley's steamer chugged to the top of Mt. Washington, N.H. The following year, a "Baldwin" was touted as "the greatest hill climber as shown by tests in the Allegheny Mountains." In the same year, a "White" won the New York-Rochester endurance test, and a "Locomobile," the Stanley's hissin' cousin, carried W.B. Felker and C.A. Yont to the crest of Pike's Peak.

The American Bicycle Company, struggling against this stiff competition, put a lot of trust in its product and the value of promotion and advertising. True, a Locomobile had beaten their car to Pike's Peak, but the Toledo would be first to reach the Grand Canyon.

———————

FIVE TOLEDOS BEGAN the groundwork in October, 1901, by traveling the 63 miles from their hometown to Detroit in two hours and 45 minutes without a breakdown. At the same time, a Toledo Model A, weighing 950 pounds, journeyed from the factory to the New York Auto Show, completing the 14-day trip without mishap. No doubt about it ... the Toledo was ready to challenge the Canyon.

It was obvious to anyone blessed with an ounce of business savvy that a steam car stage line from Flagstaff to the Canyon should be a paying proposition. After all, Wilbur F. Thurber's excellent six-horse stages, which covered the 70-mile route from the city to the Cañon Hotel, was a money-maker. Now that America had entered the auto age, it would seem that a steam car could perform faster and better than the hoss-powered Grand Canyon Stage Line.

Several magazines and newspapers, including the *Los Angeles Herald*, boosted the Canyon as a "must-see" place. Popular writer-photographer C.F. Lummis gave it a five-star rating in his Los Angeles-based magazine *Land of Sunshine*: "In the fall of the evening, the coaches roll down to the piney glades where the Cañon Hotel snuggles in its charming hollow. The hotel is also managed by Mr. Thurber and the accommodations are surprisingly good."

During his five-day visit, Lummis was particularly impressed with the views from Moran and Bissell Points; complimented Pete Berry's admirable log hotel and the good trail; and raved about the new Hance Trail, which led down to the river.

"Probably, the time will come when Americans who know enough to go and see it will number more than a few score a year," he modestly predicted.

In all likelihood, Lummis stopped at J.E. Ruffin's Pioneer Drug Store, where Flagstaff citizens and tourists could buy "Grand Canyon views in colors, richly mounted, and admired by all."

There was ample evidence to titillate the optimist. The popularity of Arizona's natural wonder was accelerating; hotel building was big business; and it was whispered that the Santa Fe planned a posh inn.

The American Bicycle Company management, eager to impress the automotive world, decided to take advantage of the Grand Canyon's growing popularity. They promised to build "three big steam coaches capable of making the 130-mile round trip daily." The Toledo firm was in a hurry because the Stanley Brothers were designing a similar vehicle.

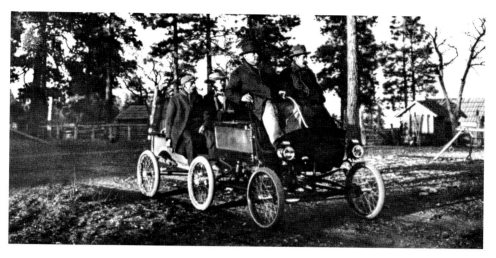

After an arduous trip, a steam-powered contraption driven by Oliver Lippincott arrives at the Grand Canyon's South Rim in January 1902. | COURTESY OF GRAND CANYON NATIONAL PARK MUSEUM COLLECTION

AND SO IT CAME TO PASS that ABC commissioned ace chauffeur Oliver Lippincott as the Toledo's pilot, and dispatched him and the car to northern Arizona.

Flagstaff's newspaper, the *Coconino Sun*, noted the arrival on December 28, 1901: "The experiment of running an automobile from Flagstaff to the Grand Canyon is attracting attention all over the West." The report also quoted the *Los Angeles Herald*, which hailed the experimental test as "the forerunner of a steam stage line."

Historical accounts do not specify who actually planned to provide the steam-stage transit service. Certainly, ABC was involved because it was in the business of selling automobiles. *The Herald*, where the news watch never stopped, was, at least, the ex-officio publicist of the event.

The Los Angeles newspaper assigned two of its top men to cover the motoring adventure. Reporter T.M. Chapman was to write the account of the trip as observed by Winfield Hogaboom, the paper's columnist-photographer-travel editor — and resident wit.

There were few direction markers on the Canyon trail, so veteran guide Al Doyle, who knew the Coconino backcountry well, agreed to join this quick dash to fame. Doyle was the same scout destined to lead novelist Zane Grey on many Arizona adventures a few years later.

The cast of characters was complete, and on January 4, 1902, chauffeur, crew and car were ready to challenge the Canyon. It was a gala day for Flagstaff as most of the city's 2,000 residents and visitors jammed the streets to ogle the first automobile in Grand Canyon country.

In its morning edition, the *Coconino Sun* noted the event in a front-page story: "The much

talked-of auto was run over our streets yesterday. Its operation was entirely satisfactory to the owner, Mr. Lippincott, who is as proud of his fine machine as the proverbial boy in his red-topped boots."

The auto was a top-of-the-line Toledo, a swift, trim 2,200-pound Model C two-seater with trailer. Its $1,600 list price made it the costliest of the five Toledo models.

"From bell to whistle, a perfect locomotive," the *Sun* related. "Equipped with 10 horsepower, high speed marine engines, copied after the U.S. Torpedo boat type, it is fitted with water coil and flash boilers, and has a storage capacity of 30 gallons of oil and 50 gallons of water."

The horizontal twin-cylinder engine had a bore and stroke of three by four inches and piston valves. Clean design provided neat, compact casings leaving no vital part exposed to dust and dirt. A sprocket on the crank journal drove the rear axle by chain.

The American Bicycle Company claimed that three persons could ride in the front seat, while the trailer, a part of the machine itself, could accommodate three more. Night offered no terrors for the driver who sat behind a 12-inch diameter, 200-candle-power headlight, illuminated by acetylene gas. This brilliant eye was complemented by two kerosene oil coach lamps.

The chauffeur managed all forward and backward movements with a single lever at the side of the front seat. The engine could be reversed with absolute safety at high speed, and a double friction bearing brake instantly stopped the vehicle.

The newspaper account also boasted that neither mud, snow or ice would seriously impede the Toledo's progress, and quoted Lippincott, who promised he would make the 65-mile trip "to the point on the Grand Canyon known as Hance's in less than the prescribed four hours."

Lippincott and crew flaunted confidence by refusing to carry food or other supplies. Their sole provision against accident or delay was a large supply of tobacco and matches. The driver, fresh from sunny California, wore a thin summer suit.

At precisely 2:10 p.m., the Toledo's whistle blew, bell clanged, and she roared off amid shouts and laughter. Bets had been freely made on the outcome and the consensus was that the trip would take anywhere from six days to six years.

Through modern electronics we know the results of a major event immediately. The Flagstaff folks of 1902 had to wait awhile before settling wagers. Hogaboom's bump-by-bump account appeared in the *Los Angeles Herald* on February 2, a Sunday. The *Sun* reprinted it the following Saturday, February 8, 1902.

"The machine worked splendidly until we were out of sight. We were thankful for that," Hogaboom explained. "But, before we covered the first ten miles, it got to acting up. Our chauffeur (whatever the deuce that means), said the trailer was bearing down too hard on the hind

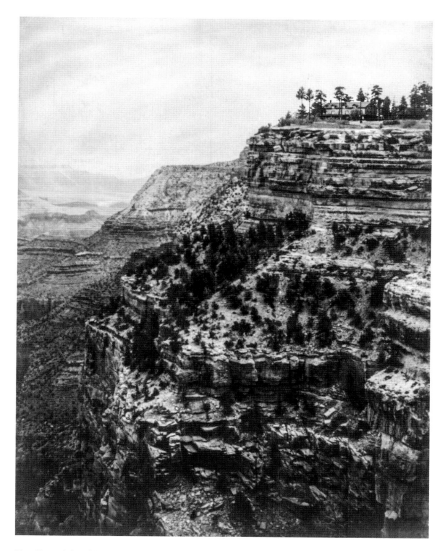

The Grandview Hotel, perched on the edge of the South Rim, is shown in the early 1900s. The hotel was torn down in the late 1920s. | COURTESY OF LIBRARY OF CONGRESS

axle. So, we got off, unloaded the outfit from the trailer, and packed it in such a way that it couldn't lean too hard. By the time we got through with this job, and got the baggage and ourselves aboard again, darkness had fallen upon us. Ahead loomed the great Coconino Forest."

Pilot Lippincott did the pioneer equivalent of "stepping on her," while the passengers held tight and prayed.

"He said that if we didn't run against any of those fallen trees or charred stumps, we'd get through all right," Hogaboom noted. "We hoped so, but it was hard to believe."

Doyle wisely reckoned that headlights or no, this was not the time or place for a wild night ride. He remembered an old cabin on the trail to the left, so they parked the Toledo and walked until they spotted a light flickering through the trees.

"Doyle reckoned there must be somebody staying at the cabin, and so there was … three cowboys," Hogaboom recalled. "They had killed a two-year-old steer, and had flour, baking powder, coffee, and honey … a supper fit for a hungry automobilist. We bunked with the cowboys, were up before daylight, had breakfast, and returned to the auto as the first light was breaking."

The Toledo was frozen stiff and it took several hours and much fuel to thaw it. The cowboys, of course, came down to see the party depart. Their mounts snorted and wheezed each time the cylinders puffed out a little steam.

All went well for 10 miles. They passed two bands of antelope who stood motionless until the Toledo reached them. Once they met a herd of wild horses that fled into the woods.

The easy going spurred Lippincott to "give 'er more steam." Then something popped. The water gauge burst and the valves failed to work. The fuel brought from California was all gone, and the reserve purchased in Flagstaff could not maintain proper pressure. Moreover, it produced dense black smoke that belched from the ventilators and covered the motorists with grimy soot.

After several hours of this and moving along at three miles an hour, the men decided to abandon the trailer, strip to essentials and put all hope of salvation into a wild dash to the Canyon. All spare gasoline, water, baggage and other gear was cached, and the four piled into the one remaining seat.

"One mile at joyous speed, then a sharp metallic click and a harsh rasping sound told Lippencott the sprocket chain had parted," Hogaboom wrote. "An auto always gets discouraged and quits when its sprocket chain parts. It took three hours to repair it."

Now, it was windy, cold, dark and midnight. Doyle reckoned there was a grove of trees about four miles ahead which would provide some shelter. The kerosene in the side lamps was almost exhausted, shedding a pale, sickly light only a few feet ahead. Two of the party walked in front of the vehicle to find the way, and in two hours, they reached the cedar grove.

The original Grand Canyon Railway was an Atchison, Topeka and Santa Fe Railway branch line. This 1904 photograph shows the original depot shack and boardwalk. A train ride from Williams to Grand Canyon Village cost $3.95 when the line opened in 1901. | COURTESY OF GRAND CANYON NATIONAL PARK MUSEUM COLLECTION

The men built a huge campfire and tried to sleep, but spent most of the night adding fuel to the blaze until daylight.

"For breakfast, we had a look at the auto and a smoke," Hogaboom stated. "There was a little dirty ice in the bottom of the tank and we melted it, but it didn't taste good. So, we took another smoke and let it go at that."

Doyle reckoned it was now 18 miles to Pete Berry's Hotel at the Canyon. They started a fire under the boilers and managed a little steam with the small amount of gas and water remaining.

Lippincott worried the Toledo along for about two miles while the others walked. Finally, they had to abandon the machine, and, led by Doyle, reached a cabin that had been built by a man named Skinner.

"Skinner must have been crazy, because there isn't any more call for a cabin there than a department store," Hogaboom commented. "On the cabin was a sign which said it was six and three-eighths miles to the Grand Canyon. The man who put up that sign ought to be killed with a dull hatchet."

Doyle and Hogaboom volunteered to make the remaining distance to Berry's and send back a relief expedition. The two left shortly after noon and had walked about a half-mile when Doyle collapsed from stomach cramps caused by drinking the gasoline-flavored boiler water.

"I left him there by the lava rocks, wrestling with his stomach, and went on alone," Hogaboom reported. "I had gone about eight miles when I happened to think of that sign on Skinner's cabin ... six and three-eighths miles to the Grand Canyon. What the deuce did he want to be so exact for?"

At four o'clock, after covering about 18 miles of that six and three-eighths miles to the Grand Canyon, the weary adventurer saw a buck pawing at a small patch of snow. The animal scurried away as the thirsty intruder sat down and ate a couple of quarts of the white stuff.

"My tongue had swollen until it made a good big mouthful," Hogaboom recalled. "And my throat was cracking. That trampled snow tasted better than the most delicious ice cream I ever ate."

His pace quickened, and an hour later, he noticed a crack in the trees. The forest ended abruptly, and the walking motorist found himself at the edge of the Grand Canyon.

"I stood upon the rim of that tremendous chasm and forgot who I was or what I had come there for," Hogaboom admitted. "Before me lay the most sublime panorama in all the world. Nature never made anything like it anywhere else. It is the great masterpiece."

Twenty minutes later, he entered the Grand View Hotel where landlord Berry welcomed him and asked what he wanted.

"Just water, food, and the address of the man who put up that sign at Skinner's cabin," Hogaboom said. "They brought me a little water and a can of tomatoes. The address was withheld."

———

BY 8:00 P.M., Berry's four-horse-team relief expedition brought in the survivors ... Lippincott, Chapman, and Doyle. The next day, they sent for gasoline, which arrived the day after that. On Thursday, January 9, 1902 — the fifth day — the first auto to reach the Grand Canyon Village rolled in at the end of a rope.

"On Friday, we steamed up and took the auto out to Grand View Point," Hogaboom revealed. "Chauffeur Lippincott drove the thing to within six inches of the rim with its own steam, and held it there while I took its picture."

Saturday morning, Doyle, Chapman, and Hogaboom rode the stagecoach to Apex, 16 miles from the Grand View, where they caught the train for home.

"Each of us told Lippincott we regretted being unable to make the return trip with him,"

Hogaboom revealed. "Doyle reckoned he had better go home at once to assist his wife in setting a hen. Chapman had to return to Los Angeles in time to prepare a speech for the Typothetae on Franklin's birthday. In my own case, it was absolutely imperative that I be at home to pay some bills that had accumulated in my absence."

Lippincott stayed to enjoy northern Arizona's scenery and hospitality until January 18, when he and innkeeper Berry drove the Toledo from the Grand View Hotel to Flagstaff, covering the 67 miles in seven hours.

The *Sun* noted that the car had returned and quoted Lippincott as being entirely satisfied with the experimental trip and confident that a steam stage line could be successfully operated between Flagstaff and the Grand Canyon.

Lippincott was also quoted as saying "several experiences were met with on the trip that would not occur if supplies were placed at proper places along the way."

Unfortunately, his optimism was unfounded because the steam stage line was a pipe dream that never materialized. ABC continued to promote its product and the Toledo was a major success at the International Exhibition in Osaka, Japan, where, on May 6, 1903, it was the only auto allowed to run on the grounds.

But stiff competition (a total of 125 steam cars were manufactured in the U.S. during the early 1900s) and declining sales doomed the American Bicycle Company, which sold out to the International Motor Car Company in 1904.

The Toledo was widely advertised and sold well for three more years because it was modestly priced. However, most sales were in the Great Lakes region and midwest fringe areas. When that market was exhausted, the company was in trouble.

Automotive historians cite several reasons for the demise of the Toledo and its steam counterparts. The public feared boiler explosions which were common, many insurance companies failed to cover them, bankers were leery of financially backing a car that failed to gain a favorable public reaction.

Actually, the steam car was eliminated by the complacency of early manufacturers and the lack of research and development which failed to keep pace with gasoline vehicles. After 1910, the steam car was no longer a significant factor in the automotive marketplace.

Although the dream of a Flagstaff Canyon Steam Stage Line fizzled, the great-granddaddy of all Grand Canyon motor trips entered the annals of history as an accomplished fact. Today, 75 years later, more than three million people say it's the only way to go. 🏔

NOVEMBER 1978

THE GRAND CANYON — MY RELIGION

BY ABE CHANIN

Among those fortunate few who have experienced the Grand Canyon in all its many remarkable moods and become intimate with its deep-lying secrets, the name Emery Kolb draws from the wells of memory a graphic picture of a man profoundly captivated — almost religiously devoted — to its rocky peaks and valleys and the great river, which over eons brought about its birth — a love in return for which the great Canyon bared its very soul.

It was just after the turn of the century that Emery and his brother, Ellsworth, arrived there. On the rim of the Canyon they built a home with a magnificent vista and a photographer's studio, to which were drawn some of the great personalities of the political world, science, stage and screen, art and philosophy. They were people like Theodore Roosevelt, Albert Einstein, William Jennings Bryan, Cecil B. DeMille, Frederic Remington, John Muir, William Howard Taft, Douglas Fairbanks Sr., and Mary Pickford.

Why did they come? Primarily to see the great natural miracle, which they could stare at for hours from the Kolb's huge picture window. Here, too, they, and thousands of others, could almost literally sit at the feet of the two brothers and listen to tales of their Canyon adventures and see films which probed the Canyon's secret depths and hidden mysteries.

Sadly, both men are gone now; Ellsworth died in 1960, and Emery, in his nineties, in 1976. Only a short time before Emery's death, however, I sat in that room with the great window

One of the Kolb brothers uses a rope to help the other get a better view of the Grand Canyon. This photo likely was made in the 1910s. | NORTHERN ARIZONA UNIVERSITY CLINE LIBRARY

overlooking the Canyon. I couldn't have known it at the time, but this was to be the last interview given by Emery Kolb.

He came into the room holding onto the arm of an aide. After shaking my hand briskly he sat on the edge of an overstuffed chair, his eyes at first looking past me through the picture window to the majesty of the Canyon in the afternoon light. When I turned on the tape recorder, he began to talk swiftly, sometimes lapsing into lines from the lectures he had given in his studio so many times in the past. But always there was a brightness to his eyes and excitement in his voice, as he told me the story of his love affair with the Grand Canyon.

———

Emery began the interview by relating how his brother, Ellsworth, had left Pittsburgh in 1902 to adventure in the West.

"I was just 20 years old at the time. Ellsworth had left town with just $2 in his jeans to see the world. He beat his way out West, worked on a telephone line in Manitou, Colorado, then at Yellowstone on roads and trails and then the same in Yosemite, and then to San Francisco to work on a concrete building. He signed up to sail to China, but he thought he'd better see Grand Canyon first — it was just when the Grand Canyon was beginning to be talked about.

"In those days you could go to any employment office in the West and for a dollar or two get a ticket to any of the western states for a railroad job. So naturally he chose the Santa Fe. When he got to Williams, Arizona, he didn't have money enough to pay his fare to the Canyon. He hiked out 50 miles on the ties, flagged the train down 12 miles out and rode the rest of the way to the Canyon. Got a job chopping wood for the man who was running the Bright Angel Camp then. That was 1902."

Emery Kolb paused now; he had barely taken a breath through those opening lines. Now he turned to his own story of coming West.

"At that time I was working for the Pittsburgh Westinghouse Electric. I was running drill presses. I had developed an interest in photography at the same time and I just started with a little box camera. Began developing my own pictures, making pretty good pictures. Then finally I got a 5x7 camera. It was in those days when people were wearing buttons on their coats with pictures of their loved ones in little gold frames. So I started making those.

"And then I wrote my brother Ellsworth and asked him to keep his eyes open for a scenic photographer's job out there at the Grand Canyon. He wrote back about the possibility of taking pictures of the mule parties going down the trail there. Anyhow, he found a job for me in

Emery and Ellsworth Kolb pose with Emery's wife, Blanche, on Kolb Studio's porch on a winter day in the early 1900s. | NORTHERN ARIZONA UNIVERSITY CLINE LIBRARY

the old asbestos mine at the Canyon and the superintendent gave him $40 for my fare out from Pittsburgh. When I got to Williams I went over to a photo shop there to get some materials and the manager said, 'Why don't you buy us out? We're leaving.'

"I said, 'I've no money.'

"He said, 'Send your brother in. Let us talk to him.'

"When I got to the Canyon I found the mine had been closed down, so I had no job. My brother had started working as a porter at the Bright Angel Lodge and I held his job down while he went to Williams to talk to the proprietor of that photo studio. And he bought the studio, cameras and everything the man had for $425 on the installment plan. That was more money than I thought there was in the world.

"Well, Ralph Cameron, who built the Bright Angel Trail, you know, told my brother that he'd give us a place at the Canyon for our studio just as soon as he'd won his suit against the Santa Fe. He said the Santa Fe wouldn't pay any attention to his tolls for the trail and just used their mules going down the trail and wouldn't pay the tolls. Well, he finally won, but he didn't say anything more to us about our studio. One day my brother and I were in Williams and we saw him as we were going into the post office. My brother said to him, 'Ralph, how about getting a place at the Canyon for a studio?'

"He said, 'Oh, God, I forgot all about you. Get your tent and come out.'

"So we came to the Canyon. We didn't have a tent. We just slept on the ground. It was October and it was pretty cold, too. We had no darkroom so we hung a blanket over one of Ralph's prospect holes and that was our darkroom for a while. We had no water there, of course, to wash pictures, so we hauled water into our camp from a muddy cow pond 11 miles out in the woods — out about where the Grand Canyon airport is now. Well, we'd wash our pictures by hand in that muddy water and then give them a final washing in clear water we packed up four and one-half miles from Indian Gardens, which was 3,180 feet below us in the Canyon."

I then asked Emery if he could recall his first view of the Grand Canyon.

"Well, it was not a very nice day when I got there. It was October and it was snowing and very cold. There wasn't much color to be seen in the Canyon. And, well, I remember I thought it was a big, big place, but I felt someday I would conquer that Canyon."

And it wasn't long before the Kolbs were the conquerors, or as much as man really can conquer nature. They hiked the Canyon to its depths, rode the mighty Colorado, even assisting the United States government in a survey of the river. I questioned Emery about some of these early adventures.

The Kolb brothers tend to their boats on the Colorado River in 1911. This spot is near the end of the South Rim's Bright Angel Trail. | NORTHERN ARIZONA UNIVERSITY CLINE LIBRARY

"I guess my desire to make the Grand Canyon a part of my life developed gradually. We took our first river trip down the Canyon by boat in 1911, from Wyoming to the Gulf of California, 1,400 miles through 19 canyons. By this time we had been on the Canyon rim almost nine years. In 1906, we built our finish-room down in the Canyon at Indian Gardens where there was good, fresh water.

"Looking back I would say I made about 500 trips down there and back up. You see, we had plenty of clear water at Indian Gardens, where I used to run down to every day to finish the pictures."

Run down? And run back up? I asked about that, remembering that a summer doesn't go by that some hiker doesn't have to be hauled up from the Canyon trails.

"Oh, yes, I would always run on the more sloping places. When it was steep, why I'd just hike. But I would never stop from the time I left Indian Gardens 'till I got to the top. I would leave Indian Gardens each day when the trail parties were halfway up. I would beat them to the top with my pictures.

"It would take the mules two hours to come up and I would always come up in an hour and five minutes. Once I made it up from Indian Gardens in 55 minutes."

The interview next turned to the long list of famous people who had come to the Canyon and visited with the Kolbs. Emery's eyes glistened as the names came back to him.

"Oh, yes, I have a nice picture I made of Teddy Roosevelt going down the trail in 1911. He was here three times. I remember him as a very strong, determined man. And I can recall his lecture here when he talked about the Canyon and said to 'keep it for your children's children.'

"And I remember very well Douglas Fairbanks and Mary Pickford. They were very pleasant people. And Cecil B. DeMille — you know, the Hollywood producer — why, he became a very good friend of ours from his visits here. He printed our first set of movies for our lecture.

"In the early days most everybody that was somebody came. I remember a gentleman with two ladies out in my salesroom one day and the young man said to me, 'Hello, Mr. Kolb.'

"I said, 'How do you do?' But I really wasn't sure who he was.

"He said, 'It's been a long time since we conversed. I left Princeton with a friend to see the West some time ago and when we got here we took your advice and hiked down the Canyon. When we came back up we just about bought out all your pictures, and when we got over to the train depot we found we just had $2.50 to get to San Francisco. I was just too proud to wire Dad for fare to get home on, so we worked eight months in San Francisco for fare.'

"Then the young man bought one of my books and asked me to autograph the book for his dad. I didn't know who his dad was.

" 'What's the name?' I asked.

" 'Thomas A. Edison,' he replied."

Now the old explorer leaned back in his chair. Memories were flooding him.

"Yes, we had a lot of royalty here, too. The King of Belgium and many others were here. Can't remember them all, you know, but people got some strange impressions when they see the Canyon for the first time. One time I saw a car drive up to the edge. It was a Ford, a Ford with about eight people in it. A Texan with a big hat got out and said, 'Well, this is the Grand Canyon. Let's go!'

"Of course, you cannot really get to know the Grand Canyon until you go down into it. It is the great wonder of the world because it's so different from anything else. Those who come to the Canyon and just view it from on top will never know how really large it is. You'll never know until you go down, go round one of those peaks down there.

"And these people today who go on those big rubber rafts really never know what the river is. You won't know until you get in a little boat like we did and paddle with little oars. Most every stroke, you see, your life depends almost on every perfect stroke when you're going through those rapids.

"I really feel now that I have conquered the Canyon. I've been over more of the Canyon than any other man. I've made six runs on the Colorado. Just two years back they flew me to the mouth of the Little Colorado in a helicopter, where I joined a party — two rafts with 28 people. And they took me past here 50 miles over 11 of the worst rapids in the river. I was 92 then. And they brought the helicopter down into the Canyon and flew me back. I was wet when I got home."

The interview, after more than an hour, was almost at a close when Emery Kolb pointed out the picture window of his old home.

"This is the greatest window in the world. We watch the changing moods of the Canyon, the storms, and sometimes the Canyon is just shredded with lightning.

"The Canyon? The Canyon's my religion." AH

THE SOUND OF SILENCE

BY JACK FOSTER

You come upon the Grand Canyon suddenly, almost without warning. Oh, you know it's there, all right. As you get out of your car, you see the people lined up in front of where the earth stops, staring over the edge. And, way off on the other side, you can see the earth start up again and roll off into the hazy Arizona horizon. So you know that this is it; that out there and down there is the thing you've driven so far to see.

But when you walk to the edge, you're not really ready for it. It's like snapping on a light in a dark room. Suddenly, there it is, the whole thing, all at once, bamm — an enormous, jagged tear in the earth, a hole so huge you have to swing your head around to see it all, just as you have to in Montana to see the sky, or at dawn to see the sea. It is such a staggering sight, you expect it to do something — to rumble, to thunder, to erupt. But it doesn't. It doesn't stir. It doesn't speak. It just sits there with its mouth open, swallowing sound. It just sits there in majestic silence, like some terra-cotta Buddha, listening, holding its breath, waiting for the world to end. It just sits there.

And, for the most part, the people just stand there, listening, holding their breath, waiting. There are none of the "Oooohs" or "Ahhhhs" you hear at Disneyland and at fireworks displays and on top of the Empire State Building, none of the "Wow's" or "Look at that's" you hear at Yellowstone and Sequoia and Carlsbad. There is only an awesome stillness that wells up from

The Duck on a Rock, a well-known South Rim rock formation, rises from the cloud-filled Grand Canyon during an inversion. This meteorological phenomenon, photographed here by Josef Muench, occurs when cold air in the Canyon is trapped by warm air above it. | NORTHERN ARIZONA UNIVERSITY CLINE LIBRARY

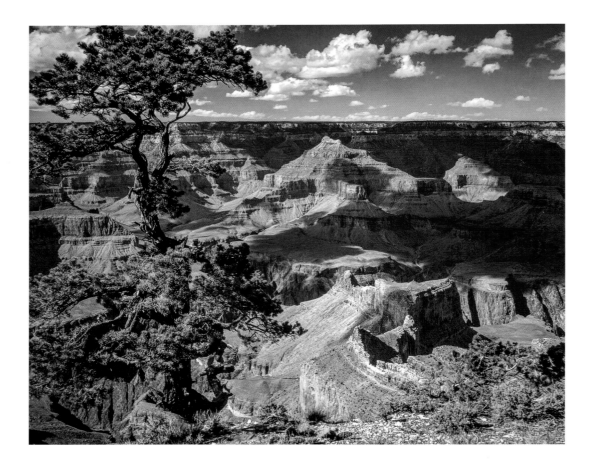

the depths of the earth and strikes you dumb.

After a while, you get used to it, and you come out of your trance, saying, "Let's walk over here a bit." But the stillness stays with you. It dogs your steps and deadens your footfalls. It wraps your voice in cotton. It clogs your ears.

And, slowly, you start to wallow in it, until finally it becomes personal and private, and you begin to understand what Kostelanetz meant when he said that, "Everybody should have his personal sounds to listen for — sounds that will make him exhilarated and alive, or quiet and calm ... one of the greatest sounds of them all — and to me it is a sound — is utter, complete silence." And as the silence becomes more all-embracive, you actually begin to hear it, just as you actually see the darkness when you close your eyes.

But just because you hear the nothingness, do not think that nothing is happening. Change is happening. Silently, imperceptibly, inexorably, the canyon is changing, just as it has for two billion years.

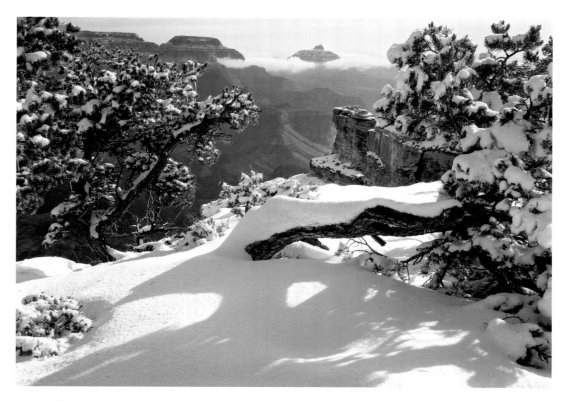

Left: A piñon pine frames Josef Muench's shadowy shot of the Canyon from the South Rim. | NORTHERN ARIZONA UNIVERSITY CLINE LIBRARY

Above: Snow covers the South Rim in another Muench photograph. | NORTHERN ARIZONA UNIVERSITY CLINE LIBRARY

For this immense sculpture is not the result of some deafening, cataclysmic, cracking-apart of the earth's surface.

It was formed by the wind lifting a grain of sand from over there and placing it down over here, grain after grain after grain; and by the sea burying a tiny, white-shelled creature in the mud, shell after shell after shell.

It was formed by the slight movements of the earth's surface, by slow shiftings and liftings and slidings and faultings and foldings.

It was formed by the slow, silent cementing action and crushing pressures of ancient seas, and by the relentless cutting of a mighty river.

And even as you look, the changes continue.

The earth is moving; the river is cutting; and a soft wind is floating through the canyon, brushing its shoulder against some Chinese temple-like pillar of stone, wearing away a relic that was formed in the same silence that now witnesses its erosion.

IF YOU'RE VERY LUCKY, you'll not only get there when the wind is down, you'll get there when it's cloudy. The clouds make shadows. And the shadows make the canyon change. They cut into the rock, flowing in pools of ink across the wrinkled, eroded, wind-ravished landscape, pouring into the arroyos, washes, gulleys, canyons and valleys, flooding the hills, ridges, buttes, plateaus, boulders, rocks and cliffs, spilling over the tops of steeples, peaks, columns, spires, pinnacles and towers.

If you're lucky, you'll get to the canyon when the wind is down. When the wind is up, you tend to listen to it, rather than to the silence from below, for it whistles through the teeth of the juniper trees that guard the rim of the canyon. Indeed, there are times when the wind is full, and then it pours through the branches with the roar of a waterfall, rustling leaves, breaking twigs, showering you with noise, with whooshes and hisses and snaps and cracks. But mostly, the wind is still, and the trees stand mute, a hushed audience to the scene below.

And as the shadows seep over the cream and gray limestone, the grey slate, the black lava, the blood and buff sandstone, the red hermit shale, they turn the canyon into a layered cathedral of shifting colors, into soft whites and ochres, fiery-reds, rusty-tans, blacks, violets, vermilions, terracottas, whitewashed greens, dusty-pinks, and lavender-browns.

But it is a symphony for the eye, not the ear. Even when the sun thunders through the clouds and explodes in a shattering flash on the raging ribbon of the Colorado a mile below on the canyon floor, even then there is no noise. It is a silent explosion. You wait, expecting a low rumble or a crack of thunder to follow the flash. But the stillness holds. And you stand there a bit longer, listening, holding your breath, waiting.

Perhaps the best time of all to get there is at dawn. Dawn speaks in whispers, and the long, low light seems to make the silence thicker, just as it makes the colors richer.

Indeed, the quiet is so dense at dawn, that you begin to wonder if it is a force, if it is being beamed to other worlds just as radio waves are being beamed — a black hole of silence, speeding through space, swallowing the sounds of the heavens. And what will those creatures think should this immense canyon of silence envelope their world? Will they answer in kind? Will they flee in terror? Will they listen in awe?

You stand there wondering, listening; watching the colors silently change, alone in your cocoon of silence. Shhhh. Be still. Quiet. "Men fear silence as they fear solitude," the French novelist Maurois says, "because both give them a glimpse of the terror of life's nothingness." Perhaps. But there is no fear, no solitude, no terror, no nothingness in the silence at Grand Canyon. There is only awe. **AH**

APRIL 1981

BACK TO THE BASICS:
Life at the Bottom
of the Canyon

BY BILL McCLELLAN

ruce Aiken gestures toward the stream that rushes past his front porch and the steep canyon wall beyond it as he talks to his wife, Mary. "This is the real world," he says, and she shakes her head, counters as if on cue: "This isn't the real world, Bruce. The real world is up there, and it's a mess. Down here, this is better, but you can't say it's the real world.

"The real world is full of pollution," she says, "and problems and families that aren't close. We've escaped from the real world. We're lucky."

"We're lucky alright," amends Bruce, "but we haven't escaped the real world. We've escaped to it."

Both recite their lines with the familiarity of actors in a play that is enjoying a long and successful run. After all, a good-natured argument is an old-fashioned form of entertainment, and Bruce and Mary Aiken, by inclination as well as circumstance, are very much attuned to the simple joys.

They have to be. There is no television in their lives, no movies, no cocktail lounges. For about 10 months each year, Bruce and Mary and their three small children live at the bottom of the mile-deep Grand Canyon without those 20th century amenities. Their life-style was chosen years ago when Bruce was an ambitious geology student, so ambitious, in fact, that he set his sights low. He knew there was room at the bottom.

"Hey, if you love rocks, there's no place like the Grand Canyon. First time I came here, I thought it would be like a fantasy to live on the Rim. Then later, when I found out that there was a job that would mean actually living in the Canyon itself, well, I knew that somehow I had to get that job."

His voice trails off. A small yard separates his house from Bright Angel Creek. In the mornings, it's not uncommon for deer to graze in the yard. In the evenings, Bruce and Mary often haul out mattresses to sleep under the stars that blanket the sky on clear nights.

"Yeah, I heard about this job," Bruce continues. "I was summer help, working on a trail crew living over at Cottonwood Camp. We were working on the North Kaibab Trail, so we used to come right past this house on our way to work. I used to look at it and think how great it would be to live here. And then, of course, I got the job. That was eight years ago.

"And I'll tell you something else, and I'm really serious. Mary and I kid about it, you know, but right now I'm being serious. I think this is the real world."

Mary has gone inside and is reading to the children. Only the slight whirl of a tape recorder and the rushing of the creek disturb the silence. Since neither seem able to respond to the cue, Bruce shifts to another subject.

"I don't know if I want you to print this, but the Bright Angel, at times, has the best trout fishing in the state …"

He talks for a minute about the dietary habits of brown trout and the convenience of having dinner swim by the front porch, then excuses himself. It's time to go to work.

"Drop by the pumping station later," he says. "I'll show you around."

———

THE NORTH RIM OF THE GRAND CANYON is one of the wettest dry spots in the world. Despite an average annual rainfall of more than 22 inches and an average annual snowfall of more than 120 inches, there is virtually no groundwater. It disappears into the 250-foot-thick layer of Kaibab limestone that forms the capping formation of the north and south rims. This limestone is a perfect aquifer, readily dissolved by water with a slight acid base. The pine forests on the northern rim add just the right touch of acid to the rain and snow.

The limestone soaks up the water like a sponge, temporarily holding some while the rest passes down through channels that are steadily being carved and enlarged. After having descended more than 4,000 feet and taken on the appearance of an irresistible force, it runs smack into the immovable object — the Bright Angel shale.

When the water hits the shale, its downward flight is abruptly halted. It moves along the top

Shirley Aiken, age 5, splashes in Bright Angel Creek near her family's home in the Grand Canyon. | JEFF KIDA

Bruce Aiken paints one of the Grand Canyon's buttes. When this photo was published in *Arizona Highways*, Aiken had two successful showings of his work on the South Rim to his credit. | JEFF KIDA

of the impermeable shale until it finds an opening in the canyon wall. Then it pours out of that opening with such force that it could have only one name — Roaring Springs. At certain times of the year, the water rushes out at a rate of more than 5,000 gallons a minute.

And when that water comes roaring out ... Bruce Aiken is waiting for it. His job is to send it back up.

There's something special about night in the Grand Canyon. Mary slips into an almost rhapsodical monologue about night in the Canyon, as she moves along a trail on the way from the house to the pump station, half a mile away.

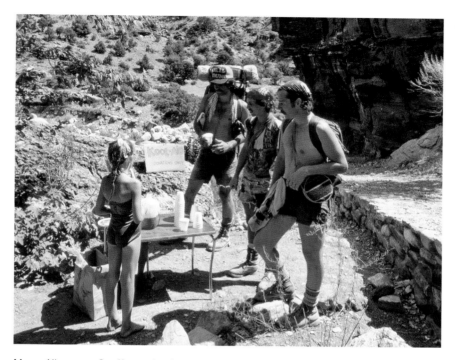

Mercy Aiken, age 8, offers refreshments to thirsty Grand Canyon hikers near the Aiken family home along Bright Angel Creek. | JEFF KIDA

"I never used to like it, you know," she says about life at the bottom, "until I started walking at night. See Bright Angel Creek? It flitters like that at night. It sparkles like diamonds as it goes over the rocks. It looks like a river of diamonds rushing past our house."

The trail she's taking is a shortcut. In one section, it begins to wind along the edge of a steep cliff. Mary turns on the flashlight she almost forgot, had remembered only as an afterthought, and shines it behind her as she walks. The night is dimly illuminated by a quarter-moon and countless stars. The canyon walls are somehow more awesome in the faint light.

"You can feel God," Mary says without pretense. "I never really knew God until I walked down here at night. I mean the power, the glory, all that stuff. You can feel God, sense His presence."

A visitor nods his assent. The sense of the creation, that this is how it all looked in the Begin-

ning, is almost intoxicating. It's easy to see why Bruce and Mary laughed at a question about drugs. They're both under 30. The question hadn't seemed so silly in the daylight, but who needs an artificial high when the real thing comes every night?

"It's really easy to hike in the moonlight, beautiful, too," says Mary. "It gives everything a different look. Some nights it's so clear down here you'd be amazed. And the stars. There are clouds of them.

"No, I've never seen a UFO. Not up close anyway. I've seen a lot of strange lights, but they were probably satellites or something. I used to look at the stars and think, 'Come and get me,' but that's when I lived in the city. I guess cities do that to you."

———

YOU OUGHT TO BE ABLE TO HEAR the pump station before you see it — inside it's loud enough with its clanking and churning that you have to yell to be heard by a person four feet away — but the water at nearby Roaring Springs is too much competition. Still, it's a noisy place to work. Outside the roaring of the water, inside the din of the machinery.

"I used to tell myself I'd never work around noise," hollers Bruce, as he shows a visitor the new pumps. "I was into quiet. Now I'm at home with this. I can hear a strange sound in all this noise and pick it up immediately. I know something's wrong, and I can usually tell by the sound what it is."

The pump station, which Aiken operates and maintains, supplies the North Rim with its only source of water. The first pumping facility was built in 1928 by the Union Pacific Railroad, which had been awarded a contract to develop the North Rim of the Canyon. Three pumps, each powered by its own 50-horsepower motor, were installed to pump water 4,000 feet up through 2.5 miles of pipeline.

The railroad turned the station over to the National Park Service in 1972, and the three original pumps, which Aiken named the *Primera*, *Segunda*, and *Stupida*.

The old station was demolished, and Aiken is sad about that decision. He thinks it should have been made into an historic landmark.

"I suppose I'm sentimental about things like that, but for years it was the heart of the North Rim," he says, and amid the clanking and churning of the pumps, his metaphor seems strangely appropriate. Then, detecting a foreign noise somewhere in the clatter, he jumps up to adjust a valve. When he comes back, he's smiling.

"Even new equipment requires attention once in a while."

Running water nourishes a thriving riparian area near the Aikens' Grand Canyon home. | JEFF KIDA

LIFE AT THE BOTTOM isn't all picking out noises, nor is it all religious hikes in the moonlight. There is the matter of making a home.

Mercy is 8, Shirley is 5, and Silas is approaching his 3rd birthday. The Aikens have been educating their children themselves. Mary has been teaching English and math and Bruce the sciences. The Aikens have no misgivings about teaching their children, but Mary sometimes worries about the lack of social interaction.

But that will be remedied this fall when the children will be enrolled in school in Ajo, the Aikens' winter home.

"There aren't many children hiking around down here. Whenever I see somebody with kids (the Aiken home is at the foot of the North Kaibab Trail), I rush out and offer to babysit. Usually the parents are delighted. But, like I say, it's unusual to see small children down here."

On the other hand, Bruce sees some advantages to the children's relative isolation.

"When we're on the outside, they fight a lot. Down here, they have to get along together. After all, if they can't get along with each other, who are they going to play with? And I think they learn to use their imaginations much more, too. They're always inventing games or singing."

Actually, the family's life-style is geared toward education. Bruce and Mary are both avid readers, and their interest has rubbed off on their children. Mercy already reads very well, and both parents constantly read to the children.

The world of consumer credit, however, will have to be taught. The kids won't learn by observation. Except for a grocery bill that arrives shortly after the monthly order has been flown in, and a telephone bill, the Aikens have few expenditures. Utilities are furnished by the Park Service and the monthly rent is automatically deducted from Bruce's paycheck.

The grocery bill is usually kept low through the family's self-sufficiency. Bruce often catches dinner in the Bright Angel, Mary is an accomplished baker, and a garden provides the family with fresh produce.

Perhaps partially because of their diet — "We couldn't run out and have junk food for dinner even if we wanted to," says Mary — the Aikens are an extremely healthy family.

"We've probably got the cleanest air in the state down here," says Bruce, "and the water from the springs is just great."

Also keeping the family healthy is the fact that they must walk everywhere. In fact, the only time the Aikens get ill is when they go topside.

"It happens like clockwork," laughs Bruce. "As soon as we get to the top, we rush out and do all the 20th century things. We go get a pizza or some hamburgers, go to a movie and buy some

candy. By the 2nd or 3rd day we're all sick, but at least we get those things out of our system."

Although the Aikens seldom drink alcoholic beverages, they usually order beer with the groceries. The beer is reserved for drop-in people.

Sometimes the people are relatives.

"They call this the Bright Angel Rest Home," laughs Bruce. "They come down and all they can do is rest. We just love it when they come.

"Yeah," he says, in response to a question, "they're all afraid of the hike up. Who isn't? It's a long climb. Sometimes just the thought of it makes them stay longer. We've had them stay for up to 10 days. But like I say, we love it. Just one time in 8 years have either Mary or I been sick, and that's when Mary had a sore throat and could hardly talk. I keep telling her, she brought it on herself by talking to her sister so much."

Sometimes the visitors are invited guests. Governor Bruce Babbitt, his wife Hattie, and their oldest son Christopher stayed with the Aikens several years ago, when Babbitt was attorney general. He had been unable to get a reservation in any of the regular campgrounds and, through an uncle who is a friend of one of Babbitt's hiking partners, the Aikens invited the Babbitts to stay with them.

"It was great," recalls Mary. "I really like them. They're just regular people."

Sometimes the people who drop in do so inadvertently. As employees of the Park Service, the Aikens offer first aid and help to hikers whose expertise is overmatched by their enthusiasm.

Some hikers fail to carry water with them. Some expect to find a hotel or a restaurant at the bottom of the trail and are dismayed to discover that the closest thing, the snack bar at Phantom Ranch, is nine miles away down Bright Angel Canyon.

Because of their isolation, the Aikens have had to manufacture their own diversions. Both Bruce and Mary paint. Bruce, who studied visual arts before moving to Arizona and falling in love with geology, has found that his interest in painting has been rekindled. He devotes much of his leisure time to the art, and has had several successful showings of his work on the South Rim. The sales of his paintings have increased dramatically, and Bruce says his art would be the only reason for leaving the Canyon.

Then there are the usual family singalongs, the nights spent reading together and, of course, the family hikes to fill up their time. The Aiken home is less than three miles from Ribbon Falls, one of Mary's and the children's favorite spots.

Perhaps most importantly, there have been hours and hours of talking. And at least a few minutes of old-fashioned, enjoyable disagreements.

"It's a back to basics kind of life," says Bruce. "That's why I call it the real world."

Mary smiles, shakes her head, counters as if on cue, "Bruce, this isn't the real world. …" ah

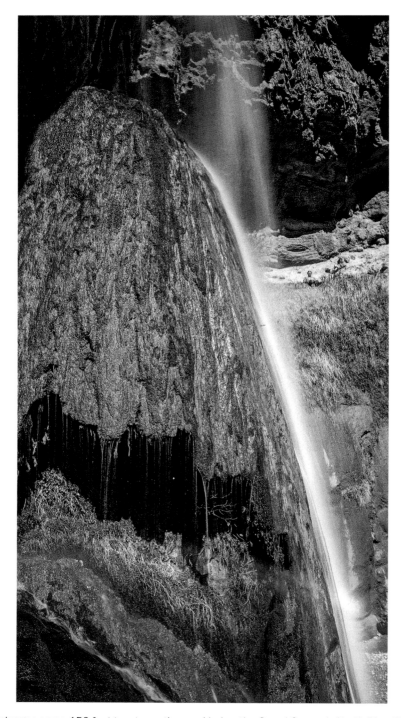

Ribbon Falls plunges some 150 feet to a travertine pool below the Grand Canyon's North Rim. Hikers can reach the waterfall via a short side trip from the North Kaibab Trail. | JACK DYKINGA

GRAND CANYON TREK:
A Personal Journey
Through a Vertical World

BY CHARLES BOWDEN

My head rests on the 1,200-million-year-old stone next to the roar of Bright Angel Creek. I am on my third day of vacation, and all the poisons seep from my body as it bakes in the seventy-two-degree sun. It is 4:10 P.M., March 20, 1984, at Cottonwood Camp deep in the stone heart called the Grand Canyon. For weeks I have talked to crime victims and taken their pain and poured it into a newspaper. I am sick, my body a reservoir of hurts I cannot seem to touch or cure.

Cottonwoods (*Populus fremontii*) strike at the sky with green buds firing from the limbs. Stones stare up from the creek bottom: red stones, orange stones; amber, brown, black, white, rust, silver, pink, gold stones. The water dancing down the Canyon splashes, swirls, roars, thrashes, babbles, crashes, tinkles.

Red drains from the sandstone walls.

I have never been in the Canyon before, and I am marching with a backpack toward some dream of peace.

My eyes drift across the water, the heat washes over my back. A hawk screams, and then a raven flaps downstream with something hanging limp from the black bill. I turn over just as the shadow rolls across my body. I fall asleep on the old stone in Bright Angel Creek.

I avoided the Canyon for a long time. The park had too many rules, the gorge sliced too deep

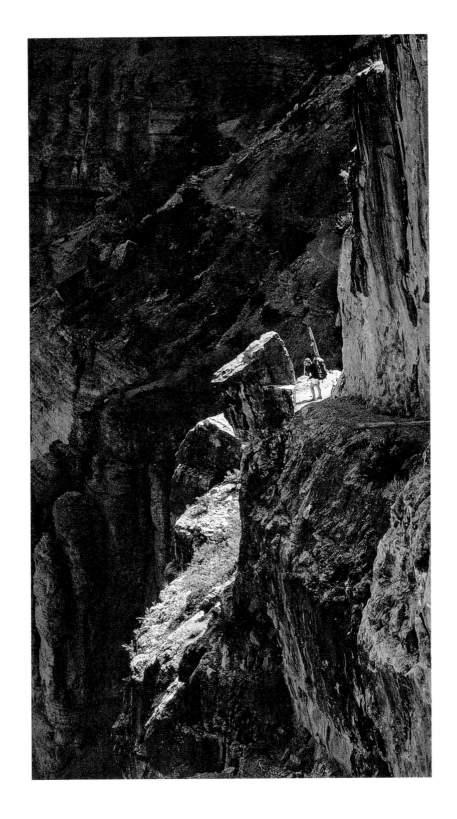

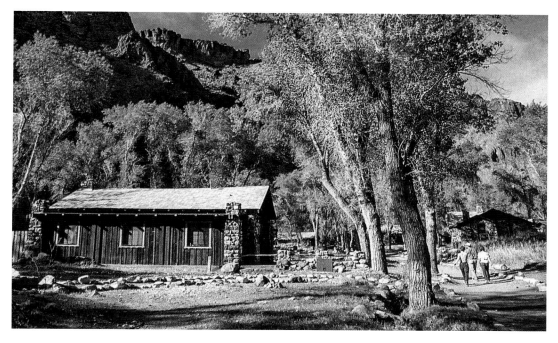

Left: A hiker treks down the North Kaibab Trail. From its trailhead on the North Rim, the route runs about 14 miles to the Colorado River. | JACK DYKINGA

Above: Phantom Ranch, a vertical mile below the Canyon's rim, offers a respite for weary hikers. | JACK DYKINGA

into the earth, the stone walls stared from too many calendars. There was no shortage of reasons.

The first time came when I was fifteen. My father and I pulled into the South Rim after dark. Generators purred in the night air, and the campgrounds rumbled with life. We showered and ate and, with the dawn, walked to the South Rim.

We looked at the canvas called the Grand Canyon, a wallpaper of a stone layer cake under a blue sky.

My father shrugged and asked, "What can you do after you've taken a look?"

And we moved on.

The names poisoned the place for me: wonder of the world, awesome, grand. And it was too big, a giant maw gaping with stone gums. I kept going elsewhere and left the Canyon to the Park Service and the tourists. The numbers coming to the Rim kept growing and growing.

And I was puzzled by this devotion.

I step off Yaki Point at 11:40 on March 19 and walk through stone to Cedar Ridge 1,500 feet below. Signs tout the names of layers, but all the geology blurs as I plod along. The junipers cling to the ridge and hikers clamber up to the red knoll with the depth of the Canyon written across their faces. Ravens twirl on the thermals, the wings whirr, the voices scream *gwawk, gwawk*.

I hurry and yet go slow as the Canyon pulls me in, and the strangeness of being on the trail slows me down. I am a refugee from the steel desk, the exploding phone, the soft shadows cast by ceilings of fluorescent lights. My lungs react to fresh air like an exotic, unproven gas, and my feet revolt at contact with the earth. Within an hour, blisters appear because laces have been tied too loosely and the hike undertaken too casually.

I sit down and put moleskin on my feet, adjust the boots, and stare off into the Canyon, a tapestry that seems impenetrable. A cavalcade of fellow voyagers passes me by: boys in shorts, a man in a trench coat, a couple from Beloit, Wisconsin, with packs and an eleven-month-old child. Below the Rim, the sounds are voices laughing, and wind, the rush of air across the stone empire.

I cannot see the colors: the reds seem faint, the greens bleak smudges.

By 2:20, the lip of the Inner Gorge reveals the Colorado River, a green ribbon thrown carelessly against dark rock. A bighorn crosses the trail five minutes ahead of me, and a high-school girl from Oklahoma shakes with excitement.

"I'd like to spend a day," she confides, "as each of the animals in the Grand Canyon."

By 3:40 I am at the bottom and in camp.

The air temperature is seventy degrees, and women lie on the beach drinking the sun.

I am 4,600 feet below the Rim.

I stretch out and sip Scotch from my Sierra cup and look at the stone wall across Bright Angel Creek.

One world falls away and sleep coaxes me toward another one.

The second day takes me through gigantic walls 2,000 million years old: Vishnu schist. The creek rips along as if the stone were butter. Then the Canyon widens, and the trail wanders through thickets of sawgrass and cottonwoods. The ground turns to muck and canyon wrens trill on all sides. I look back and see the South Rim rising up like the wallpaper of the day before. Except now, I am in the wallpaper, and it is no longer flat. The bands of color become stone, and the stone is texture rubbing across my fingers. The air sags with scent off the meadow and lizards dart. From time to time, a red squirrel watches my progress.

Off the stream a desert of blackbrush, agave, prickly pear cactus and mesquite hems in the

thread of water racing from the melting snows of the North Rim.

It is sixty-seven degrees in the shade, and, as I climb, the summer of the Inner Gorge gives way to springtime.

Green slime slides down the hard cone. Water topples from a high ledge and splashes down. I sit behind a torrent tumbling off the cliff and dancing in the light: Ribbon Falls. A small stone hollow behind the falls offers the perfect view. A high-school boy looks at me and asks, "Ain't you going to go for it?"

And then he steps out under the waterfall and stands on the massive stone cone created by calcium deposited from countless years of runoff. Green moss blazes between his toes and the sun sparkles on his soaked body. The boy becomes a swatch of blue jeans and tan skin under the white molten cascade of water.

He bounds back into the cave and says, "Feels great."

He calls down to a friend: "This ... is ... awesome!"

A couple of dozen people sit at the base of the falls eating lunch, watching the water tumble, and devour the quiet of the Canyon. The cone covered with moss stands against the muted tones of the terrain like an emerald thumb. No one speaks of the sight; they nestle within the calm.

The high-school science class from Jenks, Oklahoma, rests on a sandstone bench. One boy pans for gold in the stream. Down the creek, a delegation of the Iowa Mountaineers suns on a big rock. They are part of a party of thirty-two who have driven west for five days in the Canyon. The forty-four-year-old club has been coming here a long time, and they demonstrate a point that is easily forgotten. The Grand Canyon may be in Arizona, but it is claimed by the whole nation and much of the planet. So far I have run into Chinese, Britons, and Japanese. One man from Iowa figures half the people in the Canyon are foreigners. He says they always tell him they have three goals in the United States: New York City, the Mississippi River, and the Grand Canyon.

Three college girls from California sun on a cliff overhead. Everyone talks but no one remarks about the stone and the water and the splatter of light off the falls. This place has moved past the words into a better country.

The water hits the rock with a roar and inside the roar live brighter sounds that pierce the din like flashing daggers.

At Cottonwood Camp, the trees are barely in bud at 3,900 feet. Spring has just brushed this place. Rufous-sided towhees dart through the brush, and green peeks from the brown mat of the meadow. There are four people here tonight.

I finally move past my ideas about the Canyon and enter the Canyon. My boots have come

through meaningless tons of time. Vishnu schist, Bass formation, Hakatai shale, Diabase Intrusive sill, more Hakatai shale, Shinumo quartz, and now I stretch out in my sleeping bag in the Dox formation. My hand constantly runs across the rock feeling dead fires, dead seas, dead lives whispering from the trapped molecules. The waters of Bright Angel Creek have ripped open the tomb, and a past I cannot comprehend swallows me as the sun dies behind the cliff. A breeze brushes my skin, the trees scratch the sky with bony fingers.

The moon comes up and pours white over the stone like spilled milk. A satellite slips through the stars, and I listen and look and then fall into the tunnel that leads to dawn.

The sun cracks the hold of night, and it is forty-two degrees.

I swallow black coffee and spoon a meal of instant oatmeal. The birds fire salvos of song, and the creek moves from dark thunder to a swirl of light. The trail above Cottonwood Camp follows a gentle climb through the rock. A quarter-mile up the path, the cottonwoods have no buds, and spring is still a dream. Rainbow trout thrive in the cool waters, and in the morning light I see forms facing the drive of the water.

The sun washes over the riffles like pressed leaves of gold, and I become hypnotized by a nineteenth century romantic painting suddenly emerging from the stone and quiet of the Canyon.

I have been below the Rim now for more than two days and remembering this fact requires effort. Day of the week, month of the year become facts empty of information. Like the digital watch flashing on my wrist, the bits of data tell me nothing.

The Grand Canyon is a subject that has snacked on the photographs, paintings, and prose of thousands of visitors. It has sent writers ransacking dictionaries and artists scrambling through their palettes.

The place probably does not exist.

I am standing on a path a foot or two wide at about 4,200 feet on the North Kaibab Trail in the early morning as swifts ride towers of air and the stone shakes off the cold as the sun comes on. The sounds available are the drive of water, the whisper of air, the songs of birds, and the bang of my heart. I can see part of the Canyon framing Bright Angel Creek and glimpse the top layers of the North Rim standing against the sky.

I cannot see the Grand Canyon.

That one is for the big books and aerial photographs.

This place is for me.

The trail wrenches left and crosses a bridge to enter Roaring Springs Canyon under the North Rim. A small house with a picket fence sits among the trees. Chicken wire protects a garden from the deer.

Mary Aiken fled Seattle one day years ago when it was fifty-six degrees there and she climbed from an airplane in Phoenix to a sun throwing down 112 degrees. She realized two things at that moment. One, she had been cold all her life. Two, she had found home.

Eleven years ago she and her husband Bruce came to Roaring Springs. He had jumped at the chance to man the pump house which supplies the water for facilities on both the North and South rims. Mary, a young mother with a child under a year, was not so sure about making a home five miles by trail from the top of the Rim.

At first, she wondered about living eight months of the year in a giant stone hole. And then for a decade she wondered if she could ever leave.

Bruce took the job so that he could pursue his career as a painter, and now he does very nicely selling oils of the Grand Canyon. The family has grown to Mercy, eleven, Shirley, nine, and Silas, six.

Bruce's training for running a pump house amounted to going to fine art school in New York City. He fuzzed his background a bit on the application and did a fast study of a pump manual. Now he is the local expert on the plumbing.

The previous master of the pump stayed twenty-four years and raised five children.

Bruce is not real sure when he will leave. At first the job was a way to finance the painting. Now the painting has succeeded, the galleries call and the canvasses sell and Bruce has to face the fact that he simply does not want to leave the Canyon.

Mary teaches the children.

"It's really hard teaching your own kids," she sighs. "Besides, I've forgotten how to do things like fractions."

A chalkboard by the kitchen table holds an English lesson. A quote runs across the top: "Man does not live by bread alone, but by every word that comes out of the mouth of God." — Matthew 4:4.

The water crashes over the rocks out the window, the sun eats its way down the cliff, and Mary pours black coffee into the cool china cup.

Now the stone becomes mine as the trail crosses the Tapeats and enters the Bright Angel shale. I move up into the golden Muav limestone, and at about 5,500 feet reach the Redwall with its sheer cliffs.

The trail becomes a rock ledge hanging over the giant hole of the Canyon. Ice and snow cover the shadows, and I finally believe I am in a monster wound reaching deep into the planet. I cross another bridge and enter the Supai formation, and the climb becomes a steep trudge to a tunnel that takes me to the Hermit shale.

I am 7,000 feet in the air, and oak gives way to pine and pockets of Douglas fir. A stone tower leads me up and up into a world that looks like Canada if I stare straight ahead. Behind and below me lie layers of oak, layers of juniper, layers of desert, successive waves of winter, spring, and summer.

At 8,200 feet I top the Rim in a grove of aspens. The ground is snow and ice, and I look back to see the San Francisco Peaks eighty miles away, lording it over the Canyon.

I make a cup of hot cocoa, pitch the tent, and wait for dark to change the blaze of white snow into the shimmer of silver.

First clouds roll in, then the thunder and lightning begin, and a spate of showers. The temperature sinks below freezing, and the rain goes to ice, the ice to snow. I listen to the tent shift under the fists of wind and finally let sleep take me.

At 12:49 A.M. a slash of lightning followed instantly by a clap of thunder pulls me from my dreams. I look out the tent door at moonglow caressing the fresh snow. Two screams shred the night air. A lion moves along the Rim to my left.

Stars search through the drift of clouds on the North Rim of the Grand Canyon.

At first light the mercury stands at eighteen degrees. My feet crunch against the clean flakes. I walk the forest of fir and spruce, black fangs raking the deep blue sky minutes before dawn.

The Canyon stretches before me, a black stone throat.

My body is sore from twenty-two miles of hard trail with a heavy pack. I cannot say that this walk is for everyone. But everyone should dream about taking this walk through stone worlds and seasons and life decorating vertical walls. Behind me the roads of the North Rim lie buried under the winter snowpack.

I will descend the Canyon to the Inner Gorge where it will be in the 70s or 80s, and in two days I will climb over the lip of the South Rim and be out.

I will take a second look at the pockets of flower and rock and stream and waterfall. Perhaps, I will understand.

No matter.

I will be back. ᴀʜ

DECEMBER 1986

FORWARD ...

BY FRANK WATERS

The first picture of Grand Canyon I saw as a small boy was a photographic card inserted into our family stereoptican. It evoked from me the clamor of every boy for the Big Adventure of those days: a mule trip down into the Canyon.

So of course we went, riding the spur train to the South Rim and looking down from Fred Harvey's new hotel, El Tovar. Mother in long skirts and big hat, holding her parasol in one hand and little sister by the other. Papa in riding boots, and the mule driver boosting me upon the back of a scrawny mule. Then down we plodded on a narrow, twisting trail.

The greatest chasm in our global earth then seemed to me more than I could comprehend. It still does, after so many years of trying to plumb its sublime expanse. Grand Canyon has never been adequately described. It never will be. We can be wary of the wordy rhapsodies written by so many observers.

My view back in Colorado, where I lived, had been of lofty Pikes Peak and the front range of the Rockies. Down here in Arizona, I now can practically see it again — but upside down: an immense intaglio instead of a cameo, 217 miles long, up to thirteen miles wide, and a mile deep. In it rise high peaks, flat-topped mesas, squat buttes, and wide plateaus. There emerge in the shifting light other archetypal forms named for Cheop's Pyramid, Wotan's Throne, King Arthur's Castle, and temples for Buddha and Brahma, Zoroaster and Confucius, Apollo and

Jupiter, and the sanctuary of the Holy Grail.

It often seems as if Grand Canyon is an immense house of worship itself, dedicated to every faith and myth-drama spawned in the world — a vast universal recollection of all mankind's architectural and religious heritage.

You may not distinguish the varied forms at sunset when color floods and dissolves their sharp outlines. The hues are royal purples, angry reds, shrieking yellows, cool greens, and soothing blues, all enacting their own drama. During this magic hour when the cliff swallows are skittering below my own perch on rimrock, the Canyon seems unreal. A realm of the fantastic unreal, the nonexistent material world of the senses defined by the ancient Sanskrit word Maya — the world of illusion.

The Canyon shows its hard-rock reality on a muleback ride down through a vertical slice in its mile-deep walls. Yet even then it suggests another element of its unfathomable mystery.

At the bottom, where the river is still patiently gnawing at the foot of the sheer walls, one can experience the Canyon's impalpable fourth dimension. Here its depth translates into time. The compressed, twisted, and folded layers of its rock walls, seen in profile, reveal the great geologic eras and ages of the earth measured in hundreds of millions of years. From the Cenozoic or Modern Era on top — with its brief one-million-year Age of Man — we read down through the periods of reptiles and dinosaurs, fishes, toothed birds, and land plants, to the oldest Archeozoic Era. Here protrudes part of the earth's original crust formed before the planet had cooled. An earth some two billion years old, if geology has put its decimal points in the right places.

We can go no farther back into the past. Nor can we extrapolate into the future.

There have been schemes to commercialize Grand Canyon, even to flood it, like its neighbor Glen Canyon. To bureaucratic and private-interest promoters nursing similar ideas, I would recommend the advice of the distinguished English author J.B. Priestley: "If I were an American, I should make my remembrance of it the final test of men, art, and policies ... Every member or officer of the Federal government ought to remind himself, with triumphant pride, that he is on the staff of the Grand Canyon."

Yet it is not ours alone. It belongs to everyone, of all races and nations, to preserve as a temple of our one common Mother Earth. ▪▪

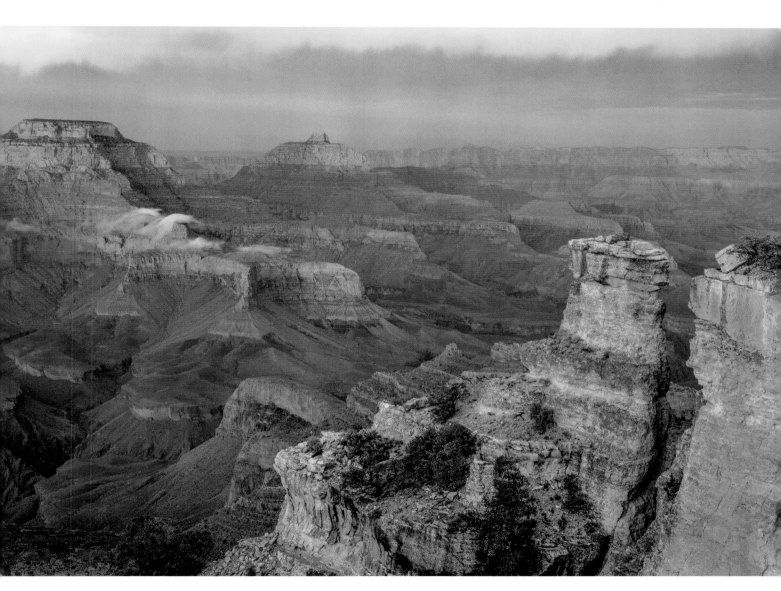

The Grand Canyon glows and distant storm clouds turn purple in the light of late sunset, as viewed from Yaki Point on the South Rim. | JACK DYKINGA

HARVEY BUTCHART AND HIS GRAND CANYON

BY ED SEVERSON

Harvey Butchart's legs have logged a lot of miles in the last 40 years. The 80-year-old retired Northern Arizona University mathematics professor, now living in Sun City, has scrambled, climbed, clawed, slid, and inched his way through 12,000 miles of the Grand Canyon — mostly between the crowded contour lines that, on topographical maps, indicate steep walls, abrupt drop-offs, and plunging slopes.

Take Saddle Canyon, for example, west of Marble Canyon at a spot where it appears that if you stumble, you'll fall forever. If you had been there on a late December day in 1969, you might have noticed a rope attached to a small tree, and the end of the rope pulled tight over the edge of a cliff. Creeping forward to peer down, down, 80 feet or more — as your stomach clenched like a fist — you would have seen someone hanging upside down. It was Harvey Butchart, who at that moment was busy solving a serious problem.

But to back up a bit: Harvey Butchart began life in Hofei, China, where his parents were missionaries. He might have taken his first step toward Saddle Canyon when he was five years old. "My father and another man were going on a hike," he said. "I begged to go with them, insisting I could keep up, and my father made me promise that I'd walk all the way." Unfortunately, young Butchart's legs turned out to be shorter than his promises. "The other man took some pity on me and did some carrying," he remembered.

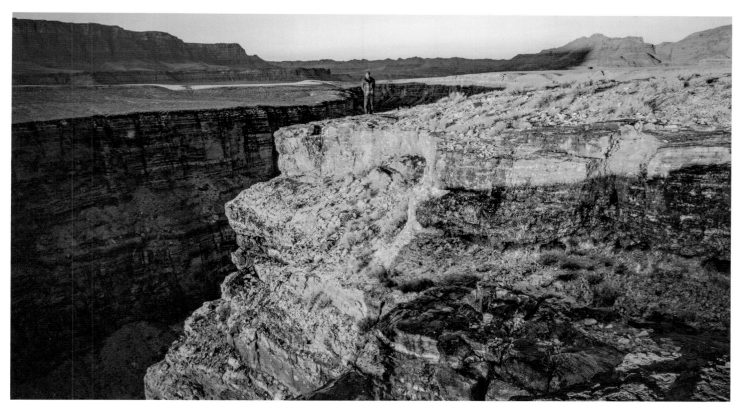

Harvey Butchart surveys Marble Canyon, the eastern section of the Grand Canyon. Butchart, who died in 2002, spent nearly three years' worth of days in the Canyon. In 2008, a previously unnamed peak near Point Imperial was officially named Butchart Butte in his honor. | JACK DYKINGA

Butchart got his early education at the American school in the area, where hiking was the main recreation. As a Boy Scout, he would go camping two or three days at a time, a habit that left him with a lifetime craving for the outdoors.

When his father died in 1928, the family returned to the United States. By the time he went to college, he had developed a spare, efficient physique that he put to good use on the tennis team by winning all of his singles matches.

In 1945, fate funneled him in the direction of the Grand Canyon. Armed with a Ph.D. in

With the help of a rope, Harvey Butchart navigates a difficult stretch of Jackass Creek, one of the many routes to the Colorado River that he pioneered. | JACK DYKINGA

mathematics from the University of Illinois, he accepted a job at NAU (then Arizona State College) at Flagstaff. He soon became involved with the ASC hiking club, and was its sponsor for 12 years. During that time, he hiked most of the Grand Canyon's main trails. Gradually his interest in the Canyon grew, until it became a passion.

His explorations eventually branched out to abandoned trails, to deer, burro, and sheep trails; finally he was pioneering his own off-trail routes. In his more than 1,000 days of hiking and climbing in the Canyon, Butchart has found 108 different approaches to the Colorado River. He climbed 83 of the named Grand Canyon summits — those temples, thrones, castles, and ships that loom up from the floor of the great chasm. Twenty-five of those climbs were first

ascents. He has also climbed the Canyon's 500-foot Redwall limestone cliffs in 164 different places. After a time, almost everyone planning a really serious Grand Canyon hike sought him out for technical information.

One such was writer Colin Fletcher, author of *The Man Who Walked Through Time*. When he was preparing for his long trek across the Canyon, he discussed his plan with Butchart. "Dr. Harvey Butchart, I was relieved to find, knew exactly what he was talking about," Fletcher wrote later. His gratitude is reflected throughout his classic adventure odyssey. Butchart's name permeates the book like the Canyon's own underlying layer of Vishnu schist.

Butchart has written his own books on the Canyon, too, condensing 1,069 pages of meticulous trip notes — a tad longer than *War and Peace* — into three slim paperback guidebooks: *Grand Canyon Treks* and *Grand Canyon Treks II* and *III*. Written by a determined man for determined hikers, the books have sold more than 64,000 copies.

In 1972, *Time-Life* editors referred to Butchart as the "most experienced of all Canyon hikers" in the book *The Grand Canyon*. That experience came at a high price. His explorations nearly cost him his life on three occasions, and he's broken half a dozen bones.

Butchart's guidebooks are for experienced hikers. "When you read his books, you get no idea of the difficulty of the routes," claimed Tony Williams, who has hiked with Butchart numerous times. "If you talk to Harvey, he'll say, 'Oh, yes, I chickened out of that twice before I finally did it.' But in his books, he just dryly describes how this route goes. Yes, it does go, but it may take a lot of guts, strength, and skill to do it."

The first time Jim Ohlman went into the Canyon with Butchart, they climbed Newton Butte. "Basically, he wore me into the ground," Ohlman recalled. Ohlman has climbed about 130 of the Canyon's 147 named summits. He is one of several men competing to be the first to climb all 147. All the men have hiked and climbed with Butchart.

Ohlman remembered that on that first climb, Butchart took along two expert climbers. When he reached a place that was beyond his climbing skill, he pulled out his Jumars. (Jumars are a pair of handles that attach to a climbing rope. They will slide up a rope but not down. By putting your feet in slings that hang from the handles, and by alternately moving the jumars up, you can climb a rope.) "He had a special goal he had set out to reach," Ohlman said. "And he was going to reach it whatever way was necessary to get there."

Not so with Al Doty, who has been on two dozen trips into the Grand Canyon with Butchart and has climbed more than 70 of its summits. "If things get to looking bad, I'll give up," he said. "Butchart will just keep going. I've been with him when he had his mind made up to reach a certain point, and he wouldn't stop until he reached that point."

"If you know the vocabulary of his books, you know that when he says a particular thing is 'sporty,' or worse yet, 'very sporty,' it's going to give you pause," Tony Williams said.

All of which gives you an idea of why Butchart was hanging from his heels in Saddle Canyon. He had set out to get to a ledge below, and he was going to get there. Period. He had attempted it twice. But to get to where he wanted to go, he had to do an 80-foot rappel, tying on a diaper-like sling, hooking it to a rope, and sliding down. It was indeed a sporty route. "When I came down the rope, it turned so fast I was almost sick to my stomach when I got down," Butchart recalled.

He remembered how happy he was to find the nerve to follow through "after I had chickened out." But when he started back up the rope, using his Jumars, he began turning again. To avoid that, he untied the belly band that attaches to the rope. A mistake: the band is what keeps your feet under you.

His feet flipped chin-high, and he found himself hanging by his hands from the Jumars with his feet through the slings. After a few minutes, he couldn't hold on any longer and fell backwards, hanging by his feet from the slings about 10 or 15 feet off the ground. It was now a very sporty route.

He found he could reach down, grab a shrub, claw his way up a steep slope, and rest his shoulders on the ground enough to fumble with his shoelaces. It took 40 minutes of struggling, but he was able at last to get his shoes off, pull his feet out of the slings, and free himself.

But he wasn't out of trouble yet. Now he couldn't go back up the way he'd come down. And getting out and back to his vehicle was going to test his very ability to survive. All night he hiked in near-freezing temperatures without benefit of a warm coat or jacket. In the dark he stumbled through a thicket of thorns, and later found himself groping along a ledge on all fours. Not until the next afternoon did he finally arrive at his car, bruised but undaunted.

Two weeks later, he returned with a friend, Bob Packard, to get his rope and Jumars. Packard took one look at the place where Butchart had rappelled and said, "You couldn't pay me to go down there."

Once Butchart was attracted by a photograph of a place called Mystic Spring that he saw in a 1903 book titled *In and Around the Grand Canyon*, by G.W. James. He wanted to stand where the photographer had stood and take a picture of the spring.

"I went on one of his searches to duplicate the picture," said Packard, a dedicated Canyon hiker in his own right.

"Third try for Mystic Spring picture, Jan. 30, 1972," Butchart wrote in his notebook. "First we looked carefully at the place where the map showed Mystic Spring, and Bob led me down a couple of levels below where I had looked before."

Although they didn't find the spring that day, Butchart was pleased that Packard "took a keen interest in the old sport of picture identification." It took seven tries over a period of 10 years before he finally found what he was after.

On another occasion, an Indian named Wahlin Burro had told an anthropologist that Indians had once farmed near the mouth of Fossil Bay. Intrigued, Butchart sought out the Indian and questioned him about the route. Burro gave him the impression there was a shorter way down to the river than the normal one, which was a two-day walk. That was enough to get Butchart excited. For the next 10 years, he searched for the shorter route, making repeated trips to the area and studying it from the air. He kept chipping away at the problem, even after he broke his heels near Royal Arch Natural Bridge. He had been through the same place before and had jumped the same small pool. But this time he landed awkwardly. "I was grandstanding," he said. "I have to admit I was trying to keep from looking like a weak sister."

Other embarrassments followed. A National Park Service helicopter responding to a companion's call for help had to land on top of the arch, which meant Butchart would need assistance in getting to the aircraft. "I had to be piggybacked part of the way by a strong ranger," he said. It was the first time he'd had to be carried back from a hike since he was five years old.

But eventually he rediscovered the old route he'd been looking for. "It gave me more satisfaction than any other," he said.

A new climax to his Canyon hiking career came one morning not long ago. High above Badger Creek Rapids, the 80-year-old Butchart waited for his companions to crawl out of their sleeping bags. "Do you mind if we do a little project I have in mind?" he asked when they were awake.

They agreed to go along and, after breakfast, he got behind the wheel of his old blue car and they headed off toward traces of old roads near Echo Peaks, close to the Colorado River. At road's end, everyone slipped on packs. Butchart strapped a canteen over his shoulder and stepped out fast. He was in such a good mood, he even told a few old jokes, and everyone laughed.

It wasn't until later that his friends realized this wasn't just any hike. Something special was going on. Butchart was a little too jovial, a little too excited. What was happening?

When the group at last arrived at the water's edge, Butchart climbed carefully down out of the rocks and walked across a small beach. Kneeling very slowly, he dipped his hand into the water and looked up at them, grinning and radiant. He had now hiked to his river by a total of 108 different routes. ⏹

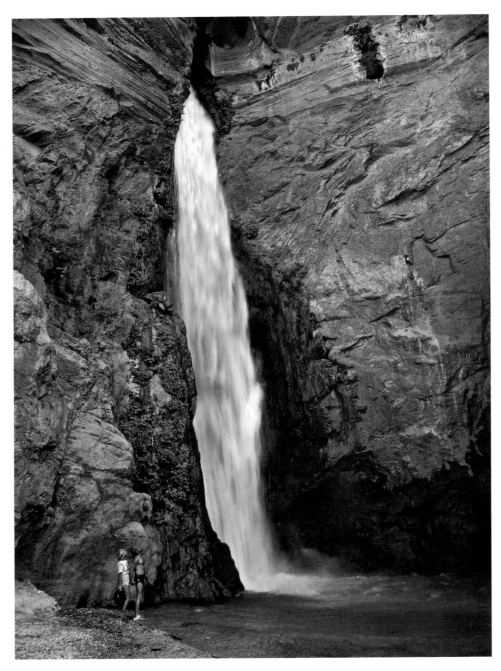

Grand Canyon explorers admire Deer Creek Falls, which nourishes a hanging garden as it pours into the Colorado River. The waterfall is a popular stop on Canyon rafting trips. | JERRY JACKA

CANYON MAGIC:
White-Water Adventure and Calm Contemplation Work Their Spell on Grand Canyon Rafters

BY LOIS ESSARY JACKA

When I first boarded a rubber raft with a group of friends to travel through the Grand Canyon, I didn't know what to expect. But I went armed with two essential ingredients for a successful trip: enthusiasm and a spirit of adventure.

During the 300-mile Colorado River voyage, I discovered not only the incredible power of the river but a quiet sanctuary of desert wilderness laced with streams and waterfalls — and several reasons to take the trip again: beautiful scenery, unexpected thrills, relaxation, and just plain fun.

The river's course descends almost 2,000 feet between Glen Canyon Dam and Lake Mead, the final destination, providing plenty of white-water thrills. Some 60 major rapids lie along this stretch, several of which are rated among the most challenging in the country. Like kids at a carnival, we whooped and hollered as the raft pitched and tossed through these rocky channels.

Wilderness River Adventures had promised a maximum of service and safety, adding a confident "Leave everything to us." We did, and they more than lived up to their promise. Our only responsibility was holding on while riding the rapids; the only decision we had to make was where to place our bedrolls at night. Time lost its meaning. There were no telephones, no appointments or schedules, no newspapers or television. And certainly no concern about appearance — everyone looked slightly disreputable in a very short time. The outside world faded as we traveled through a time warp of lost days.

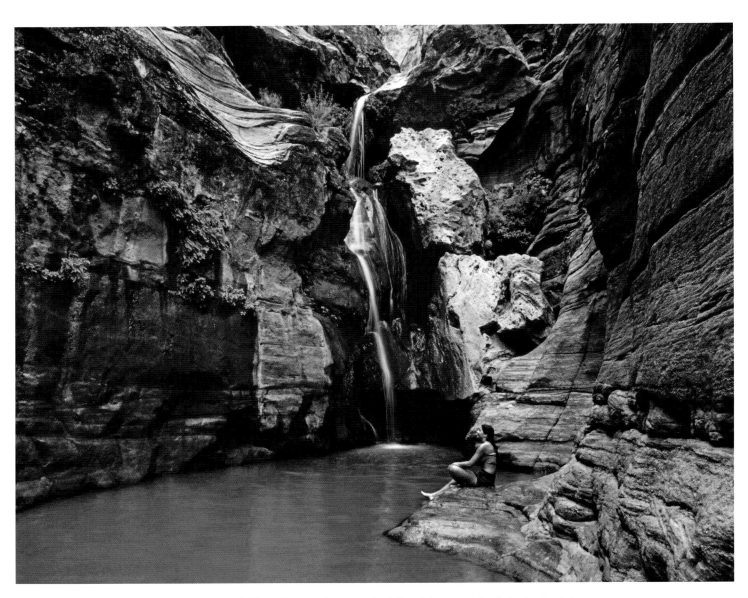

Sandy Lewis relaxes in shady Elves Chasm, where a waterfall sustains a variety of plants along steep canyon walls just off the Colorado River. | JERRY JACKA

We also became fascinated with travel off-river: short hikes up serpentine sandstone canyons and over desert hillsides leading to cascading waterfalls surrounded by ferns or tall cottonwood trees; clambering up steep narrow gorges such as Blacktail, Matkatamiba, Travertine, Deer Creek, Elves Chasm; hiking to Indian ruins; and trekking three long miles on a twisting uphill trail to Thunder River. There, an almost unbelievable waterfall roars from a cave high up in the Muav limestone cliffs and plunges, leaps, and streams its way down through narrow chasms and canyons to Tapeats Creek and the Colorado River far below.

On the river's calm stretches, we floated along and enjoyed the scenery and wildlife on the shore. On several occasions we spotted mountain sheep, and two big rams once posed majestically on the rocky cliffs high above.

We gazed at incredibly blue skies rising above the Redwall cliffs or the black schist walls of Granite Gorge and marveled at the ever-changing colors: hues that vary from moment to moment with the shifting light.

The Canyon worked its magic well. After several Colorado River trips, I now know that the water may be so muddy that, as the old saying goes, "it's too thick to drink and too thin to plow"; rain may pour down; winds may sandblast my skin while playing havoc with a campsite; the day may be unbearably hot or the river water unbelievably cold. But I have also gazed in awe as a storm swept into the Canyon and a double rainbow appeared out of the black rolling thunderheads, spanning the Canyon rim to rim. I have camped on white sandy beaches and savored time spent in unbroken solitude and silence. I have marveled at the incredible hush that settles into the great gorge, the millions of stars that fill the night sky, glorious sunrises, surrealistic sunsets, and moonlight that casts a mystical glow.

And I know I must return. ◫

SEPTEMBER 1993

ARIZONA WILD AND FREE

BY STEWART UDALL

Three generations ago, Stewart Udall got his first real taste of the wilderness from his uncle while pursuing the elusive Apache trout in the small streams of the White Mountains of northeastern Arizona. Udall was 10 at the time. So impressed was the boy that he later devoted much of his life to protecting and managing the environment, even serving in the 1960s as secretary of the Interior.

Sixty years later, he had another wilderness experience, this time in the Grand Canyon with his nine-year-old grandson. Here is Udall's account of that adventure. It is excerpted from Arizona Highways' *latest book,* Arizona: Wild and Free, *which also features photographs of the state's diverse scenery and its amazing variety of wildlife.*

Hiding from the searing sun under a piñon tree 2,000 feet above the Colorado River, I rebuke myself for being so stupid. I should have known better than to try to hike out of the Grand Canyon on an abandoned mining trail in midsummer. And yet here I am — with my grandson Kyle Townsend in tow — wondering if my legs will get me to the South Rim by dark.

But I'm getting ahead of my story. Some months earlier, Grand Canyon Trust, an environmental organization, had asked me to host a week-long trip down the Colorado River for its

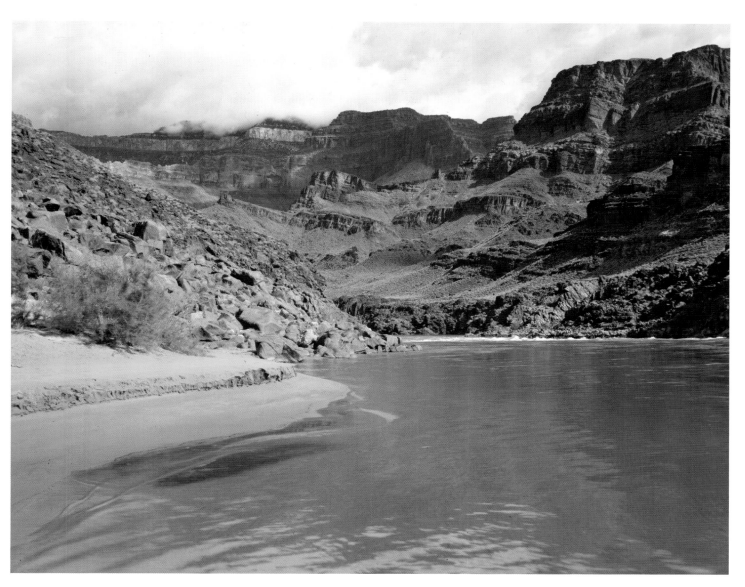

A beach at the end of the South Bass Trail, which descends from the South Rim to the Colorado River, offers a view of Bass Rapids downstream. | RICK DANLEY

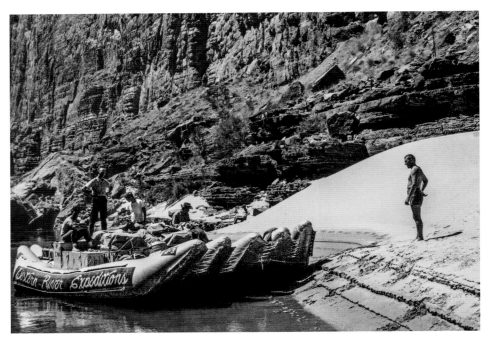

Interior Secretary Stewart Udall stands on a Grand Canyon beach during a June 1967 trip down the Colorado River. | COURTESY OF GRAND CANYON NATIONAL PARK MUSEUM COLLECTION

members. Since I sit on the group's board, I happily accepted the invitation, but on the condition that I could bring Kyle. A last-minute change in plans, however, made it impossible for me to spend an entire week on the river. In hindsight it would have been wiser to cancel. But, not wanting to disappoint Kyle, or the people from the trust, I told them we would come for part of the trip.

And so, three days before, our small party of adventurers had hiked down the Bright Angel Trail to Phantom Ranch where we met the rest of the group and embarked on the river. Kyle was the youngest participant, and I was the oldest. The head boatman put us in the bow of his oar-powered raft where he could keep a watchful eye on us as we bucked through Horn Creek, Granite, and Hermit rapids. It had been 24 years since I had been on the Colorado, and this was Kyle's introduction to river running, but both of us reveled in the whitewater. The next day we ran the big one — Crystal — before making camp on a beach below Bass Rapids. From here our plan was to hike up to the South Rim via the Bass Trail.

Having had a taste of the Canyon's fiery heat, I was apprehensive about what the morrow

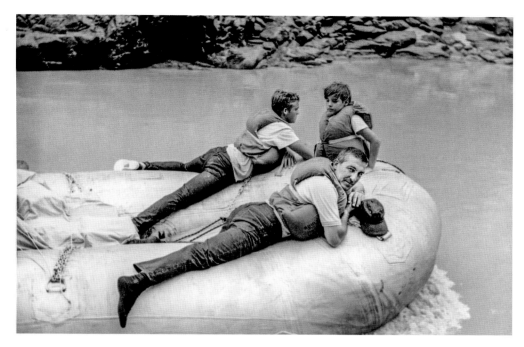

Udall relaxes on a raft during the same trip in 1967. Behind him are Jack Metzger and Udall's son, Denis. | COURTESY OF GRAND CANYON NATIONAL PARK MUSEUM COLLECTION

might bring, and that night, after Kyle went to bed, I had a chat with our boatman. He, too, was worried. Walking into the Grand Canyon is one thing; walking out on one of the hottest days of summer is another. This would be a challenging climb for someone in their prime. Though wiry for his age, Kyle was just nine — and I was 71. Were we up to it? Once we left the river, there could be no turning back. The only thing that made our plan feasible was that the trust had sent one of its interns down the trail to cache water at two spots. He and an outdoorswoman who had run the upper part of the river would accompany us back out. Having two sturdy guides and water in place would make a big difference, I reassured myself.

The next morning, we rose before dawn. After a hurried breakfast in the dark, our boatman rowed the hiking party across to the trailhead. By sunup we were moving. The first mile, in the coolness before the sun breasted the Rim, was easy. When we reached the top of the Inner Gorge, we could see the jade-green river and our campsite far below. Kyle shouted and waved to the small sticklike figures on the sandbar. Then, after saying goodbye to the boatman who had accompanied us this far, the four of us turned our attention upward. The real work lay ahead.

A long-abandoned mining trail that leaves the Rim 20 miles west of Grand Canyon Village, the Bass Trail is rarely hiked. Winding through a wild reach of the Canyon, the unsigned path ascends 4,400 vertical feet in eight miles. My companions put Kyle out front and let him set the pace. They also gave him the responsibility of picking out the cairns that mark the trail where it has been obliterated by rains and rockfall.

We made good time for the first hour or two, but then, as the heat began to build, my pace slowed. Every few minutes, I found myself needing a breather. Between us we were carrying two gallons of water. By 11:00 A.M., most of it was gone. When we reached the first water cache, we thankfully refilled our canteens and ate something in the shade of an overhang.

By now the temperature was approaching 110° F. No birds sang. Even the lizards and small creatures of the desert had vanished, seeking refuge in their burrows. After lunch, fatigued by the morning's exertions, I lay down on a rock and fell asleep. My nap ended when Kyle poked me in the ribs and said, "We've got to get going, Poppy."

Thirty minutes later, switchbacking our way up the Redwall, we suddenly found ourselves boulder hopping — we had lost the trail! Immediately I called a halt. We couldn't afford to waste energy or to risk someone spraining an ankle. Sending our two companions back to relocate the trail, Kyle and I sought shade under a piñon tree, where I silently second-guessed my role in this risky venture.

"Are we going to make it out?" Kyle's voice interrupted my thoughts.

"We've got to," I said. "Have another drink. You've been setting a nice steady pace."

We sat there for a few minutes — grandfather and grandson — gazing out at the buttes and castles that rose shimmering out of the chasm. Our friends' shouts broke the silence. They had found the trail a few hundred feet above. We scrambled up to rejoin them.

The afternoon was a sun-baked grind, an agonizing test of a young boy's spirit and an old man's pride. Above the Redwall was a flat stretch across the Darwin Plateau, and the last water cache. Then came the final thousand-foot climb. Kyle, showing no sign of his fatigue, stayed in front. My energies, though, were flagging, and I had to call for frequent panting stops. Slowly we inched skyward along the dusty trail.

And then, 10 hours after leaving the river, it was over. We were on the Rim.

"We made it, Poppy!" Kyle said, a note of triumph in his weary voice. I was proud of his spirit and stamina, and the praise that his newfound friends gave him seemed to make the whole ordeal worthwhile. "This is a hike you'll remember all your life," I said.

As I slumped, exhausted, into our vehicle, I wondered whether on this day I had passed the outdoor torch that my uncle had put in my hands in the White Mountains 60 years before. **AH**

DECEMBER 1993

SHRINE OF THE AGES:
Christmas Eve at Grand Canyon

BY WILLIAM HAFFORD

It is Christmas Eve at the Grand Canyon.

A chill wind whispers. Transient snowflakes float down the night through boughs of pine and cling to headstones in the old cemetery where early Grand Canyon pioneers sleep, some for nearly a century. A few hundred yards to the north, the world's most awesome gorge lies shrouded in darkness.

Just beyond the headstones, the massive rock walls of the Canyon's Shrine of the Ages stand in silhouette against winter sky. Inside, under a beamed ceiling of native timber, hundreds of flickering hand-held candles define the faces of the assembled.

Some of the people live and work at the Canyon's edge: a National Park Service ranger, a mule wrangler and his family, waiters and cooks from a nearby hotel. But most have come from afar. The voices sing as the voice of one.

Silent night, holy night.

Candlelight catches the dark features of an exchange student from Nigeria.

All is calm, all is bright.

It touches the countenances of a husband and wife, who, five years before, fled from the People's Republic of China.

It flickers across the high-cheekboned, almond-eyed faces of Navajo visitors from their res-

ervation to the east.

Blond-haired children. Babies held in arms. Old and young. From nearly every state. From nations around the globe. From New Zealand and New Jersey. From Norway and North Carolina.

They sing in the darkened shrine illuminated by candlelight. Bundled in scarves and winter garb. A living Norman Rockwell painting.

———

UNSEEN, AND 5,000 FEET BELOW the Canyon Rim, the unrelenting liquid force of the mighty Colorado River carves deeper and deeper into the oldest exposed rock on planet Earth. Carves as it has for millions of years, as the voices sing.

Three days before, my college-age son, Bart, and I had started north from the palm-lined avenues of Phoenix to spend Christmas at the Grand Canyon. Through the dark of early evening, we drove north on Interstate 17, climbing out of the Sonoran Desert, across a broad plateau of grassland, into forests of junipers, then piñon pines, then towering ponderosas.

Along the way, I spoke with Mother Nature and told her that we needed a storybook scene for tomorrow's steam-train ride north from Williams to the South Rim. By the time we had ascended above 6,000 feet, the sky was spitting snow.

The next morning in Williams, I anxiously pulled aside the curtain on our motel-room window. "Yes, indeed. Thank you, Mother Nature!" The mountains behind the Mountainside Inn were dressed in winter white.

Later one of the antique engines of the Grand Canyon Railway — a 1906 model — chugged, tooted, and whistled us from Williams through a Christmas-card landscape. The restored three-car train, filled to capacity, swayed rhythmically around the white flanks of pine-covered volcanic hills. Across broad meadows. Past the ragged escarpments of limestone bluffs.

On a broad plain, the snow appeared only in scattered patches. Beside the tracks, a herd of grazing pronghorns eyed the mechanical intrusion. The engine whistled, and the tawny white-rumped creatures — among the fastest animals on our continent — wheeled and darted toward the horizon.

Attendants served steaming coffee while a pair of roving minstrels plucked, strummed, and sang us along our 64-mile journey to the Canyon.

That evening, under a clearing sky, Bart and I stood on the limestone surface at Trailview Overlook just west of Grand Canyon Village. To the east, beyond Wotans Throne and the multitude of ragged buttes that spring from the Canyon floor, a full moon, orange, huge, and

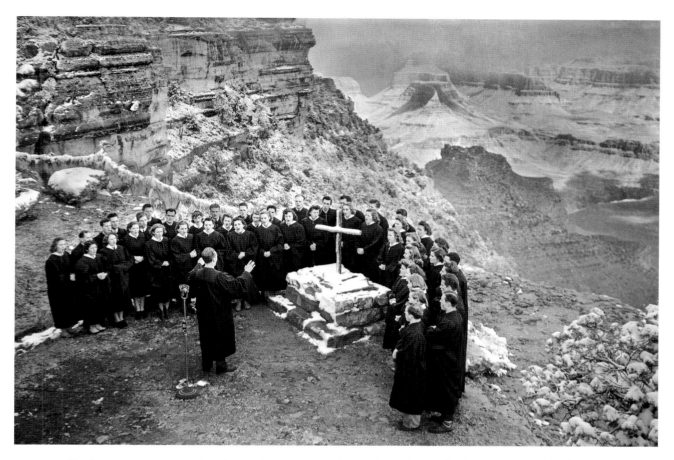

The Shrine of the Ages Choir performs at an Easter sunrise service on the South Rim. This Emery Kolb photo likely dates to the 1930s or '40s. | NORTHERN ARIZONA UNIVERSITY CLINE LIBRARY

slowly rising, appeared above the mile-deep gorge.

On Christmas Eve morning, I walked to the mule corral near the Bright Angel trailhead to watch tourists mount up for a winter ride into the Grand Canyon's depths. Before departure, their guide, wearing a wide-brimmed black Stetson, provided a crisp lecture on mule-riding manners and safety. "The trail is icy today," he said, "but them mules all have steel cleats on their shoes. For near a hundred years, no mule has ever fallen from the trail and killed a rider." He spit tobacco juice.

The riders, a few displaying weak smiles of trepidation, hoisted themselves into the saddles.

Some had scarves wrapped around their faces; some wore earmuffs. All were bundled against the cold.

From a good vantage point, I watched as the line descended the serpentine snow-covered path. Although the sky above was almost clear, the gorge itself was filled with heavy clouds that had settled in during the night. The Canyon was hidden, except for the highest protruding buttes.

Down, down, down the mule riders went, entering the vapor mass, and for a few moments — before they disappeared from my view entirely — it looked as though they and their mounts were floating through the clouds.

Later Bart and I visited the geologic museum at Yavapai Point, where huge plate-glass windows face the Canyon. For long minutes, we could see nothing but swirling clouds below the Rim. Occasionally ravens would emerge from the white mass, wings extended, gliding on a Canyon current. The dark birds would sweep across the landscape then dive back into the enveloping white.

Finally the clouds parted, and, far below, we could see the narrow line of Bright Angel Trail where it makes its final descent down the plum-colored nearly vertical walls of the Inner Gorge. Through an eroded cleft, a stretch of the great river, highlighted by a shaft of sunlight, could be seen. Usually the Colorado is a jade-green stripe, but winter runoff had turned it rusty red.

In the afternoon, I lounged in front of the massive rock fireplace in the lobby of the El Tovar Hotel, built in 1905 by the Fred Harvey Company.

Compared to crowded summers, the year-end holidays are lightly booked. Historic El Tovar and neighboring Bright Angel fill up, but other lodges in the national park and the nearby community of Tusayan usually have vacancies, even on Christmas Eve.

Near dusk Bart and I drove west along the Rim to Hopi Point, where we left our vehicle and walked to the precipitous edge. The heavy cloud mass had drifted out of the Canyon, but a few lingering tufts floated below us, sliding between the shadowed buttes. High above, a new cloud bank rolled in from the east, bringing the promise of evening snow.

The winter sun drops quickly. We remained there on the promontory until darkness slid across the buttes and down the harshly eroded cliffs. Two hours later, we are among the faces touched by candlelight.

And the voices singing:

Silent night, holy night.

It is Christmas Eve at the Grand Canyon. 🄰🄷

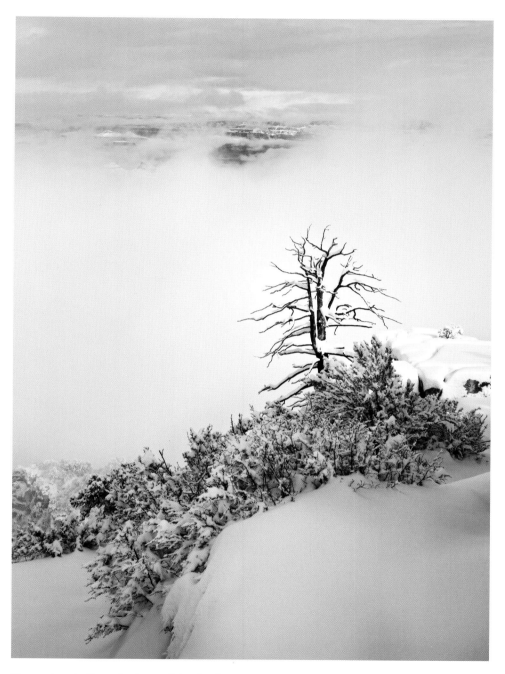

The sun breaks through a layer of clouds after a January snowstorm at the Canyon. | SUZANNE MATHIA

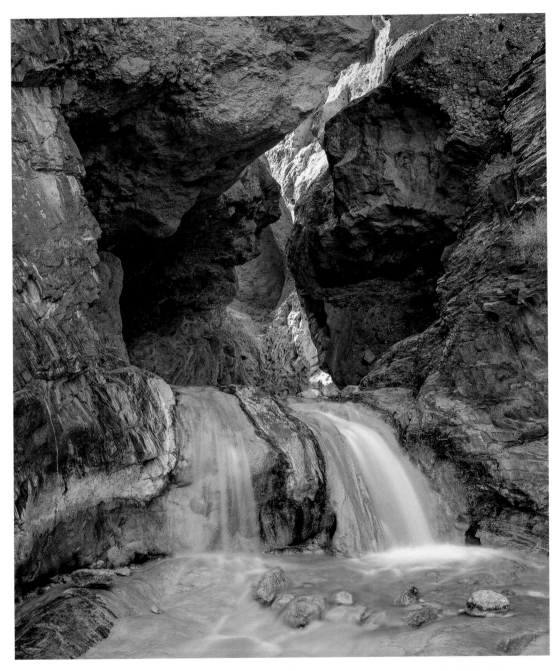

Water from a Grand Canyon spring flows through a travertine grotto, leaving deposits of minerals along the way. | GARY LADD

APRIL 2001

THE QUEST FOR WATER:
Natural Springs in the Grand Canyon Quench Hikers' Thirst for Adventure

BY CRAIG CHILDS

The interior of the Grand Canyon opens beneath the head of South Bass Trail as if acid cut through hundreds of square miles of rock. Pausing at the edge, I tightened the straps on my backpack as a group of three travelers showed up. We all peered down as if about to jump from an airplane.

As we exchanged bits of information about our lives — the quick discussions often had at trailheads — someone casually asked how much water I was carrying.

"A quart," I said.

Their brows furrowed. They studied my gear and boots to see if I had ever been hiking a day in my life. My thinking was that for a three-day winter hike, a quart of water would get me down a thousand feet, where I would set camp and head off looking for more water in the form of springs. They kept staring at me.

I had to break the silence. "How much are you carrying?" I asked.

"Three gallons each," was the answer.

Hearing of such extra weight made my back ache. My brow furrowed. I studied their gear and boots. We smiled politely at each other, said farewell and set off, equally convinced that the other was going to die.

Now, don't mistake what I am saying here. Carry 3 gallons of water if you wish and ignore

the ascetic fools who explore the Canyon sweating while you've got enough to gargle and spit out after each meal.

I carried only a quart because the Grand Canyon is really a "well," dug 6,000 feet into the Earth, and hosts a hive of springs. In certain locations, water bursts from cliff walls and rushes out of cracks in the Canyon floor. Spilling between terraces and precipices, ropes of water lace the deep insides of the Canyon. It takes only time and endurance to learn to find them.

More than 900 square miles of plateau land north of the Canyon gather rain and snow-melt. This surface water sinks into the ground through incalculable cracks, faults and caverns beneath. In some cases, the springs fill and empty in a matter of days, while others steadily dole out water that has waited in the Earth for thousands of years.

When I came down South Bass Trail, I was still new to the Grand Canyon, but I already had a routine for desert travel. At the end of every day, I suit up with a small pack of empty containers and set out from camp looking for water. I spend more time exploring and hunting water than I do carrying a pack full of gear and food.

By the end of that day, as the people I met earlier were likely settling into a comfortable meal with plenty of drinking water, I was thirsty down inside the Canyon. I poked in and out of crevices with the scurrying intensity of a mouse, pushing my finger into soil to test for damp-ness. By sunset I'd found hardly a trace of moisture.

Just before dark, I reached behind the cables of a black widow spider's web. Beneath a small ledge I felt a sponge of moss. I pushed into the center and water squeezed out. I maneuvered a bottle into place and sat for an hour as drips of seep water gave me a new quart.

While I waited, I pulled out my notebook and wrote details about the spring: the type of rock, the direction it faced, the vegetation nearby. It was small, but enough to keep me alive.

Those notes I took began the first of hundreds of pages and many years of recording the springs of the Grand Canyon. Some entries indicate volume, temperature and plant species; others report on taste or smell. One section relates the entire day I timed with a stopwatch the sequence of water drops, looking for some concealed pattern.

As I waited for my second quart bottle to fill, I looked into the dark canyons below. Water waited down there. I couldn't hear it or smell it, but I knew.

———

THE COLORADO RIVER, a peculiar beast in the Grand Canyon, remains a stranger to the des-ert. It hardly visits. It just keeps moving, cutting and growling as if frustrated with the desert's imposing rock. Each time I have gone down the river, the desert passes around me, a quiescent

One of the Canyon's countless waterfalls pours from a craggy wall. | GARY LADD

The fulsome cascade at Deer Creek fosters a colony of moss. | GARY LADD

observer of the river's restlessness. Each time I think, *This is not desert water*, and I tie off the boat and explore far from the river on foot, looking for the real desert water. South Bass Trail had begun my search, and the river now provided a convenient way to get farther inside.

I first came down the river as a cook for a rafting group. After preparing a meal one evening, I abandoned camp and scrambled up a narrow canyon in the rippled orange floors of Hakatai shale. I carried bread and an apple for my own meal. Miles from the river, small waterfalls flowed over domes of rock, sheeting into pools below. I followed them to a slot canyon where six full-grown cottonwood trees extended from the floor, crowding toward the last daylight. In the back of the slot ran a thread of a waterfall. It emanated from a spring in the limestone just above. The waterfall met a small pool, huffing up champagne-like air bubbles.

By its location on the south side of the Grand Canyon, I knew the spring was old, technically known as "fossil water," likely dating back thousands of years — maybe to the last Ice Age. I removed my boots and stepped into the pool of ancient water, moving slowly so the basin would not muddy. Like tumbling balloons, the eggs of canyon tree-frogs swept out from under my feet. I rested my hands on each wall and leaned toward the waterfall. It had carved itself a thin 30-foot-long trough down the rock face. Streaks of its white water slipped into the pool, hardly troubling the surface around my legs. I touched the waterfall with a single finger. The water broke around my finger and rippled the pool below. I pulled back.

LATER IN THE YEAR during a 20-day Grand Canyon hike, I came to a place where the water on the walls dripped like candle wax. Pillars and caves hung over the floor of a side canyon. The rock, called travertine, was a remnant of the mineral-rich water from the spring. You could see how springs had overlapped and migrated over time and left eerie plastered shapes all over the Canyon.

Where springwater moves swiftly, such as in waterfalls, travertine forms slabs of white rock, smooth as sculpted marble. The basic minerals of travertine exist in most of the springs here and are dissolved into the drinking water, which supplies most human developments in Grand Canyon National Park. I once spoke with a man who had worked in the park for 10 years and drank from the park's supply all that time. During his stay, he passed nine kidney stones, which he blamed on pearls of travertine gathering in his body.

I hiked upward through the hard, soapy folds of rock. The spring, the size of a large stream, revealed itself in waterfalls and rock-lined lagoons. So much of the canyon wall had tumbled in, the place turned into a steep labyrinth of chambers glued together by travertine. The spring

filled every passageway. I took off my clothes and draped them on one of the boulders. I climbed through dark openings, where streams sprayed over my back. Ten or 12 waterfalls furrowed into the velvet mosses.

I swam through deep pools of springwater, beneath cascading sheets to openings beyond. I crouched like an animal in a hole, pressed against the walls, squinting as I looked up through the drips. Shafts of sunlight shone between boulders.

I looked out from this thicket of water and rock and saw the desert beyond. Prickly pear cacti hung from arid ledges. Sharp-tipped agaves nested in the dusty debris of crushed boulders.

I squared my hands around my eyes, framing out the desert so all I could see was the green shroud around me. It was a mossy, equatorial rain forest in the desert. The plants there appeared outlandish both in number and diversity: rock mat, maidenhair ferns, bear grass, yellow columbines, crimson monkeyflowers, lemon verbena, saw grass, pore-leaves, Western redbuds, acacias, birchleaf buckthorns, squawbushes, peppergrass, Fremont barberries, seepwillows, lip ferns and brittle ferns. And orchids not yet blooming — orchids in the desert seemed nearly mythical.

Maidenhair ferns ruled that particular canyon. They grew upon themselves in such numbers as to build flying buttresses off the walls. The spring strained through the great mounds of ferns, forcing hundreds of gallons of water from their undersides. I stepped beneath one of the balconies. Cold dabs of water spattered against my body until they accumulated and ran, covering my skin like winding snakes. The sound of water pouring on rocks at a thousand intervals was that of a long night's rain. I kept my eyes closed inside this rainstorm.

When I came out to the sunlight, shaking water from my body, I found my clothes, riffled through them and pulled out my notebook and a pen. Already, in less than a year of traveling by boat and foot, I had recorded a couple hundred Grand Canyon springs.

———

AS I HUNTED THE SPRINGS, I found myself enchanted equally with the huge and the minuscule. At some I only drank and moved on, while others were the entire focus of my being there. On my most recent trip into the Grand Canyon, two years after the spring below South Bass, a friend and I walked for nearly two weeks with no other purpose but to see a particular spring. We clawed off-trail with heavy packs, climbing and ducking boulders and collapsed cliff faces. After seven days of this, we reached a spring that thundered from a hole in a canyon wall. Huge, cold boils of water surged from the rock. We put on the wet suits we had carried and dove into the hole. We pulled and swam, breathing cool, misty air along the ceiling of the cave. Following the beams of our headlamps, we spent more than an hour tracing subterranean wells and

rivers. All of this was springwater, yet to see the light of day.

It felt the temperature of a glass of ice water. In places we swam against the chill, and in others we climbed along damp, exposed ledges. Our lights seemed feeble against the darkness, disappearing into reflective wells of deep green water. The architecture of the cave fluctuated wildly, going from thin, roaring passages to open chambers decorated with grottos and small waterfalls. Passages went on for hundreds of yards, winding deep within the seemingly solid rock of the Grand Canyon.

Far inside the spring, my voice stolen by the clamor of dark rapids, I stood with half my body in the water. My arms held me against the current, hands clutched to sprayed-wet rock. The first Grand Canyon spring I had found behind the spider's web near South Bass Trail could have seemed inconsequential at this moment. It had taken an hour for its drips to give me a quart. Now I stood against thousands of gallons rushing by in a matter of seconds, deep within the source of the spring.

In drips or in rivers, the water emerged sweetly from the Earth, fed by the Grand Canyon's underground maze. I bent forward in the cave and drank.

EDITOR'S NOTE: Before entering the Canyon, hikers should be aware of the Grand Canyon National Park Service's safety recommendations, including how much water they should carry. Sometimes bat droppings pollute pools of springwater, making it unhealthy for humans to drink without treating. **ॱ**

MAY 2006

THE OLD MAN AND THE CANYON:
Pioneering Route-Finder George Steck and His Acolytes Sought the Solace of the Grand Canyon One Last Time

BY CRAIG CHILDS

The old man sat in the bottom of the Grand Canyon, relaxed among sheaves of bedrock. He posed like a lanky Buddha, his body resting on bands of red stone as if he had been born here. We had a camp down by the river where we lounged in the afternoon after dipping naked in frigid water.

George Steck was 73 years old at the time, a pioneer route-finder from the Grand Canyon, a master of long journeys through an untrailed, cliffbound wilderness. He looked at me with wry, intent eyes frayed with gray, professorial eyebrows. He was always looking at me this way, as if a question waited constantly on his tongue.

With a gravelly, slow and thoughtful voice, he asked if I would rather lose my eyesight or my hearing. I studied his face, unshaven and bristled. He was slowly losing sight in his left eye, his hearing peppered with hums and pops. That must be what old men think about, I mused. I told him I would rather not go blind.

I imagined he would agree. With a Ph.D. out of Berkeley, he was a theoretical mathematician who had spent most of his career inventing equations at the Sandia National Laboratories in New Mexico. I thought, of course he would choose to keep his eyesight. He would need to see the numbers and symbols of his profession. He also needed his eyes to feast on the slender ledges and boulder choked slopes of the Grand Canyon. Otherwise, how would he ever find

Legendary Grand Canyon hiker George Steck, who died in 2004, blazed hundreds of trails in the Canyon's remote and unexplored areas. | GARY LADD

George Steck leads the way on a rocky slope above South Canyon. | GARY LADD

his way through?

He did not answer as quickly as I had. He licked his lips and looked around the Canyon. "I would rather not go deaf," he said wistfully.

He told me he likes particularly melodic music: Brahms, Chopin, piano, wind, water. The rustle of a breeze through reeds. After that, we were quiet, listening to the hollow gulping of the Colorado River below us, the whisper of gusts across cliffs thousands of feet over our heads.

———

GEORGE SPOKE IN MATHEMATIC RIDDLES, always testing me, asking impossible questions, finding the Golden Mean in the growth patterns of an agave, borrowing my journal to scribble out geometric calculations. It was our great debate, what math has to do with route-finding. The two of us argued to no end, sitting at his coffee table or wandering through canyons, me saying that it is no coincidence that he was both a mathematician and a famed route-finder. It is the same process, I told him, scouting through wells of logic and numbers or picking your way across a terrain of palisades. His response to me hardly ever changed: a long, concerned glance, a smack of his lips and a flat denial. Math is math. Landscape is landscape. He said he could see my point, but it seemed esoteric, unproven.

I gathered his personal equations — pages upon pages of theorems, postulations, symbols, numbers and hardly a single word of English — in an attempt to understand the vast mechanism of his mind. Meanwhile, I traveled into the wilderness of the Grand Canyon with him, following his steps as year by year he slowed, staggering around the boulders, his eyes tinkering intently with small moves.

He had walked hundreds of days in the Grand Canyon. At the age of 57, he made his first 80-day trek from the beginning to the end, plumbing the stone for routes, clutching ledges with his fingertips. Of any land I have ever traveled, this place requires the most delicate of calculations. The Grand Canyon is an enormous and subtle riddle.

———

GEORGE CHOSE A SMALL NUMBER of inheritors. We were the lucky ones. He shared knowledge of routes, of certain places and ways inside the Grand Canyon, of stories, recollections of flash floods and massive boulders calving off their cliffs, exploding into clouds of dust and debris. These stories and routes were conveyed to us not at a kitchen table with maps unfolded, but in the field.

George was 75 when we dropped off the edge of Marble Canyon in the upper reaches of the

Grand Canyon. We carried our gear between pale and enormous pillars of Kaibab limestone, skittering down rockslide slopes — no trail anywhere in sight. He wanted us to know about a route deep inside — a cave that cuts through a cliff.

Half a day down inside the first layers of cliffs and slopes, George sat down and decided he could go no farther. Too old, too tired, too far, too steep. He insisted that the rest of us continue without him. He explained that his presence was no longer needed. By now we should have known well enough how to navigate, how to take the clues he had given us and find our way to the cave. From there we could figure it out.

We left him on a ledge, a solitary figure watching over the depths of the Grand Canyon. Like weaned children, we moved with an awkward sense of confidence into the Canyon, movements full of timid boast, hand over hand, passing packs down. We each glanced up now and then, George long gone miles above us.

———

I ONCE TOLD GEORGE that I had been studying the geological framework of the Grand Canyon. I explained to him that the entire place had been built upon a pre-existing blueprint, an underpinning of faults and fractures. I had synthesized volumes of data about erosion and flash floods, running statistical equations through a computer. I determined that the shape we call Grand Canyon is as formed as the wings of a butterfly. It is a carefully balanced relationship between weather patterns, river meanders and geology. These vaults of side canyons that we traveled through, the deeply shadowed holes down in the Redwall and the massive platforms of Bright Angel shale could be defined numerically.

He inspected me with a sideways glance. "You keep trying," he said with all seriousness, and then a smile.

———

THE LAST GREAT TREK. George was 77 when several of us took a week to tumble into the western Grand Canyon, carrying pitches of rope to haul our packs up and down the gray-red cliffs. His movement between boulders was ticking and slow. Crossing back and forth over a clear stream on the Canyon floor, I saw a rhythmic tremor to George's step, to his speech, to his hands reaching out and planting on cool bedrock. His lips stuttered with tiredness, eyes blinking.

Shadows gathered around us in the pearl-blue narrows of this limestone canyon. When we walked into a band of sunlight, he ordered that we rest. He laid his body over the rocks like a limp piece of fabric. Even in exhaustion his eyes tracked methodically across the terrain.

A side canyon streaked up the wall across from us, its bends quickly vanishing.

"You ever think about places like that?" I asked him, gesturing up the side canyon.

"No," he said. "It doesn't go anywhere."

"But aren't you curious? Even if it's a dead end? There are springs and pools up there, different shades of light."

"That's your job," he reminded me. "It's a dead end."

George had this trip timed, exactly where we were to fetch water, where we would set our camps, how many hours it would take to get from one place to the next. He had turned himself into a straight line piercing the labyrinth of the Grand Canyon. This journey was turning him into an old and rickety man. He could not afford a single step in the wrong direction. With no paths to follow other than his memory, we had been running packs down boulder stacks and sheer walls, climbing waterfalls, descending long smooth chutes of stone. He grew older with every step.

Time to move again. I helped him up, our hands meeting. His skin felt old, but smooth, like suede, his finger bones loose and relaxed beneath leopard spots of age. I stayed back as he walked ahead. As soon as he was out of sight, I shot up the side canyon, tearing like a monkey between its high walls. Indeed, it was a dead end.

When I found George at the end of the day, he was again sprawled across the ground, his body poured into the rocks. He frowned at me. I was the last to arrive. "Where have you been?" he asked.

I was sheepish. I said that I had been checking out some routes. It was a lie; I was merely playing up in the canyons. He knew it. He excused me anyway.

———

DAYS OF TOIL, stumbling through landslide boulders along the Colorado River, pierced by the sun, then swallowed by stinging shade. A kayaker backpaddled to talk with us, an excuse for George to wither back into the shade. We sat on a balcony ledge above the river. The kayaker was curious, saying that our walking with packs through this terrain looked tedious and exhausting. We assured him that he was right.

The kayaker finally swept away from us like a bird. I got George up and we continued, earthbound, plodding slowly downstream.

Days later we were far from the river, climbing up through tiers of green desert lagoons and lapidary palisades. Moving slowly, we climbed into a hallway of cliffs, George coming up below me where his hand swept dust away from a hold where I had just stepped. Up here, the lime-

stone breaks away in fist chunks. Debris clattered down, rattling and cracking, plunking finally into a plunge pool far below.

These high cliffs were busy with shouts back and forth, rocks snapping free, ropes anchored, and tested with strong tugs. We climbed for hours. George spilled the last of his energy again and again until there was nothing left, his movements creaking like wood. He finally cleared his way to the top, where he collapsed onto the ground. One of the inheritors, a young man, poured water into his own hand, and pulled off George's hat to run his wet fingers through the remnants of fine white hair.

"That should cool you down," he said.

George conjured a deep smile, his eyes becoming sharp again. "Yes, yes. That helps."

———

THE LAST TIME I SAW GEORGE, I stopped at his house to pick up some climbing rope. He was on his way to the Grand Canyon, a short trip, just to give a talk. I was heading into a wilderness in southern Arizona. Half joking, I reminded him of a promise I had made. When he felt he was ready, we would go into the Grand Canyon where I would pick up a rock and clock him in the back of the head. He laughed. Not just yet. But his laugh was only half-joking.

He died in his bed after returning from that Grand Canyon trip. When I heard, when someone quietly took me aside and told me the news, the world collapsed around me. The byzantine framework of lines and webs that holds the Grand Canyon together for me dissolved.

When a few days later I stood at his funeral, I heard stories pouring out of all who knew him, the sweet, rippling sounds of voices, vowels swinging open like soft winds. It was not in the numbers, I realized. It was in the rivers of senses pouring into me as I stood in the back of the funeral.

I walked out to the watermelon light of late afternoon and shook the hands of mourners. I could feel the sweat of their palms, the bones of their fingers. Traffic nearby sounded like a swarm. My senses were suddenly sharpened. I could not help remembering the sound of the river mumbling its way through the Grand Canyon. I heard the far away rattle of reeds in a canyon breeze.

George got his wish. Never will these senses cease. **AH**

MAY 2010

ALL MY GRAND CANYONS

BY CHARLES BOWDEN

My first Grand Canyon is a license plate on a parked car in Chicago in the '50s. It is afternoon, the car is black and the Arizona plate announces "Grand Canyon State." Apartment buildings line the street and I only know one person that even owns a dog, the old man who lives next door and whittles all day on his front porch. The license plate feels like a message from a distant planet. My second Grand Canyon comes to a room in the newer wing of a junior high. In the fall of 1957, it is the one section of the school that has a swamp cooler. The rest of the building in Tucson has ceiling fans and large windows that open to the desert heat. The teacher places a record on the turntable, demands silence, we all dutifully put our heads down on the desks and suddenly a *hee-haw* knifes through the room. The piece is by Ferde Grofé, a name as strange to my ears as the bray of a mule. A few years later, my family made the obligatory drive, paused on the edge of the Canyon, and looked. Then, like almost all visitors, we did not know what to do next.

I've spent my life going in and out and up and down in the Canyon and I've learned what we make of the Canyon hardly touches whatever the Canyon may be.

Grofé first saw the Canyon in 1916 when he drove out from Los Angeles with some friends and camped. He thought it was the primeval world, even though trains had been dumping tourists on the Rim for 15 years. At dawn, he noticed birds and other sounds slowly emerging as the

light came on and felt words couldn't nail what he felt. He came from a long line of musicians and by age 16 was honing his skills in a San Francisco whorehouse. He became the arranger for Paul Whiteman's jazz orchestra and took George Gershwin's two-piano composition and wrote it out for all the players of the orchestra. The piece was *Rhapsody in Blue*.

But the Canyon bedeviled him. He had a few sketches of something about that sunrise and in the late 1920s sat down to puzzle out five movements he called *Grand Canyon Suite*. He got the *hee-haw* I first heard in that classroom one day when he was pushing his son down a New York street in a baby buggy. Pile drivers were pounding out the footings for a new building, the wheels on the buggy had a squeak — the clop of the mules, the bray of their cry. On his honeymoon, he was trapped in a Minnesota outhouse during a cloudburst — the sounds of the *Cloudburst* section were born. Such are the origins of the piece, one played endlessly to schoolchildren. Like all of us, he found his Grand Canyon by bringing his life to it and then pouring fragments of his life into this gigantic hole he could not really describe but could not stop feeling.

He is not alone in being tongue-tied by the abyss. In 1931, Albert Einstein got off the train, had a photograph taken with a group of Hopis who worked at the Canyon's Fred Harvey lodge and was renamed by them The Great Relative. Or that's how the story goes. In the photograph, he wears a Plains Indian headdress, clutches a big peace pipe and says nothing that is reported. Once while at sea in a severe storm, he wrote in his diary, "One feels the insignificance of the individual and it makes one happy." I'd like to think that was in his mind as he first stared into the Grand Canyon.

The Grand Canyon has been song, scored music, drawings, paintings and photographs. Various adventurers have wandered its entrails, left journals and barely scratched the rocks. Dams now stem the major author in the area, the Colorado River. And yet all these efforts to capture the Canyon or know the Canyon or maim the Canyon seem barely a second in the time that slaps one in the face at first glance. The Canyon is too big, or too deep, or too old, or too long, or too overwhelming to submit to human efforts to either capture it or destroy it.

Off and on in my life, I have walked it, been there in summer heat, camped in deep winter snow. Seen the water low and high. And I know nothing I did not know before I first came. Except this: How little I know or will ever know. Einstein with his notions of relativity and space and time imagined a universe that bends in on itself, a kind of impossible thing to imagine with curved edges, a place where my everyday feel for time and space proved an illusion when the big picture hove into view.

I have read his theories for most of my life and still as soon as I close the book I seem unable to hold them in my mind.

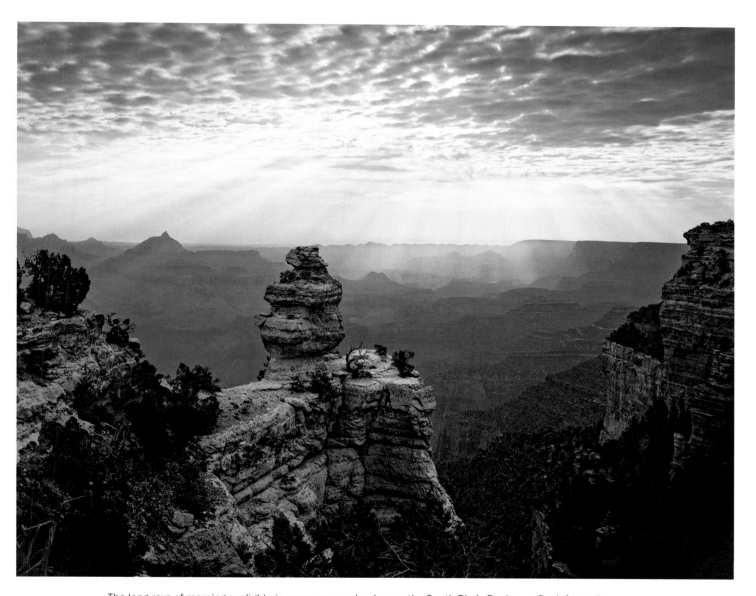

The long rays of morning sunlight pierce monsoon clouds over the South Rim's Duck on a Rock formation, south of Shoshone Point. | GARY LADD

That's the Canyon.

The land rose, a river cut, the entrails of the Earth came into view, time beyond human comprehension loomed up like a wall and the hand could rub and feel billions of years.

The night stars come out. A ringtail keeps trying to steal my food. I am 40 or 50 miles downstream from the Bright Angel Trail where Ferde Grofé heard that *hee-haw* in 1916 when he was a young guy sensing a new music called jazz. The mules gave him a sound he could not wrap his mind around until he pushed his son in the baby buggy amid the pile drivers of New York. The storm moved off yesterday, that thing like being trapped in a Minnesota outhouse. The ground is fairly dry now but still smells of life. I can watch the path of jetliners and satellites scratch the sky in the darkness.

The Canyon is all around me and the river purrs just 50 feet from where I sprawl on the sand. I guess I could say the Canyon is timeless or eternal or the face of God or the beauty of nature or a national treasure or maybe even a photo opportunity.

A year before he ever saw the Grand Canyon, Albert Einstein put down a credo, "What I Believe." He wrote, "The most beautiful emotion we can experience is the mysterious."

I think I should shut up.

And listen. **AH**

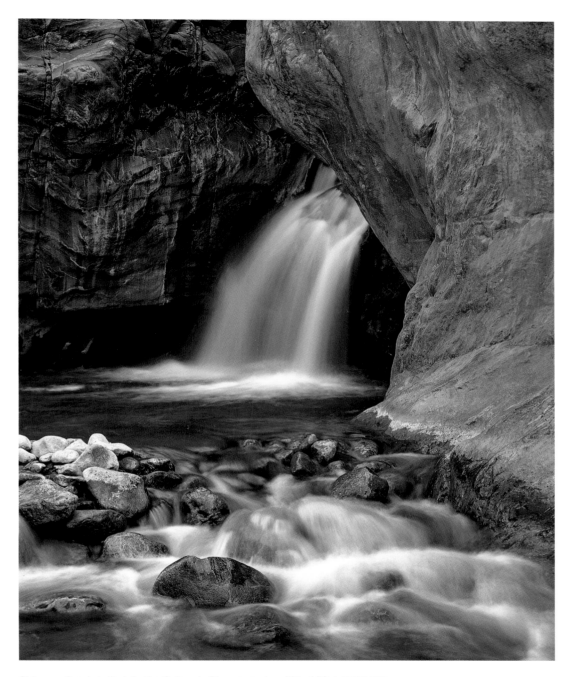

Shinumo Creek spills into the Colorado River near river Mile 109. | GARY LADD

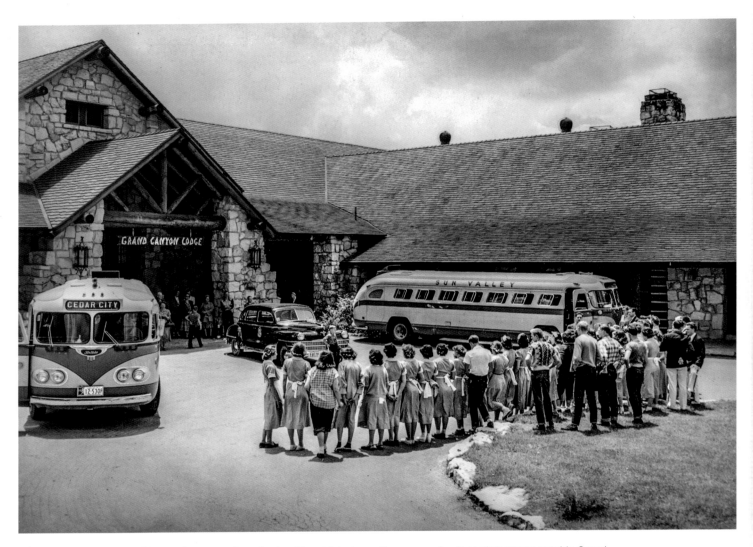

North Rim employees perform the traditional "sing-away" ceremony for departing guests outside Grand Canyon Lodge in the late 1940s. | COURTESY OF GRAND CANYON NATIONAL PARK MUSEUM COLLECTION